NORTH FORK LIVING

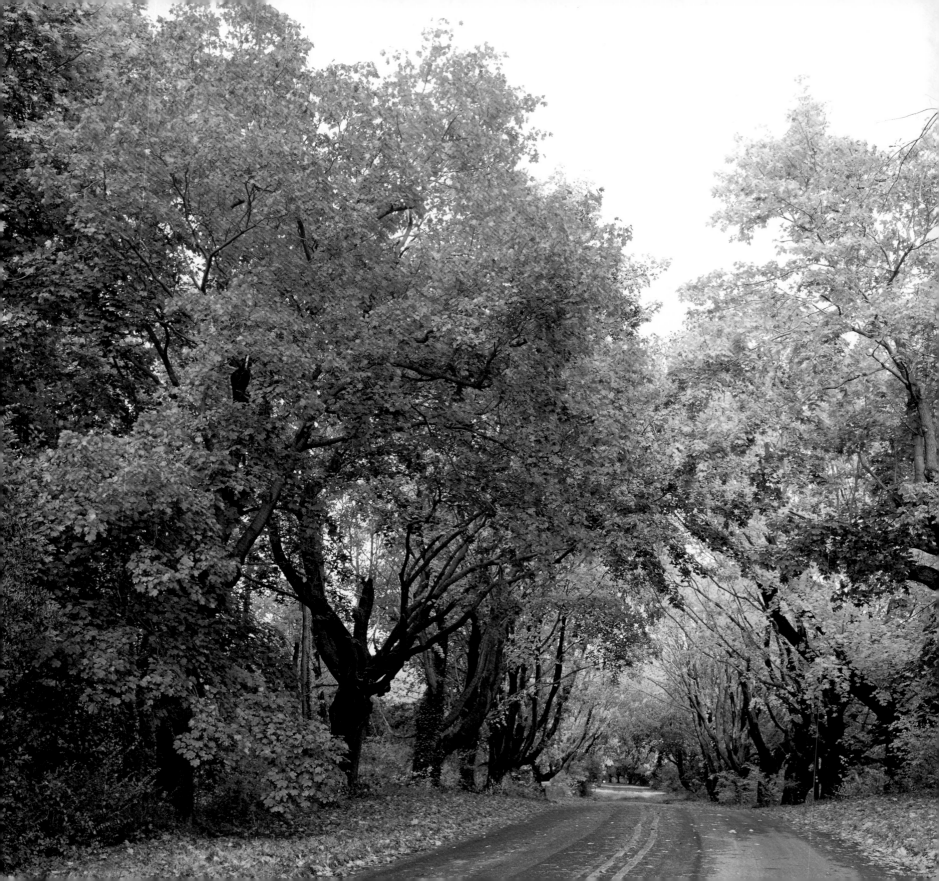

NORTH FORK LIVING

RUSTIC SPLENDOR ON LONG ISLAND'S EAST END

HARRY HARALAMBOU

ABRAMS, NEW YORK

FOR THE LATE SIR THEODORE JAMES JR., WHO WAS AN EXTRAORDINARILY
GIFTED MAN, A RACONTEUR, AND AN ETERNAL OPTIMIST.

PAGE 2: SOUNDVIEW AVENUE, SOUTHOLD
THIS PAGE: GREAT PECONIC BAY AND ROBINS ISLAND FROM NEW
SUFFOLK AVENUE, CUTCHOGUE

CONTENTS

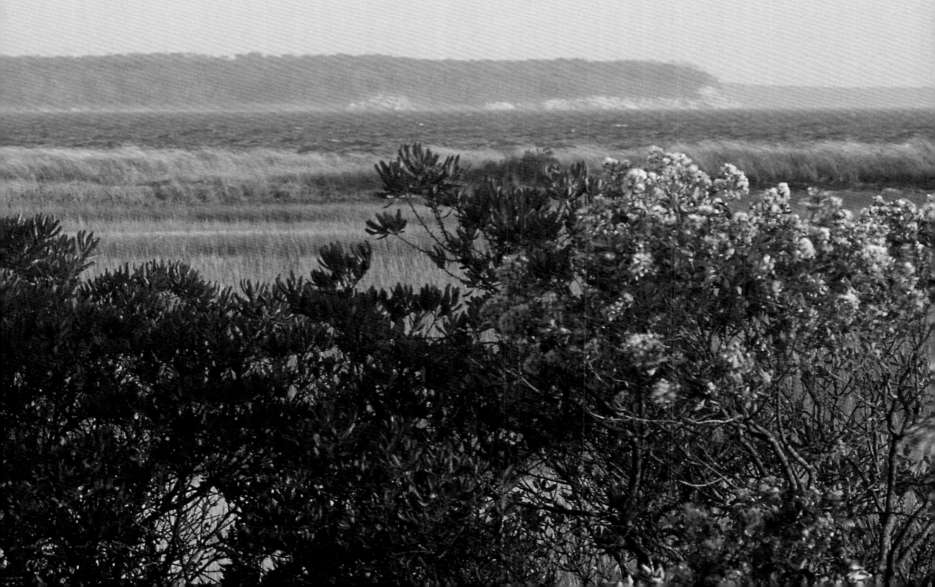

MY LOVE AFFAIR WITH THE NORTH FORK began in August of 1970
when my parents, who had emigrated from Cyprus to New York City, visited their
Greek friends in Mattituck. The North Fork, with its numerous waterways,
reminded them of their home in Cyprus. I remember that first drive to the North
Fork very well. We took the Long Island Expressway from Astoria, Queens, to exit
71 (Calverton), the last exit on the highway at that time. (Now it continues
to exit 73, Riverhead.) It seemed like we had reached the end of the world. We
continued further east on Sound Avenue, a lovely, quiet road, passing farms along
the way until we reached the town of Mattituck. To a kid raised in Queens, the
grassy fields, fresh air, and open space were completely foreign — it astounded me.
We bought lobsters and fresh vegetables for our feast, and by the time evening
fell and Perseid meteor showers lavished the night skies, I was convinced that this
was where I wanted to live the rest of my life. So it was a great delight when I
learned the following year that my parents had decided to build their retirement
home there. That was long before the Invasion, as I like to call it, which began
some sixteen years ago.

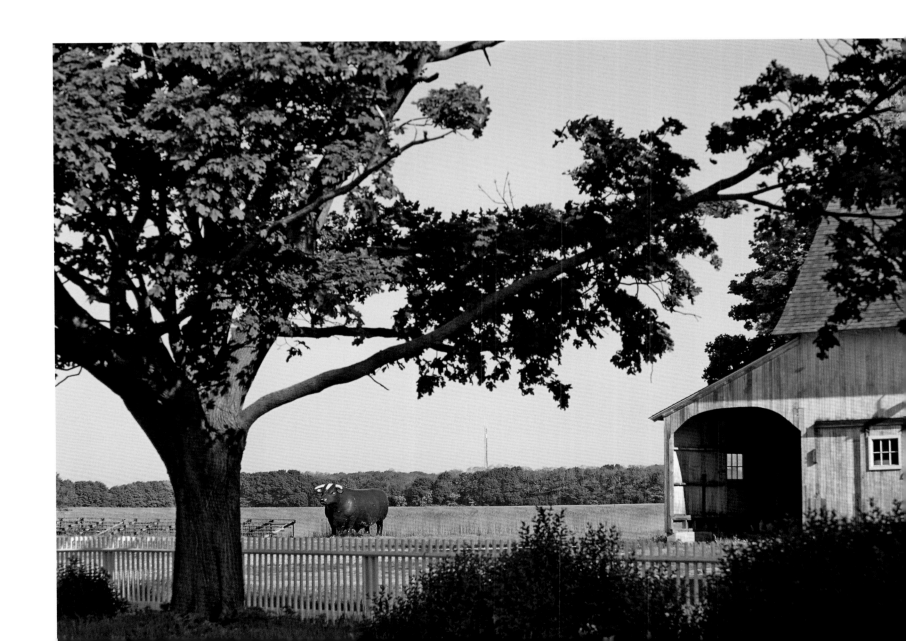

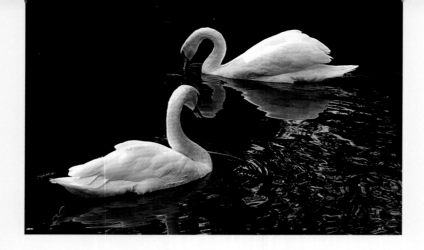

It was a subtle invasion, one that began quietly by word of mouth. "I was just in a charming place called the North Fork," one would say. "Oh? Where is that?" was the usual reply. When that question was directed at me, my admittedly disingenuous response was, "You can't get there from here." I was very protective of my beloved niche in the world. I wanted it all to myself, preserved exactly as it had been when I first discovered it long before the Invasion. That was before the vineyards, before the onslaught of tourists, before the traffic, before the pressures for development, before the pinch-faced joggers, before the cyclists in their fashionable athletic attire, before corn mazes, and before high-tech farm stands. Before all of that, the rustic, no frills, what-you-see-is-what-you-get kind of place was, for me, the real North Fork.

The North Fork is about ninety miles east of New York City, but thanks to the widening of Long Island's roads, the ride out from Manhattan is relatively uneventful until you get past the car dealerships, industrial areas, and outlet malls of Route 58. After this point in the journey, the landscape changes quite dramatically and the atmosphere of the North Fork begins to embrace you. The open spaces and uninterrupted vistas spread out on all sides, and their effect on the psyche helps you begin to unwind. Your blood

pressure drops, and you look forward to peace and relaxation in this place that seems light years away from the city. The impact on the senses occurs year-round: there's the lushness of the farms and fields in summer, the rusty hues of autumn, the romantic bleakness of the winter landscape, and the pale greens and blossoms of spring. These are the very reasons I was drawn to the North Fork nearly forty years ago. Since then I have made them very much my own, and fortunately, despite the Invasion, much of what first drew me remains intact.

I now live in Peconic in a landmark half-Cape house built in 1740. The living room has the original Maine pinewood paneling, which I have stripped and restored to its pristine state. It has two fireplaces that are connected to one another back to back, one facing the living room, the other facing the dining room. The fireplace in the dining room has a Dutch oven with the original hardware for smoking meat. The upstairs has two bedrooms, both with wide-beamed floors. On the property is a majestic yew tree, probably one of the oldest on Long Island. I also have an extensive garden divided into "rooms," with each room a different style: there is a rock garden, a water garden, a shade garden, and a Japanese-style garden.

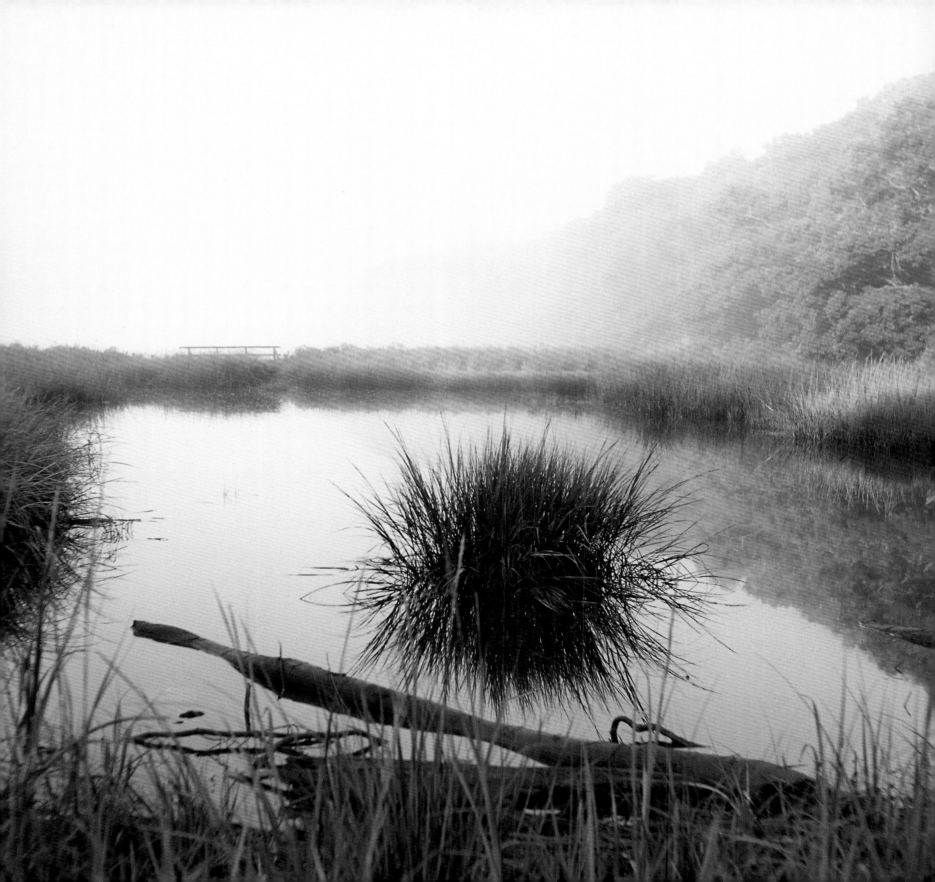

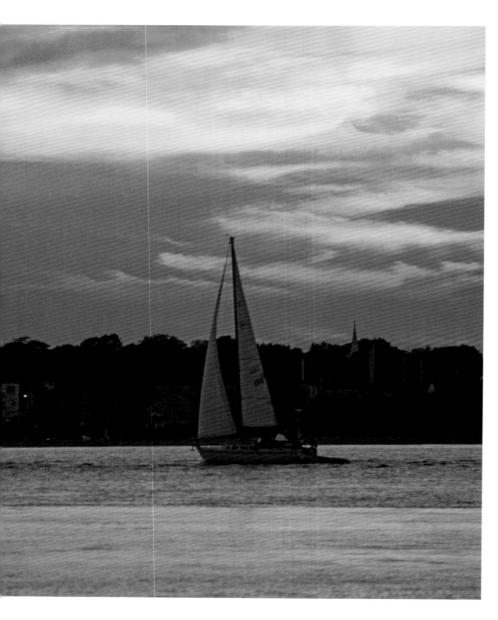

GREENPORT

PECONIC

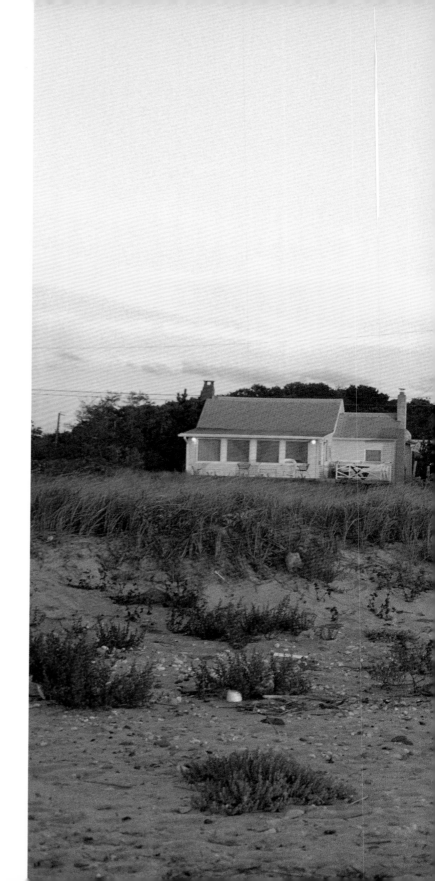

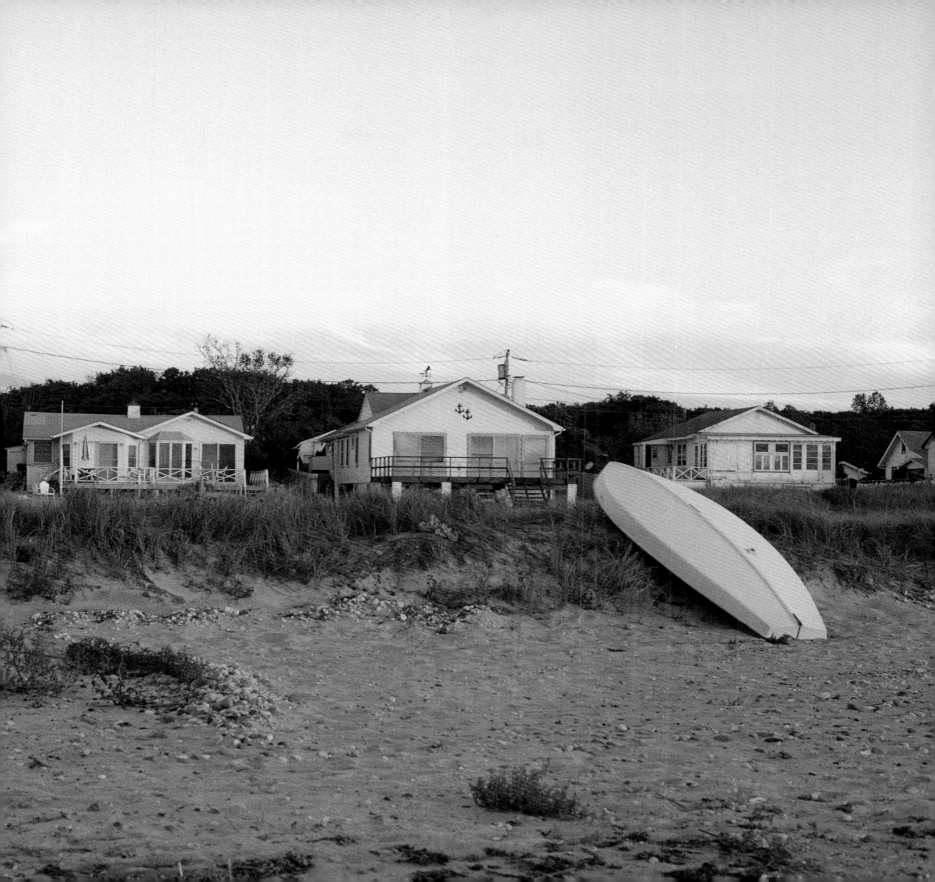

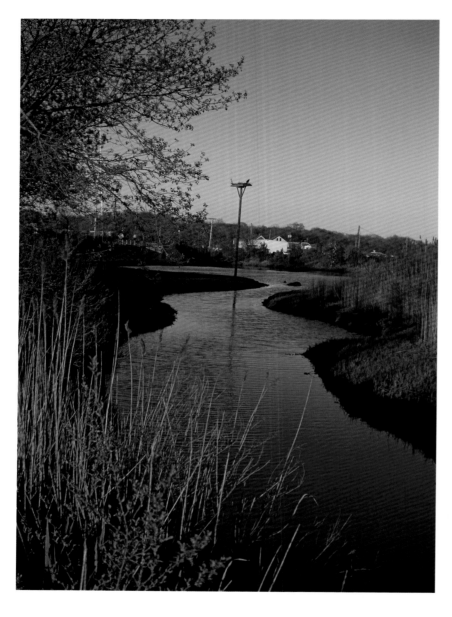

OSPREY'S NEST, SOUTHOLD

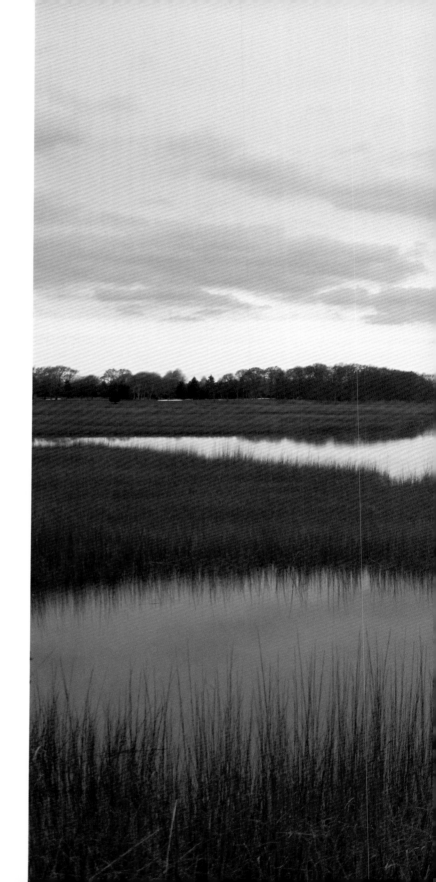

CUTCHOGUE

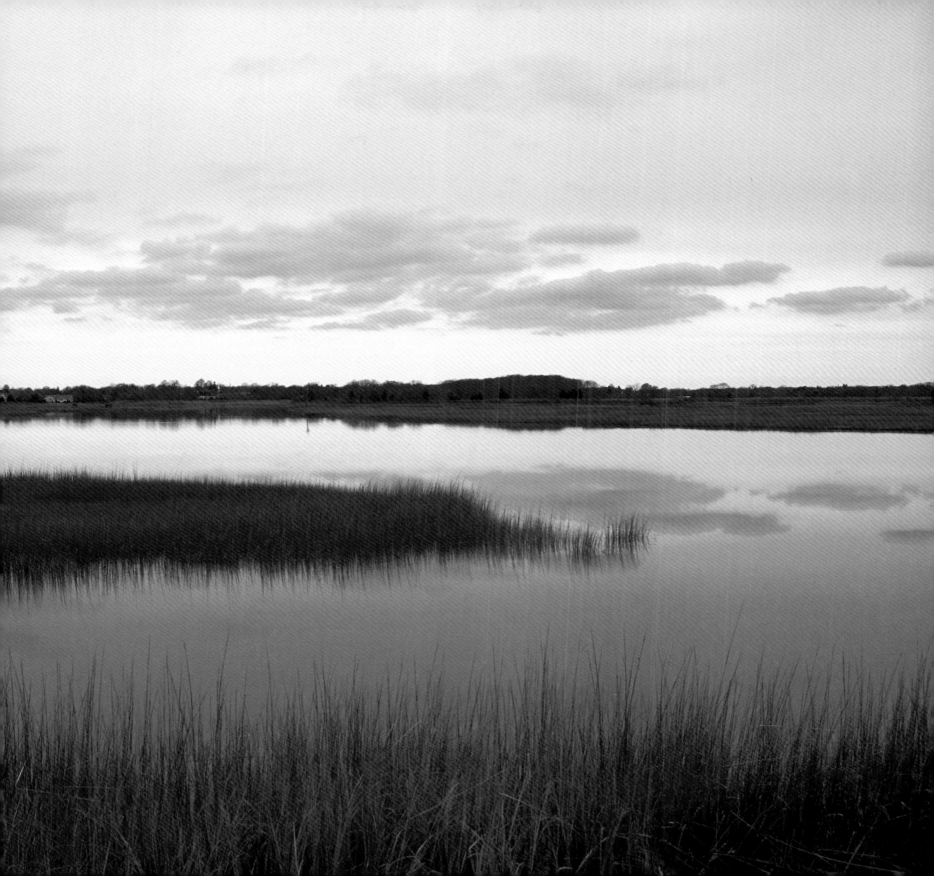

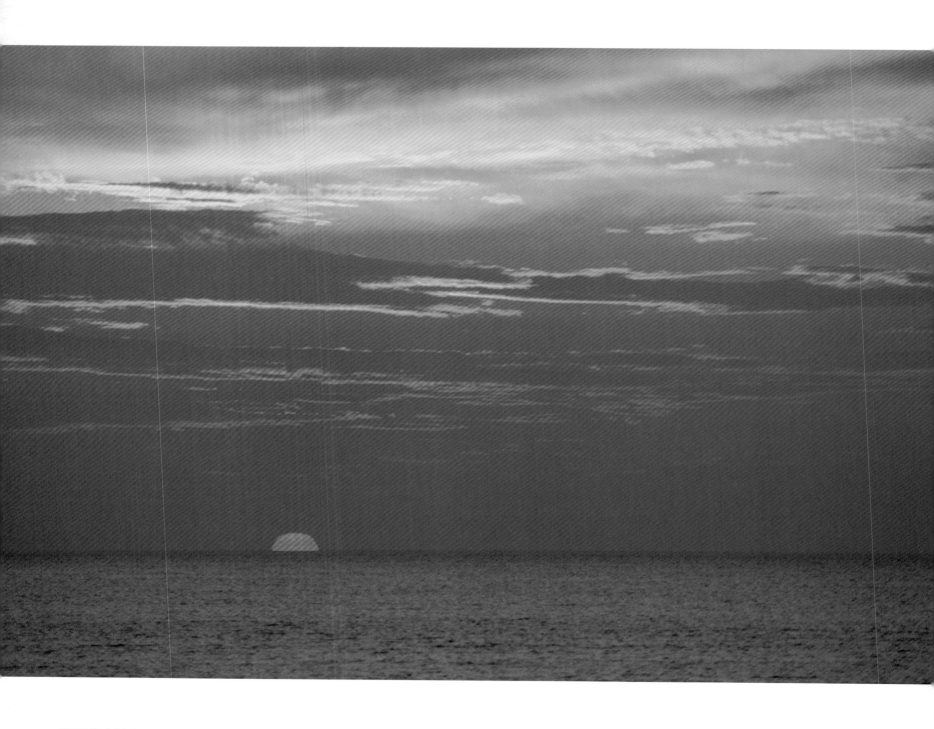

SOUND BEACH, SOUTHOLD

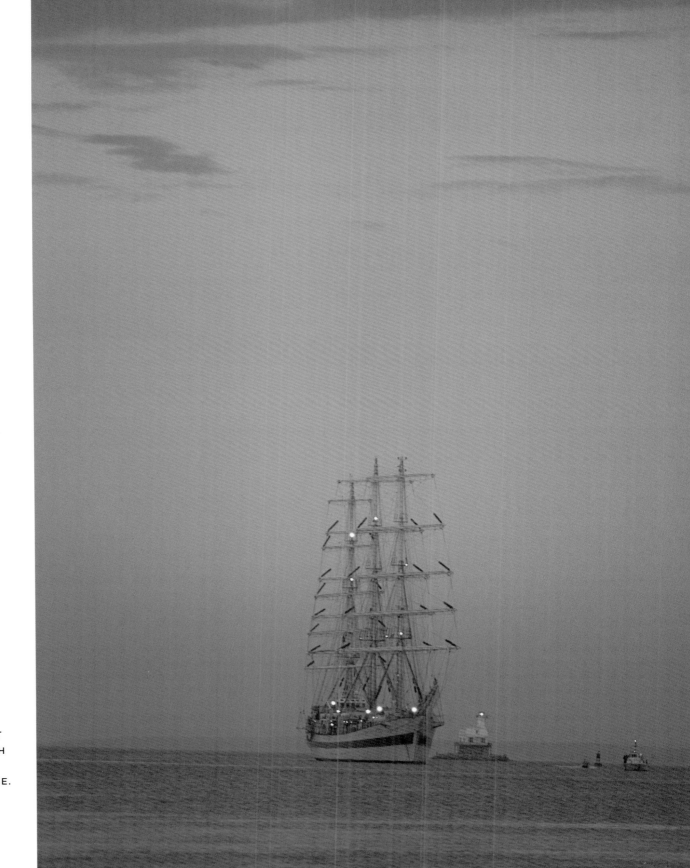

SHIP LEAVING GREENPORT
HARBOR. THE LONG BEACH
LIGHTHOUSE (BUG LIGHT)
IS VISIBLE IN THE DISTANCE.

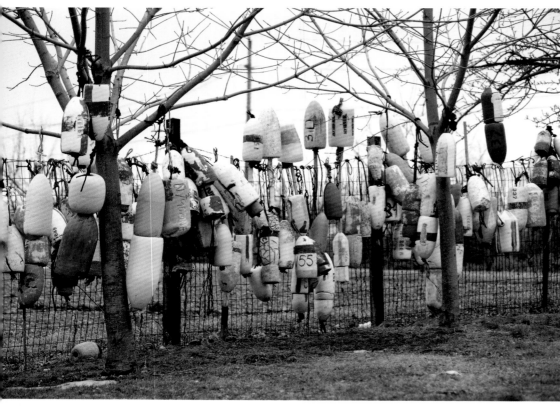

LEFT: BUOY COLLECTION, GREENPORT
BELOW: GREENPORT

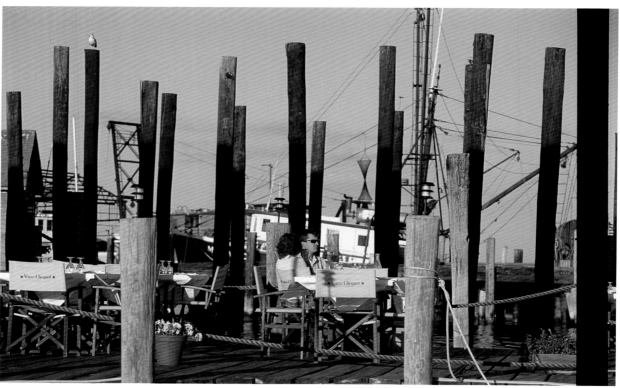

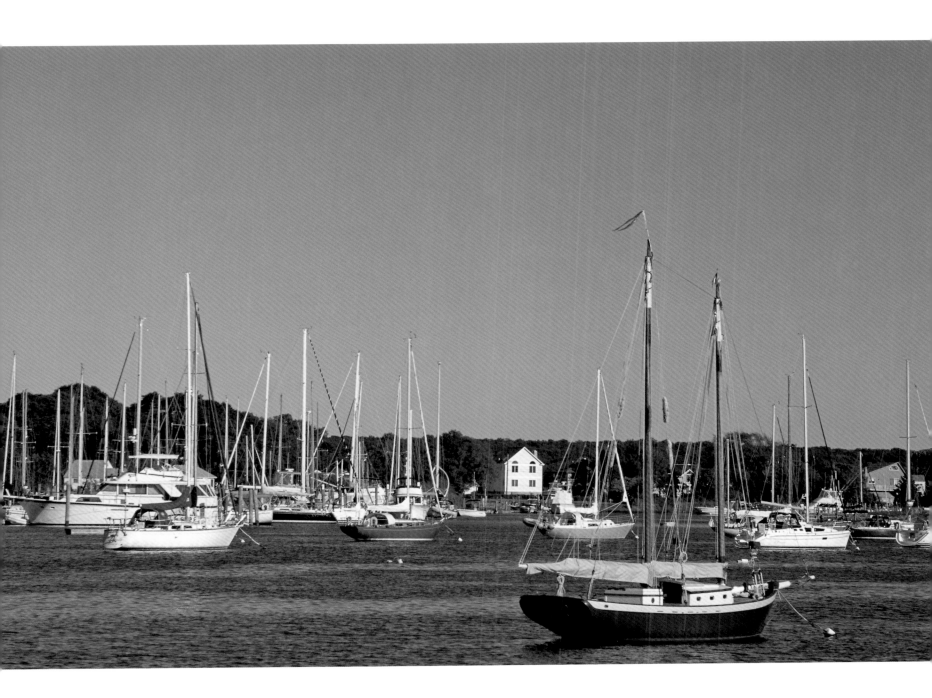

GREENPORT

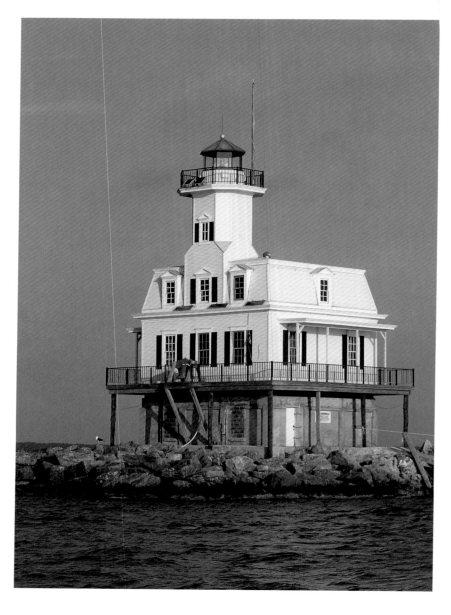

LONG BEACH LIGHTHOUSE
(BUG LIGHT), ORIENT

LONG ISLAND SOUND, SOUTHOLD

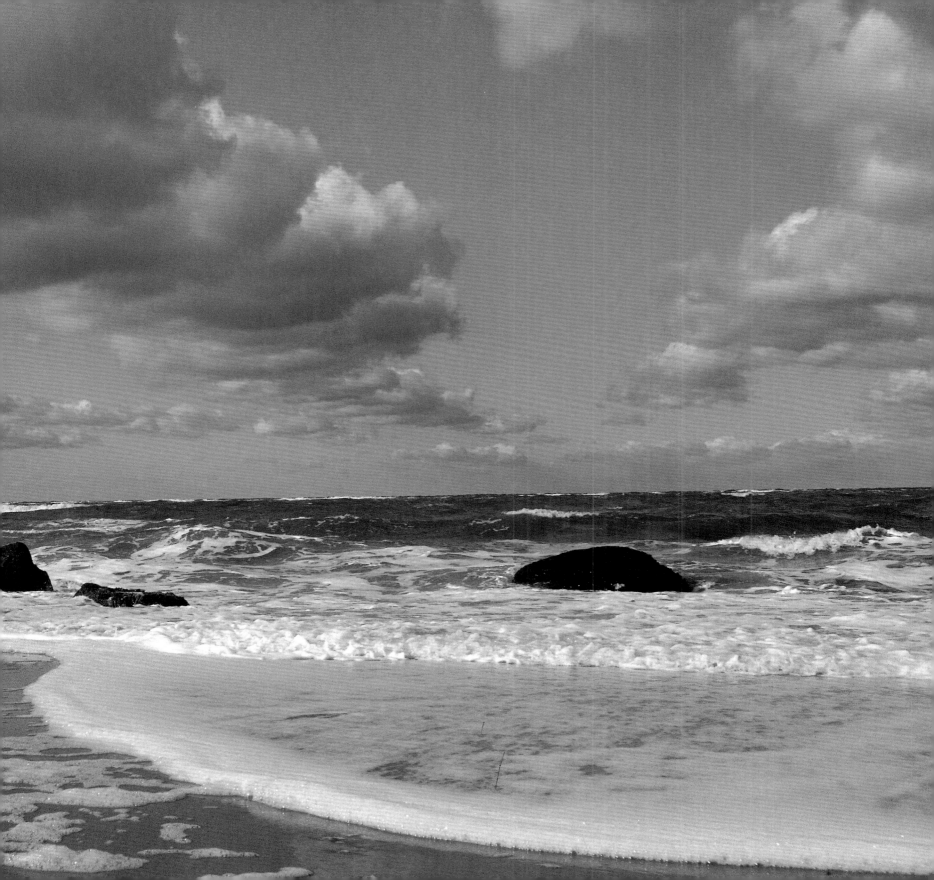

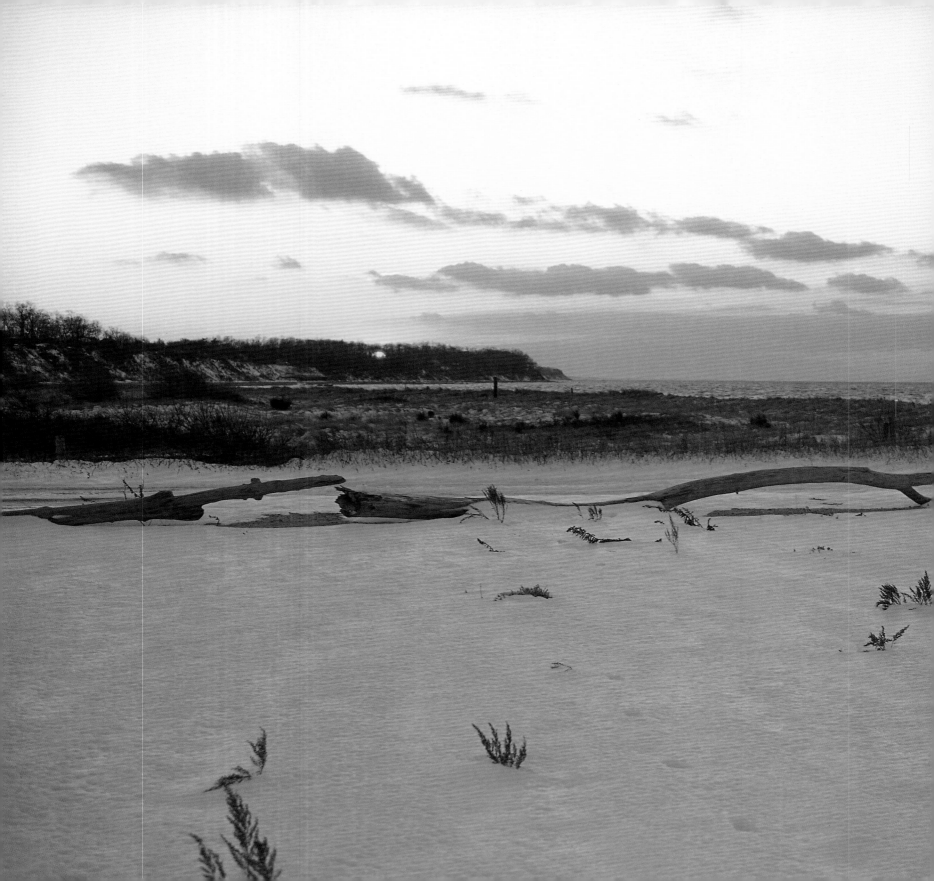

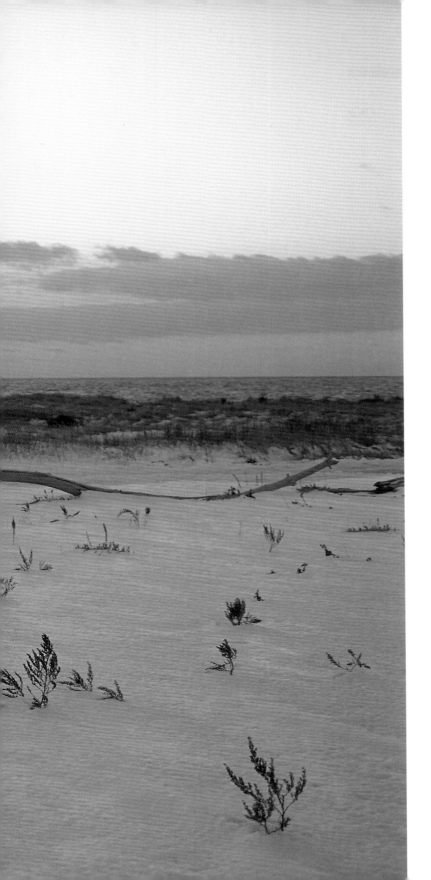

PECONIC

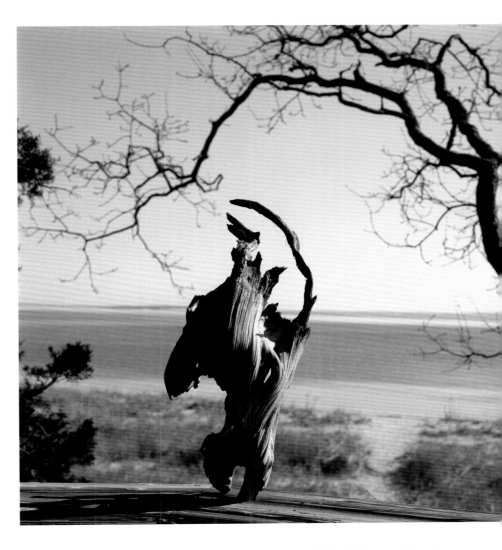

DRIFTWOOD SCULPTURE, PECONIC

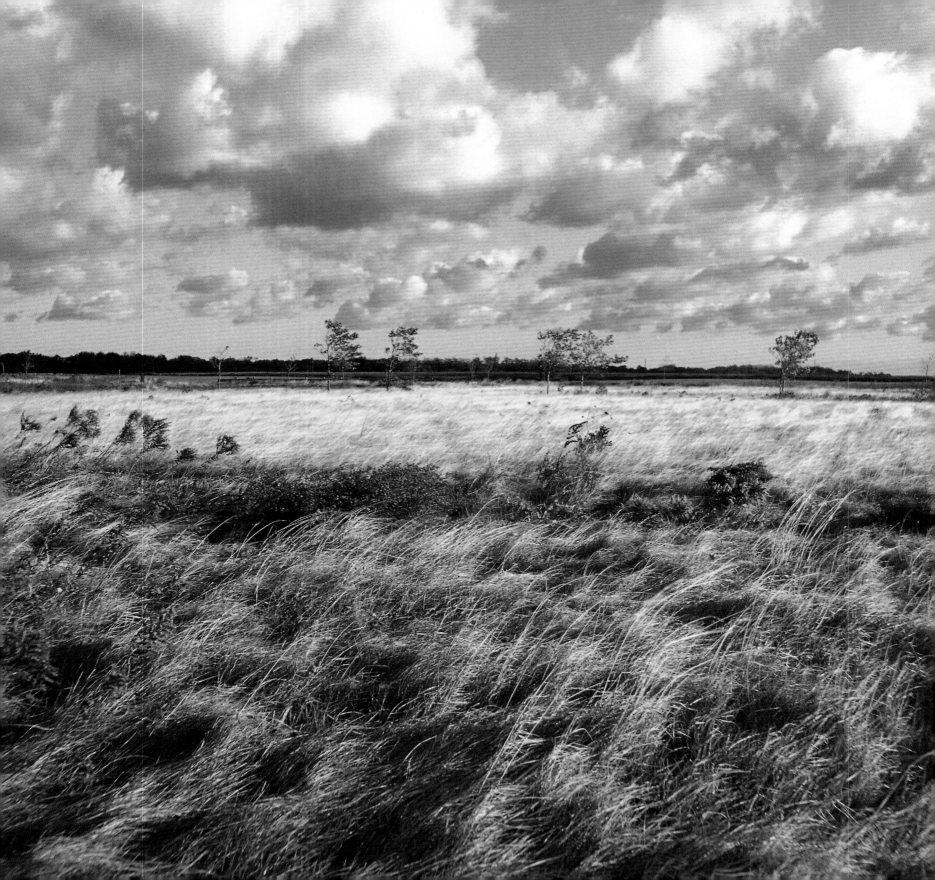

LONG ISLAND'S BIRTH AND TRANSFORMATION began five hundred million years ago when it was but a string of islands in the middle of a tropical ocean. Two hundred million years later it was a swamp at the base of the Appalachian Mountains, which were created by the collision and shifting of the continents. The land mass over the years moved north and became covered with glaciers. Long Island as we know it today, or something close to it anyway, appeared about eleven thousand years ago when the retreating Canadian glaciers caused the sea to rise and encircle this land mass. As the glaciers receded, scraping and pushing sand from the bottom as they went, they shaped the North Shore's hilly ridges. Layers of sand and clay eventually formed the rich soil of the area. Physically, the Island is in constant flux, and today it is actually shrinking in size. The sea level has increased at a rate of one foot per century for the last two thousand years, pushing back the North Shore cliffs and, at the same time, taking away from beaches along the South Shore; storm erosion and global warming can only double that rate and exacerbate the problem.

CUTCHOGUE

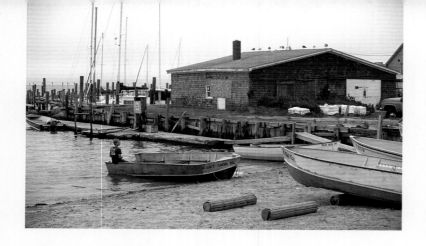

NEW SUFFOLK

The Indian name for Long Island is *Paumanok,* meaning "fish-shaped." The tail of the fish is the easternmost tip called the East End. The top section of the tail is called the North Fork, and the bottom section is the South Fork, also known as the Hamptons. The two are separated by Peconic Bay. The focus of this book is on the towns and hamlets running along the upper part of the tail from Riverhead (the easternmost town) to Orient.

The settlement of the North Fork began in the town of Southold, which was founded in 1640 by Rev. John Young, who arrived from New Haven, Connecticut, with his Puritan followers. The land that he acquired from the Corchaug Indians became the Township of Southold, extending from what is now Orient to Wading River. The Corchaugs were a peaceful people who were eventually forced out of the area or enslaved by the settlers. The colony established at Southold soon grew in numbers. But since there were as yet no roads from western towns, everything had to be imported by boat, and a thriving shipping industry evolved.

In 1727, Riverhead, part of Southold Township, became the seat of the Suffolk County government and remains so to this day. By 1792, Riverhead split from Southold and formed its own township, mainly because it was inconvenient to travel the twenty-five miles to Southold for town meetings. The town of Riverhead was created from western Southold, which included the communities of present-day Aquebogue, Baiting Hollow, Calverton, Jamesport, and Northville. Another town, Greenport, was flourishing in the whaling industry, and between 1795 and 1860, there were twenty-four whaling ships in its harbor, each making 103 voyages. Sailors would be gone for many months, sometimes years, and many of them never returned. Thus, many women in these coastal whaling towns became widows. The structures that were built on the rooftops of their houses, which they used to look out for incoming ships, came to be called "widow's walks." The whaling industry reached its zenith in 1830 and declined before disappearing altogether when oil was discovered in Pennsylvania in 1860.

As the population of the thirteen colonies grew, it became apparent that a centralized form of mail delivery was needed, and so the Postal Service was established by Benjamin Franklin, who became the first Postmaster General in 1753. Postage, according to government standards, was charged according to distance: four pence for a distance of up to 60 miles and six pence for a distance between 60 and 199 miles. As a result, it became necessary to measure the distances. Milestones, usually three to four feet long, a foot and a half wide, and two to four inches thick were placed into the ground every mile with the number of miles to a reference point (Suffolk County Courthouse, for instance) chiseled on it.

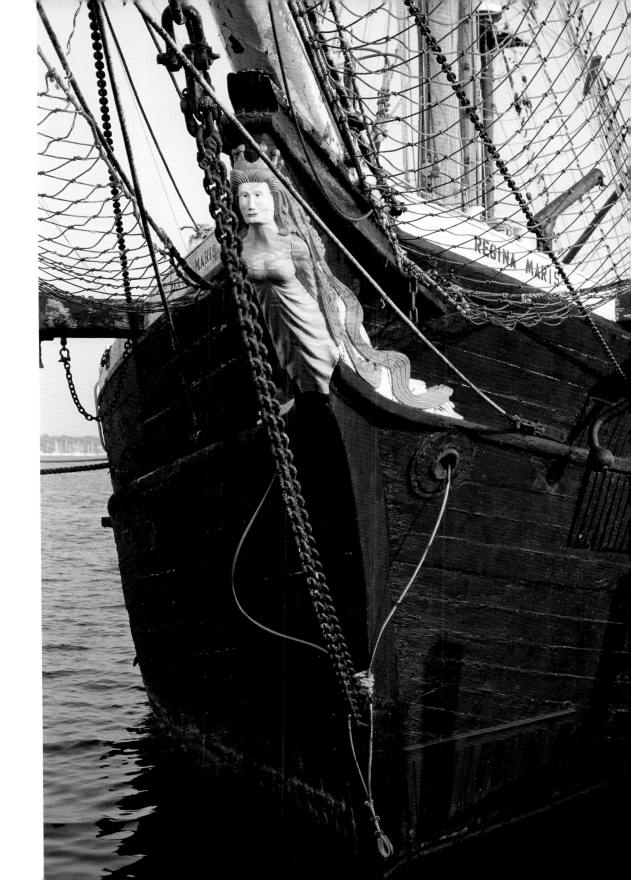

THE *REGINA MARIS*, GREENPORT

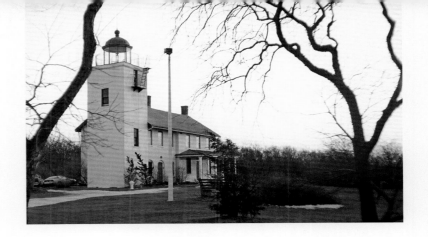

HORTON'S LIGHTHOUSE, SOUTHOLD

Milestones were placed between Orient and Riverhead. Twenty-seven of these original milestones are still standing. Franklin also invented an ingenious carriage, called the Weasel, with special wheels that measured a mile precisely by the number of revolutions they made. When a mile had been reached the carriage made a distinctive popping sound, hence the line in the children's song, "Pop goes the Weasel!" Another carriage, carrying the milestones, would follow and workers would place them in the ground. There are a few of them still left on the North Fork, so keep your eyes open and look for them on the south side of Route 25 or call the Southold Landmark Preservation Commission for a listing and approximate locations.

The British occupied Southold during the Revolutionary War, and many of Southold's residents opted for exile to Connecticut rather than submit to feeding the troops of King George. Royalists were shunned and when exposed were punished by flogging and exile. While renovating the living room of my house, I found, deep in a cavity in the wall, a medallion dated 1768 and bearing the words, "In memory of the good old days," referring to the reign of King George III before the revolution. That particular former owner of my home evidently went to great extremes to hide his royalist medallion, or so I thought. I later learned that these medallions are really *jetons,* or gaming tokens, quite common and not very old. But it makes a good story, so whenever children come and visit the house, I show them the medallion and tell them the story of the royalists and colonists.

In 1836 the Long Island Rail Road was established. Its purpose was to link, by rail and ferry, New York to Boston. The route was to go by train to Greenport, by ferry to Stonington, Connecticut, and continue by rail to Providence and Boston. A direct overland route through Connecticut was deemed unachievable because of the rough terrain of southern Connecticut. On July 27, 1844, the first train from Brooklyn to Greenport took only three and a half hours, an amazing feat at the time. The East End of Long Island changed dramatically at this time. Farmers, among others, greatly benefited from the new connection, and the overall economy of Long Island and the North Fork improved. This, however, was short-lived. Six years later, the supposedly unachievable rail line through Connecticut was built and Greenport, along with the whole of North Fork, fell into decline.

In the twentieth century, just after World War II, the economy began to swing back, and people started to purchase second homes east of the city. Soldiers coming home from the war took advantage of the GI Bill and bought houses in the suburbs, which sprang up all over Long Island almost overnight. Urban sprawl spread further and further eastward. More roads were built, too, and rural areas like the North Fork became more accessible. However, the North Fork remained relatively protected from this march of progress. It was the Hamptons that became the place to be and an artists' community, especially when Jackson Pollock moved there, raising its profile considerably.

OSPREY'S NEST ATOP AN ABANDONED CHIMNEY
OF "SAGE" BRICKWORKS, SOUTHOLD

But much of that has changed. The North Fork is no longer the quiet backwater it once was. The Invasion, which has gained momentum in the last five years or so, has taken place — the tourists have arrived. It's not nearly as crowded and overrun as the Hamptons, but it's slowly getting there.

Despite this state of affairs, the pace of my life here is slow and the visual stimulation everywhere. As I run my daily errands I am immersed in the colors, textures, and beautiful patterns of nature all around me. I never barrel down the road to my destination. Instead, I often find myself stopping along the way to take a photograph or simply to enjoy the scenery before me. Sometimes I make a note to return later for a better photo op, such as in the late afternoon or perhaps early in the morning when the fog rolls in, enshrouding the landscape. Walt Whitman said it best in "I Sing the Body Electric" — "I see my soul reflected in nature." My philosophy is the same. Living here on the North Fork, nature and spirituality become one.

My life is celebrated and measured — not like T.S. Eliot's character in "The Love Song of J. Alfred Prufrock," "with coffee spoons" — but instead by the rituals of gardening and country living: the planting of spring bulbs, summer dinners in the garden, the raking of autumn leaves, watching sunsets by the Sound, putting the garden to rest for winter, and the long, cold winter evenings by the fireplace.

I see water every day, whether it is the Long Island Sound, the Peconic River, the bays, inlets, necks, or the myriad creeks that crisscross the landscape. I see farmhouses and beautiful, old barns. Some have been restored, some cry out for a loving hand to repair them, and some, sadly, have disappeared. Fortunately, I was able to photograph a few before they collapsed and disappeared. Fine examples of Victorian architecture still survive in Greenport, and more and more houses are now being tastefully restored to their original state. I have also seen some fine examples of modern architecture, as well.

The North Fork is full of wildlife. An enormous variety of bird species have been spotted here, according to the Audubon Society, including the Song Sparrow, Swamp Sparrow, House Finch, Goldfinch, Towhee, Cardinal, Common Yellow Throat, Blackpoll Warbler, Yellow-throated Vireo, Titmouse, Scarlet Tanager, Flicker, Piping Plover, and Osprey, just to name a few. Osprey nest atop many manmade platforms, built for that very purpose, and are easy to spot in the summer months. Some Osprey, however, choose to build elsewhere — on top of electric poles, and even atop the chimney of an old abandoned brick factory in Southold. Since their diet is primarily fish, they prefer to build their nests close to the water. If you're lucky, you'll catch one plunging feet first into the water and reemerging with dinner clutched in its talons.

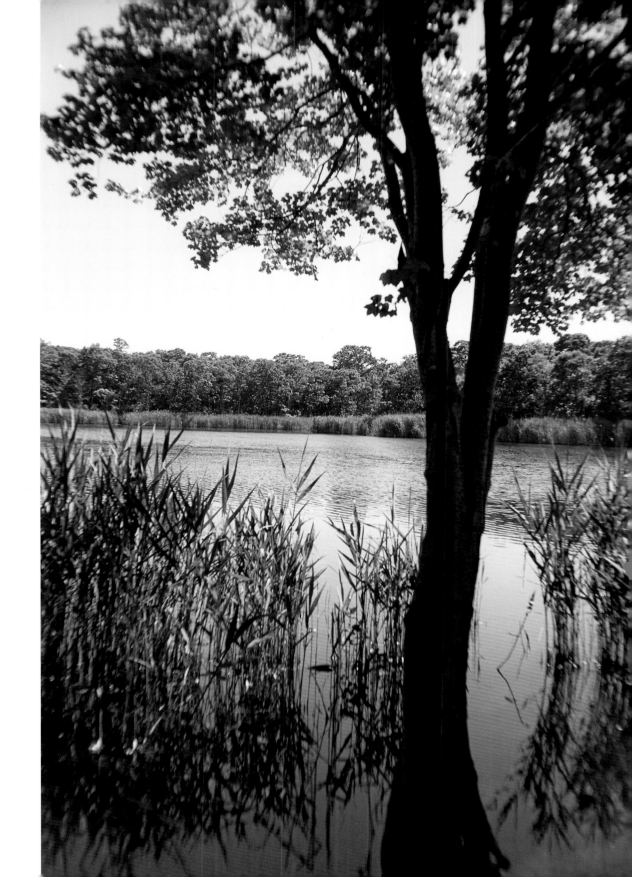

HUSING POND PRESERVE, MATTITUCK

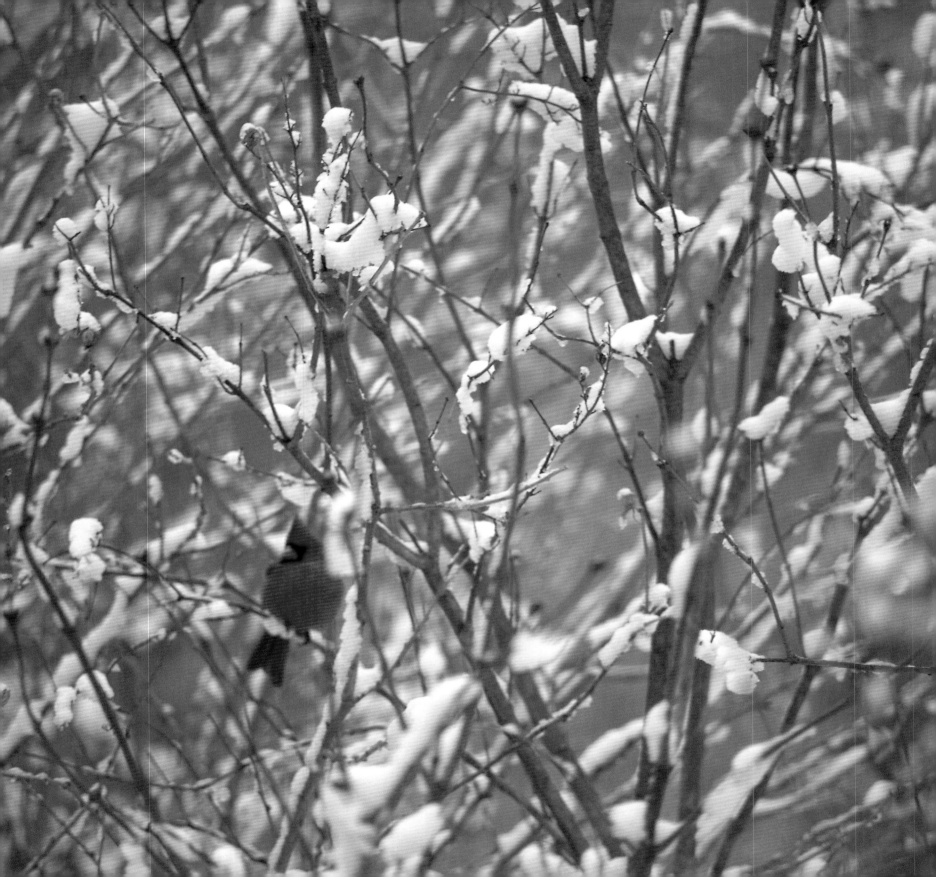

The Piping Plover, a pocket-sized, pale-colored shorebird with orange legs, arrives at its nesting site very early in the spring, goes through a courtship period in April, and begins laying its eggs in June. Each nest typically has four eggs. There are only 1,700 breeding pairs in all of the Northeast, but it's made a comeback here on the East End thanks to various organizations and volunteer groups, such as the North Fork Audubon Society. These groups have adopted a strategy of first locating and then protecting the Plover's nesting sites. Since these areas are very often on public beaches, beachgoers have been made aware of them. The known nesting areas are roped off and designated by a now familiar sign depicting the image of the bird along with information about them.

I have a feathered circus in my own backyard, where I've placed a variety of feeders and birdhouses. During the cold winter months, I gaze outside my window and watch the performance. In the spring, the birds are busy staking out their territory and building their nests. This is a time of chaos as each pair stakes out its claim. The feisty wrens are particularly entertaining. They use just about anything they can find to make their nests. I've found paper clips, shoelaces, and even part of a dollar bill while cleaning out their nests in the fall.

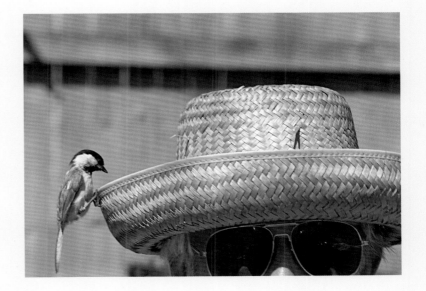

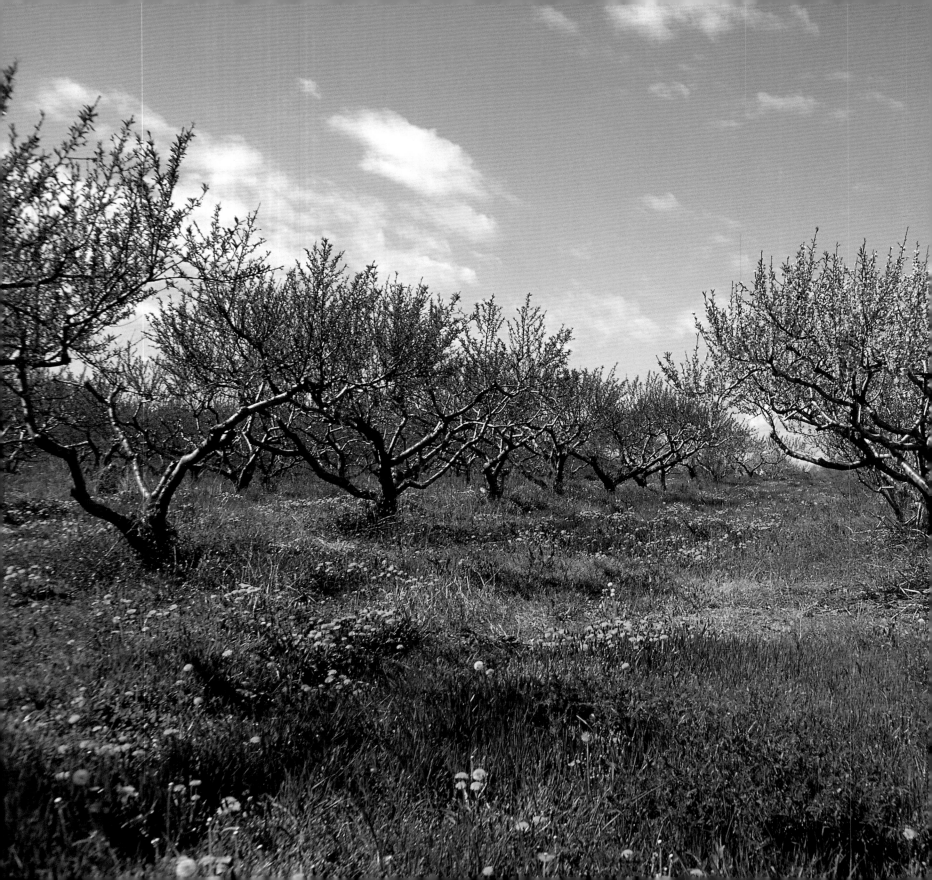

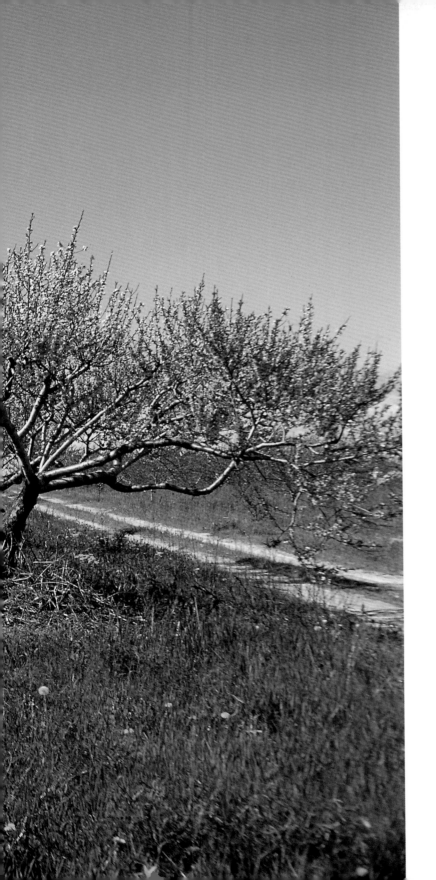

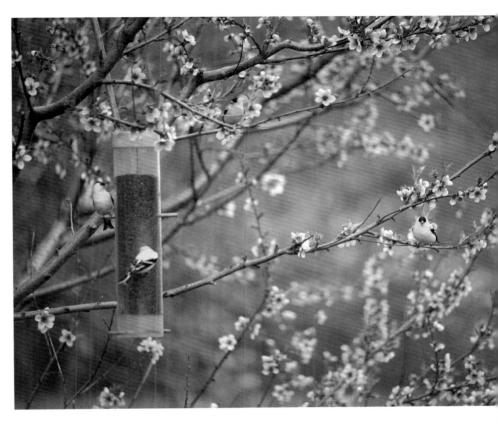

CUTCHOGUE

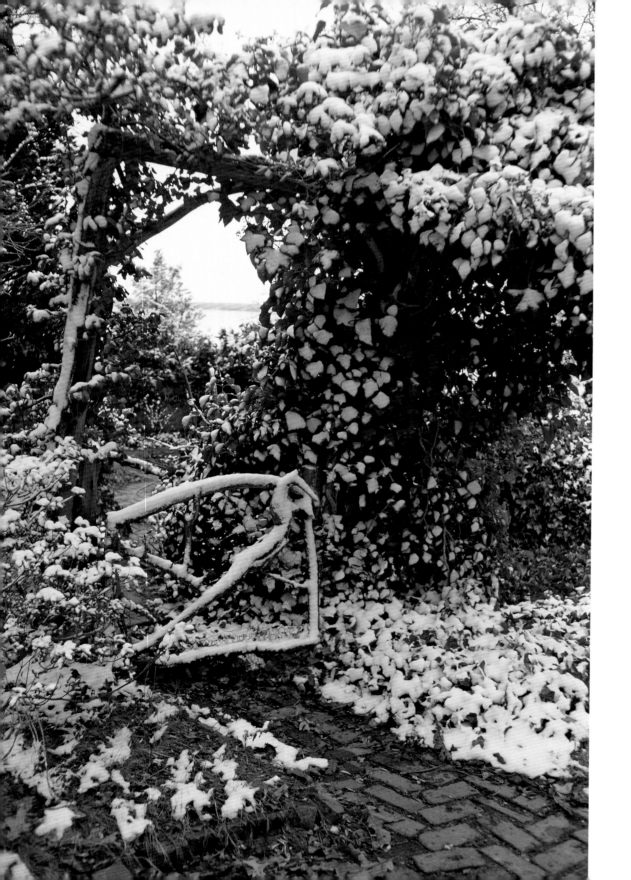

PAINTER AUGUST BELL'S HOUSE
(BELL BUOY), PECONIC

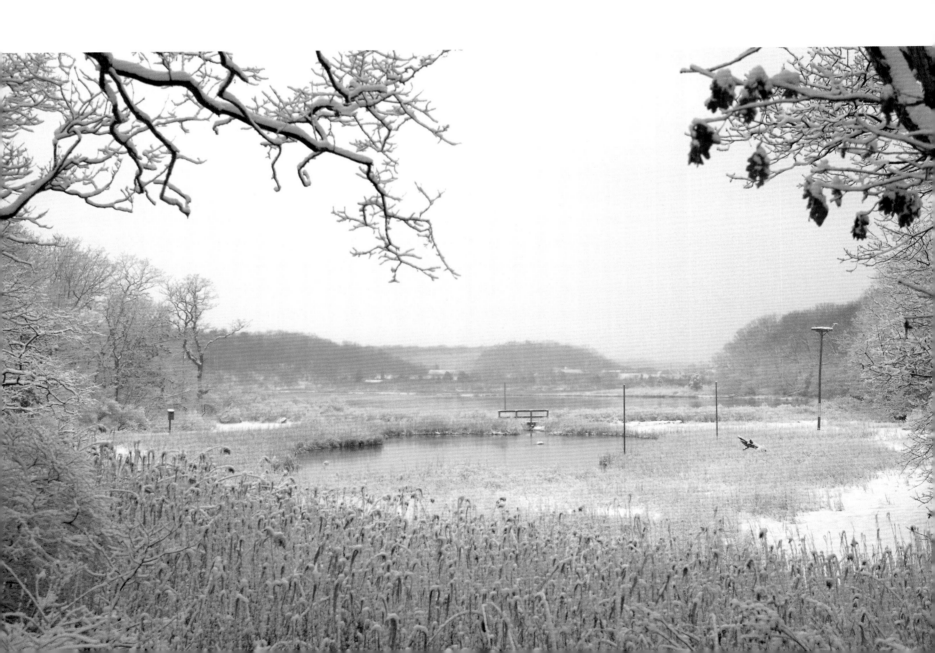

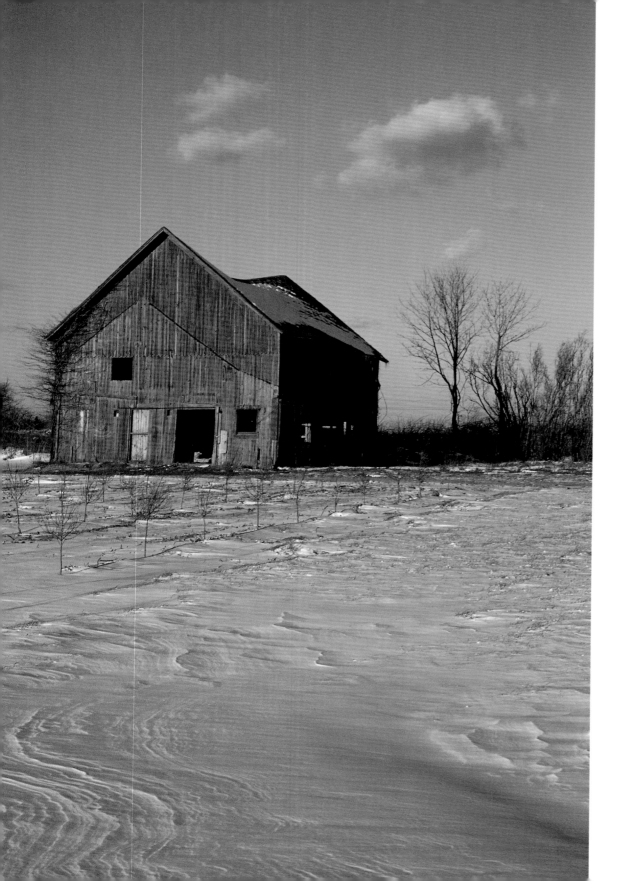

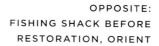

OPPOSITE:
FISHING SHACK BEFORE
RESTORATION, ORIENT

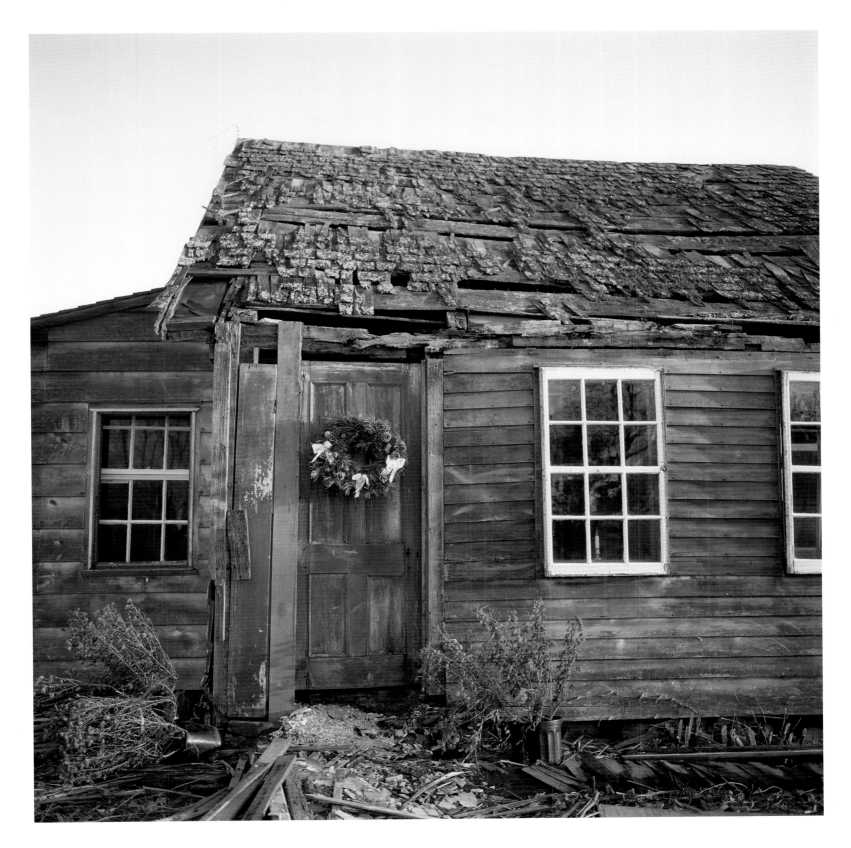

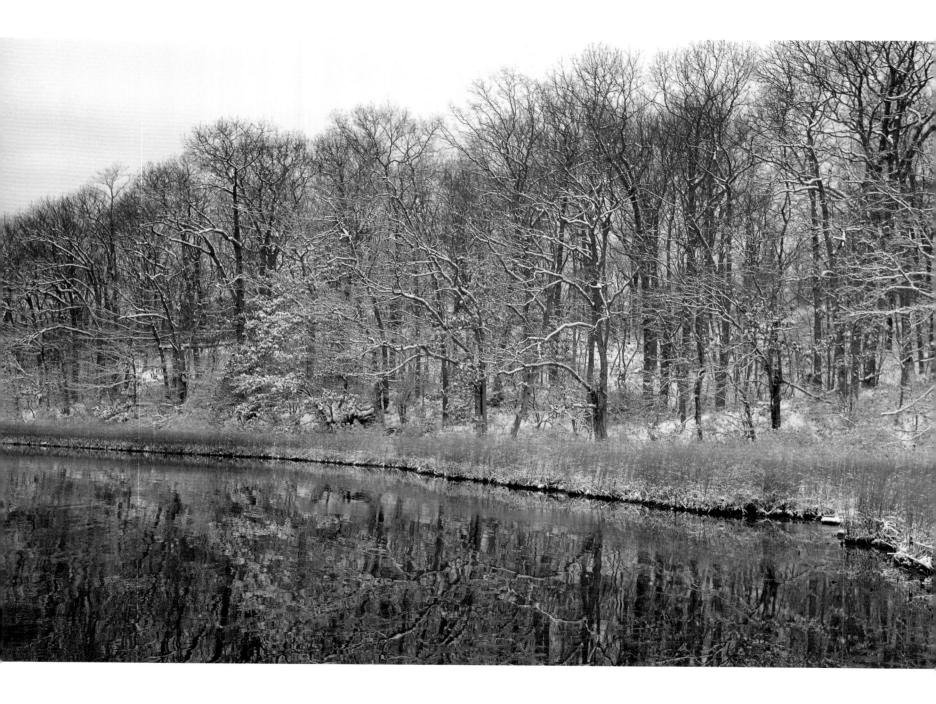

PECONIC

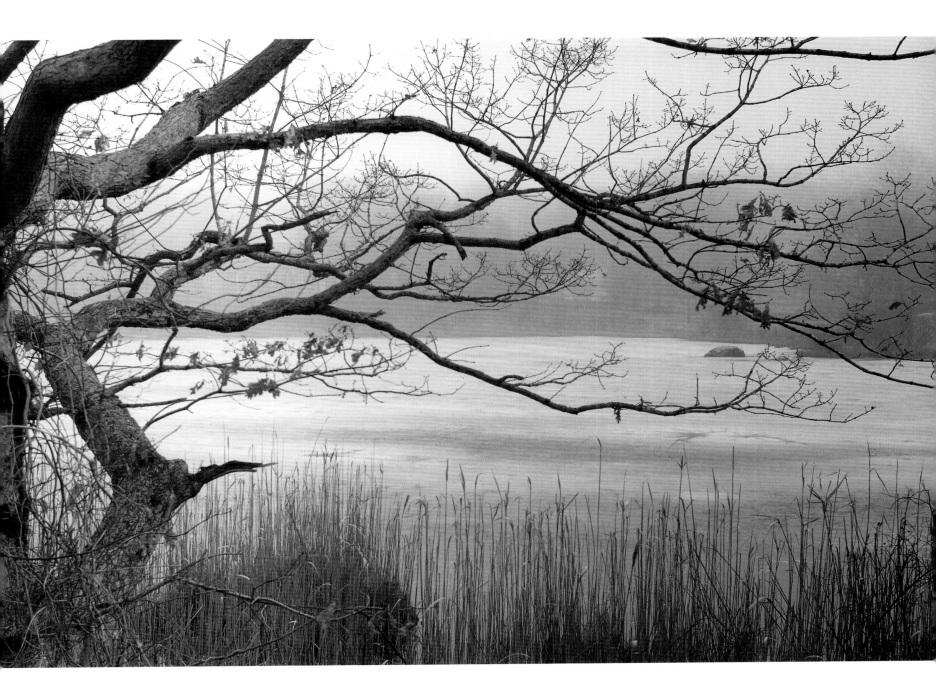

PECONIC

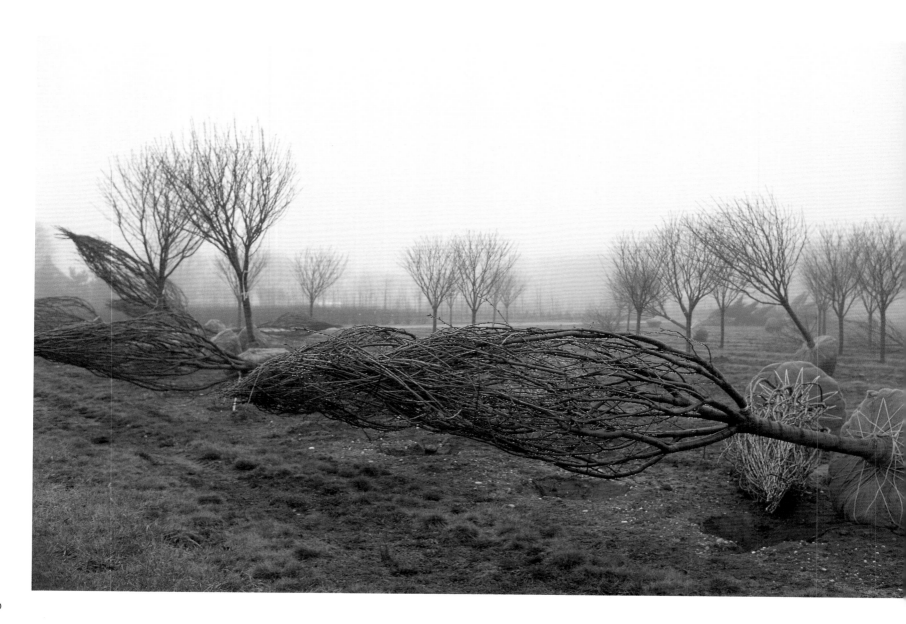

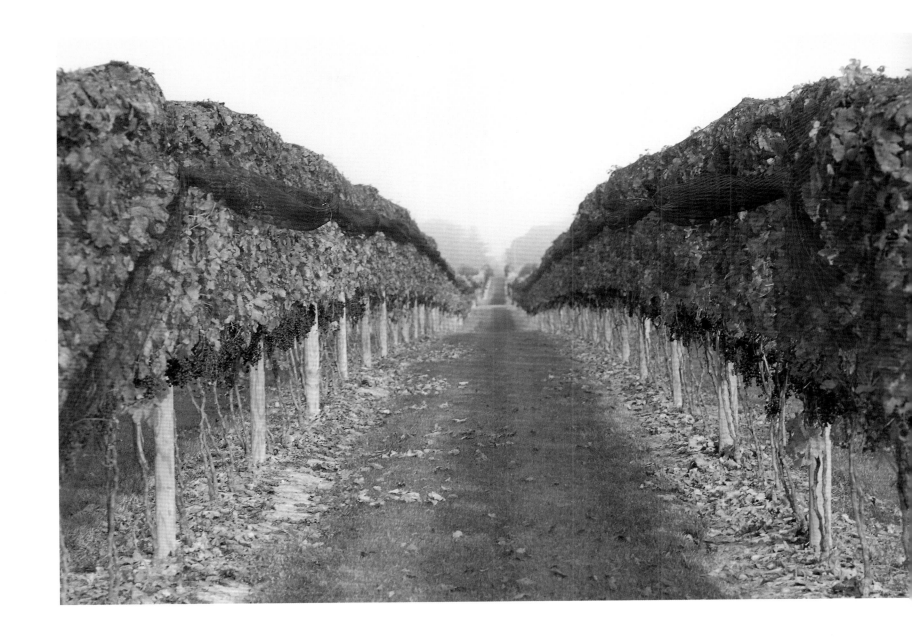

RAPHAEL VINEYARD, PECONIC

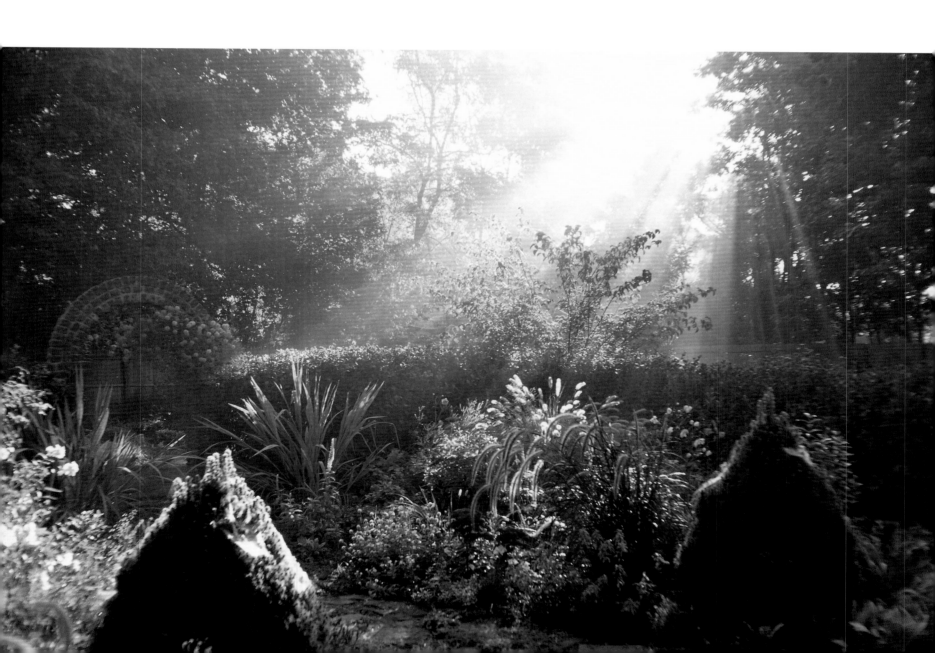

AUTHOR'S GARDEN, PECONIC

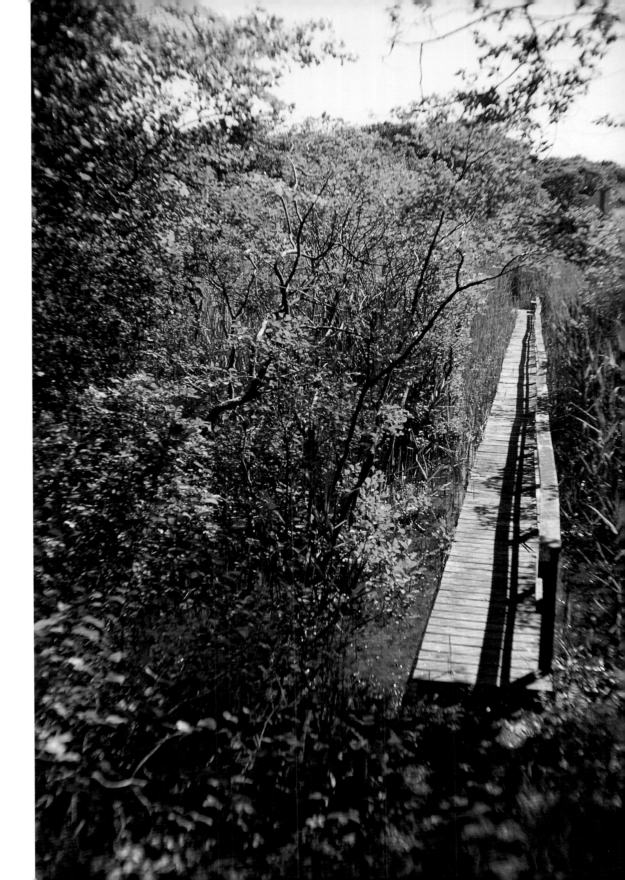

MATTITUCK

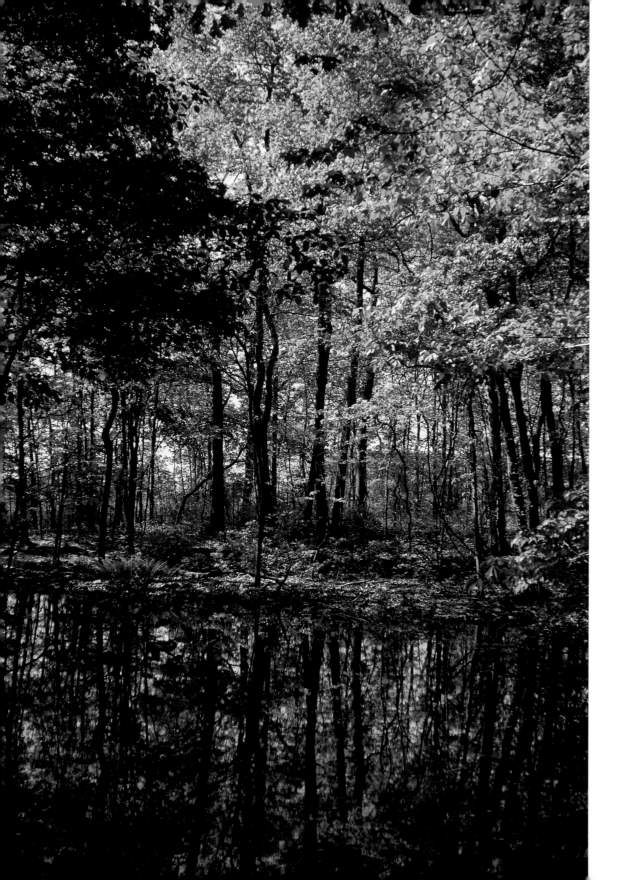

ARSHAMOMAQUE PRESERVE,
SOUTHOLD

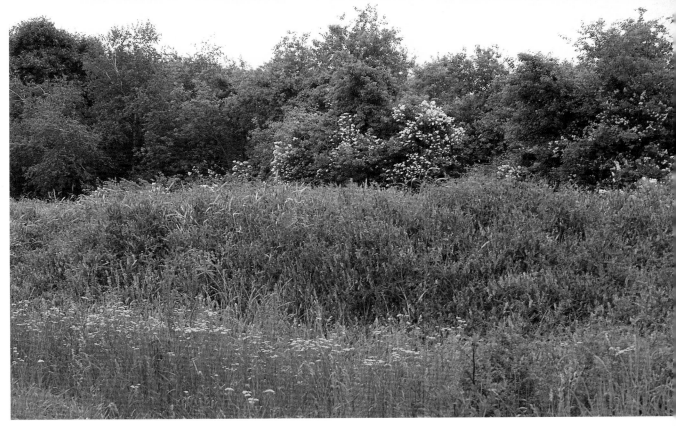

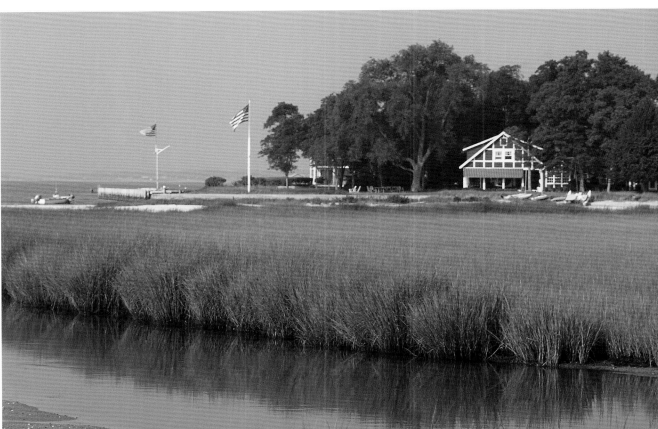

NEW SUFFOLK AVENUE,
CUTCHOGUE

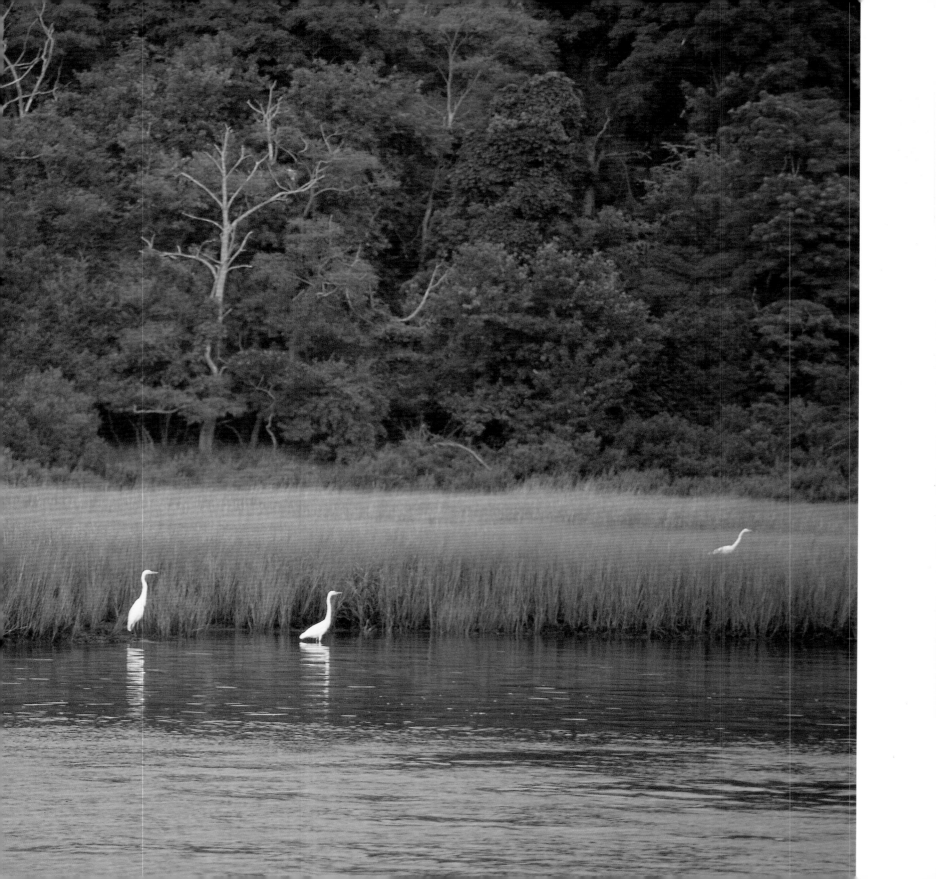

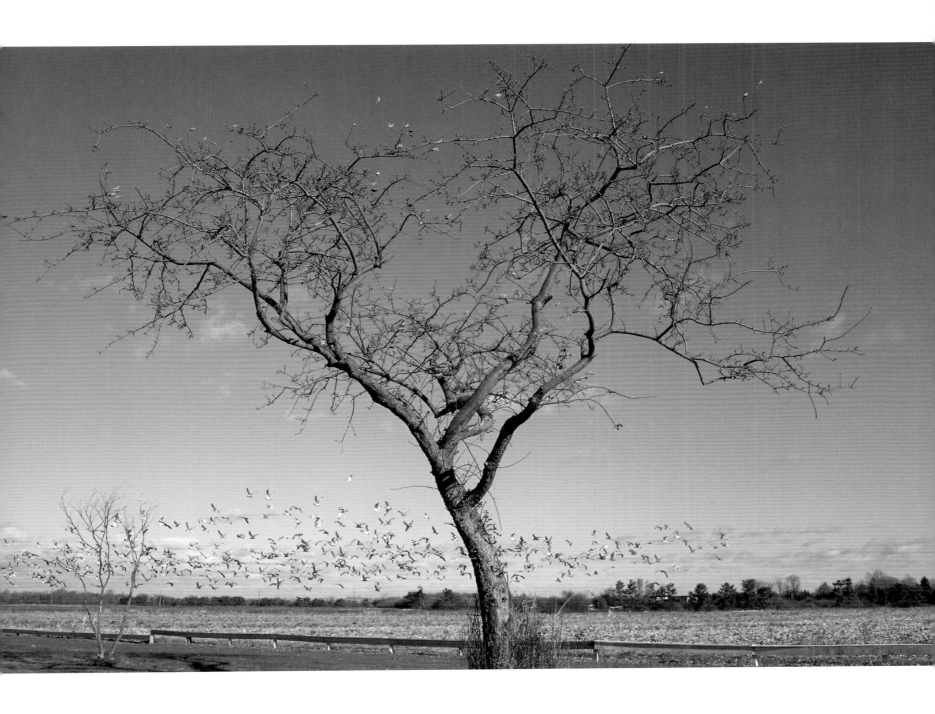

OPPOSITE: MATTITUCK

ORIENT

GREENPORT

OPPOSITE: PECONIC

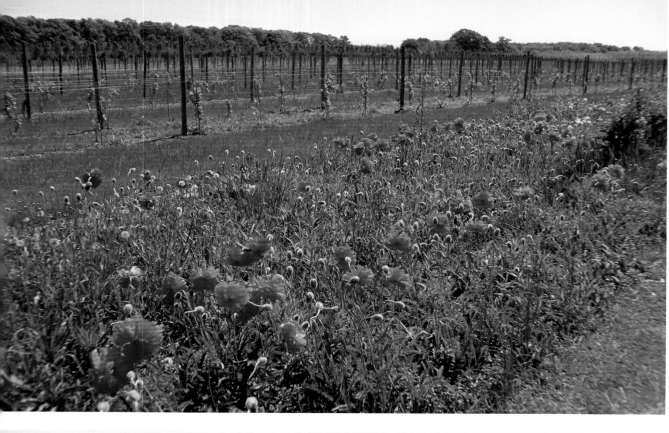

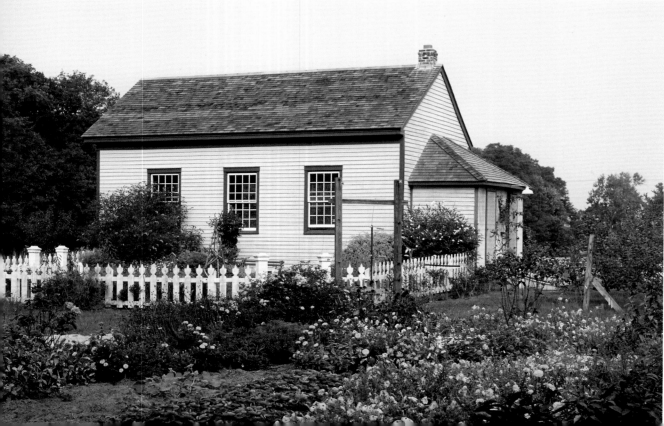

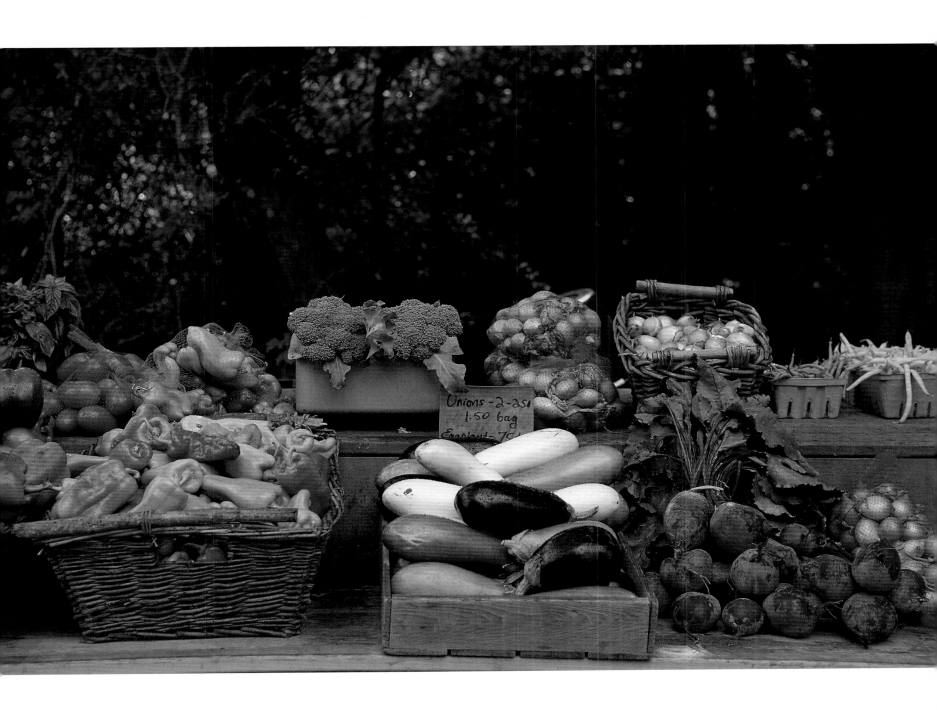

Onions - 2 - 25¢
1.50 bag
Eggplant - 75¢

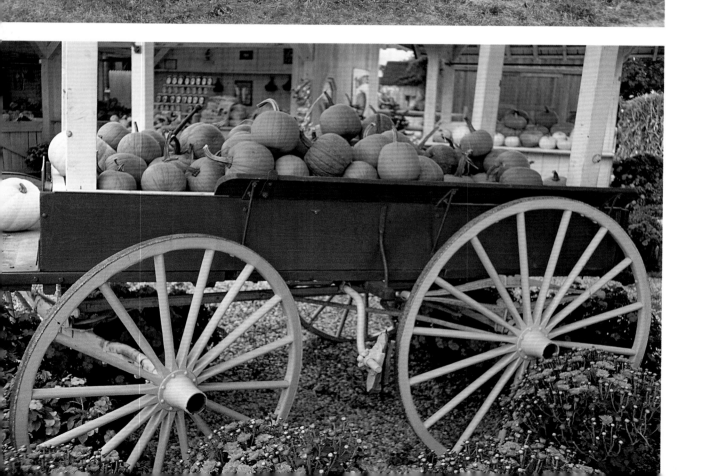

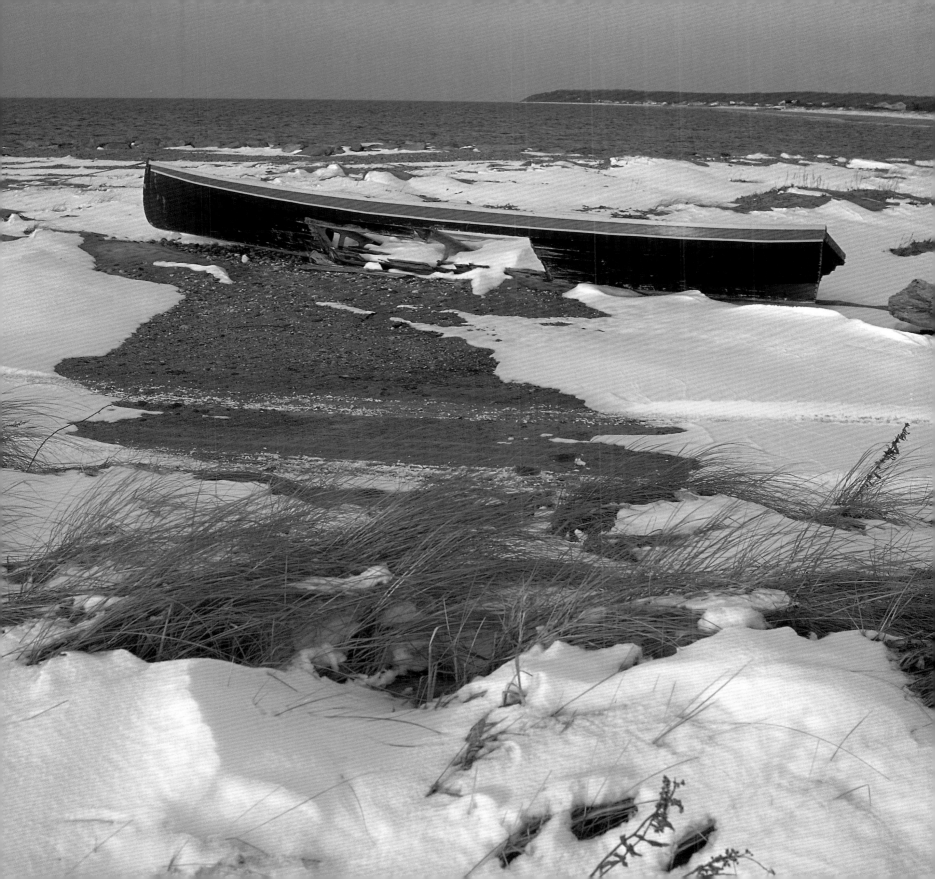

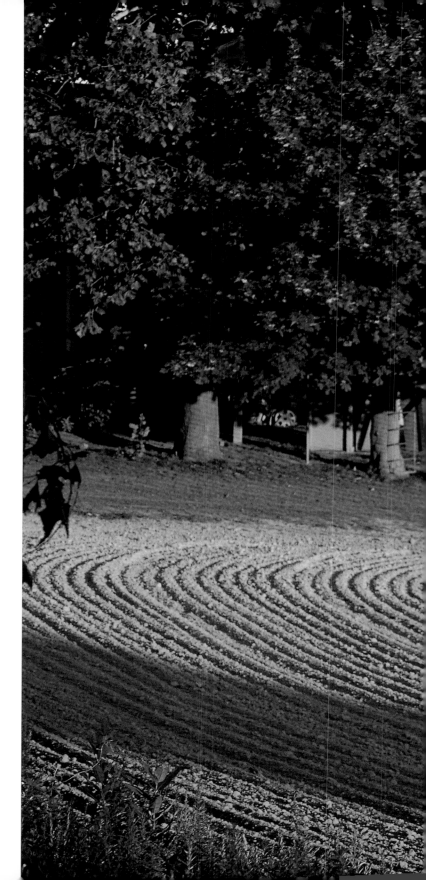

CUTCHOGUE

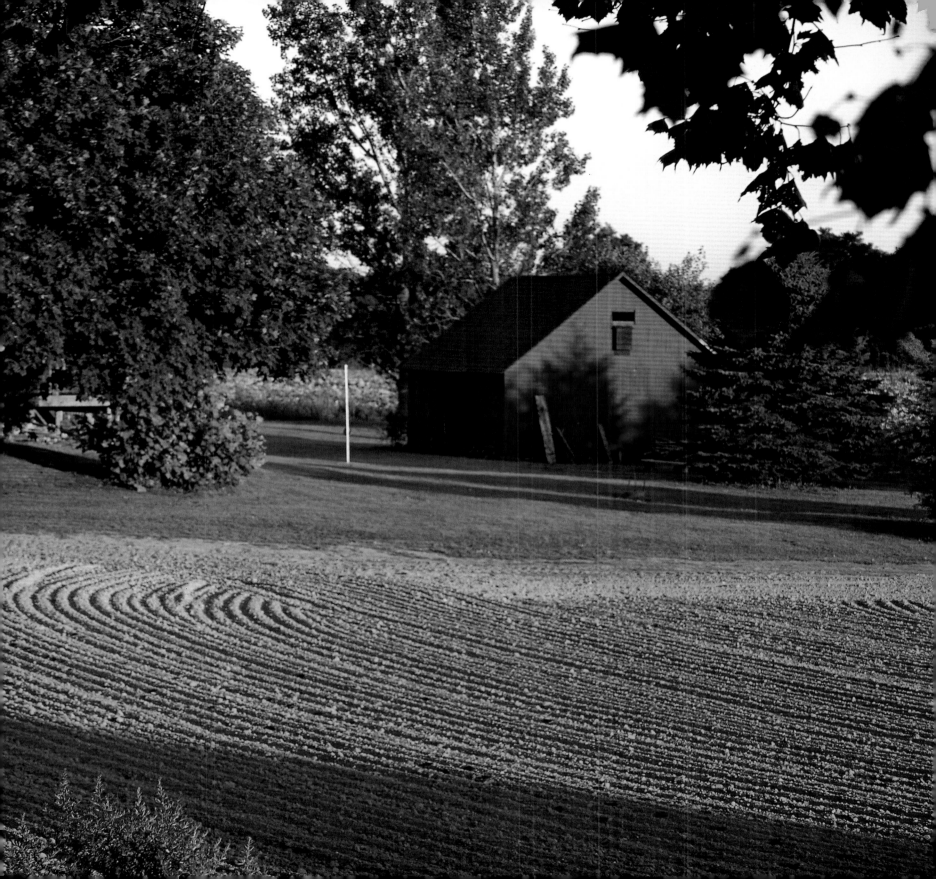

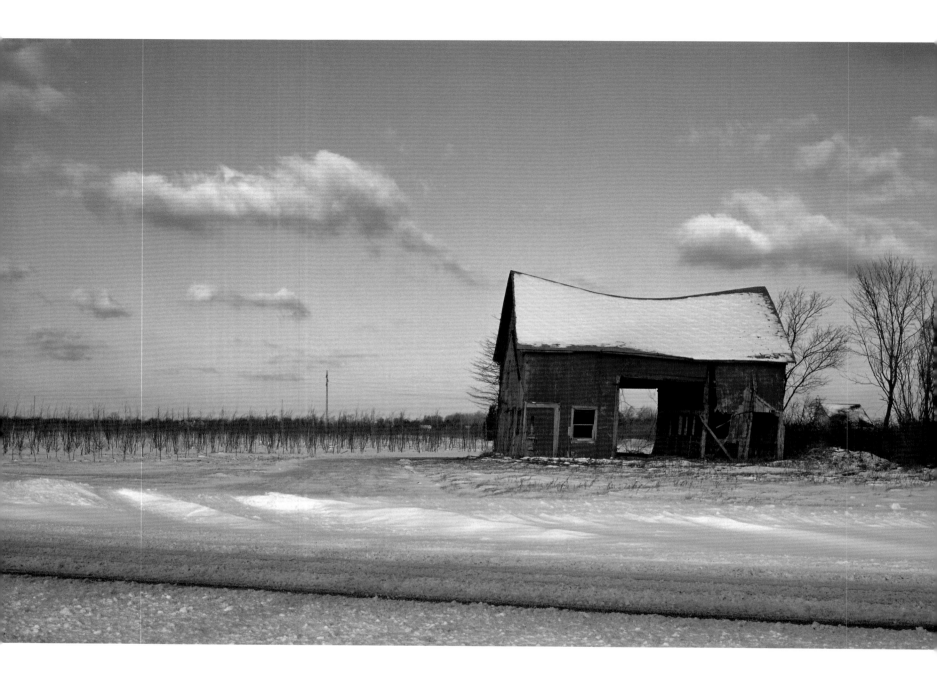

CUTCHOGUE

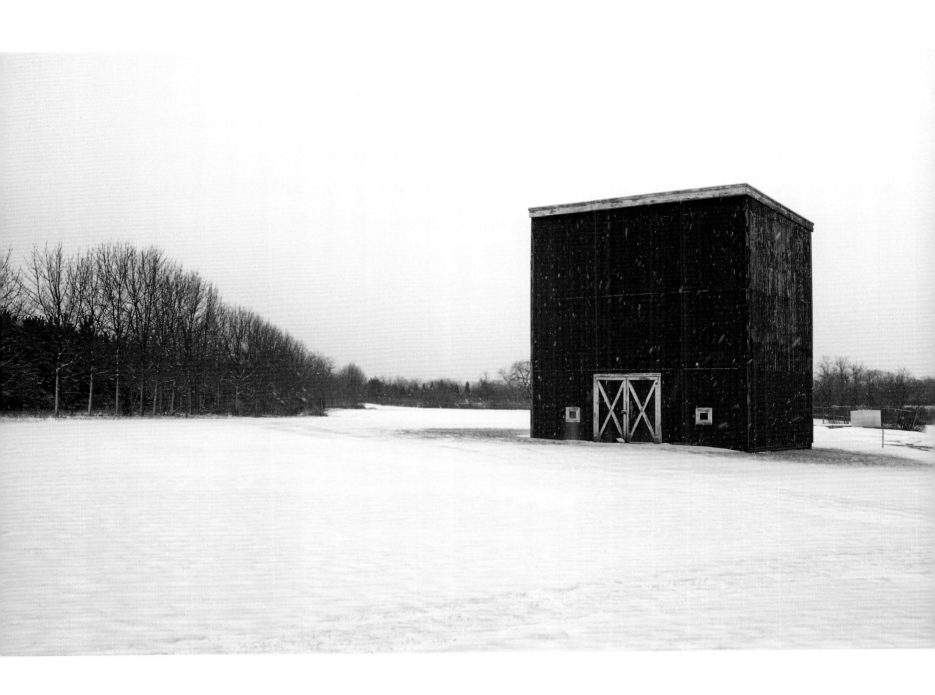

SOUTHOLD

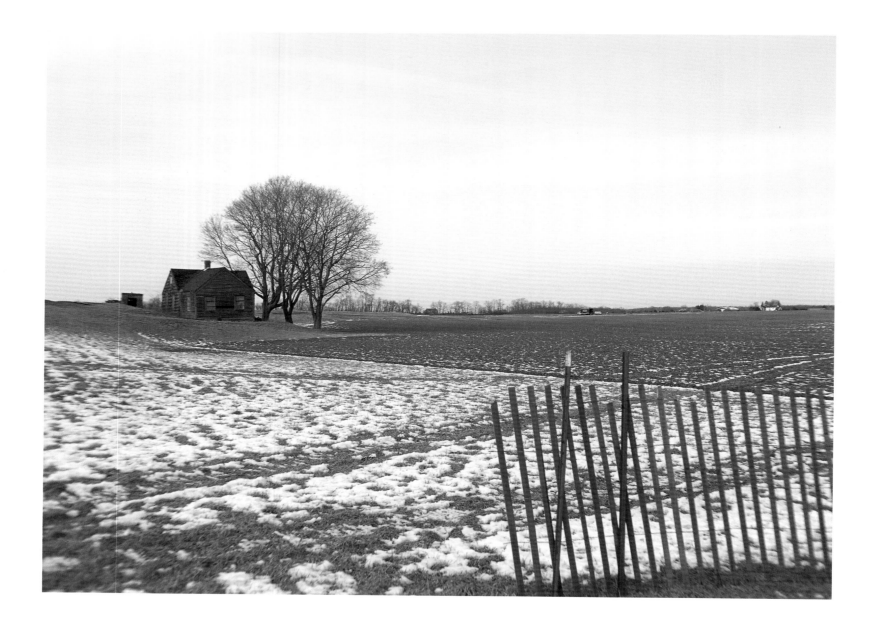

CUTCHOGUE

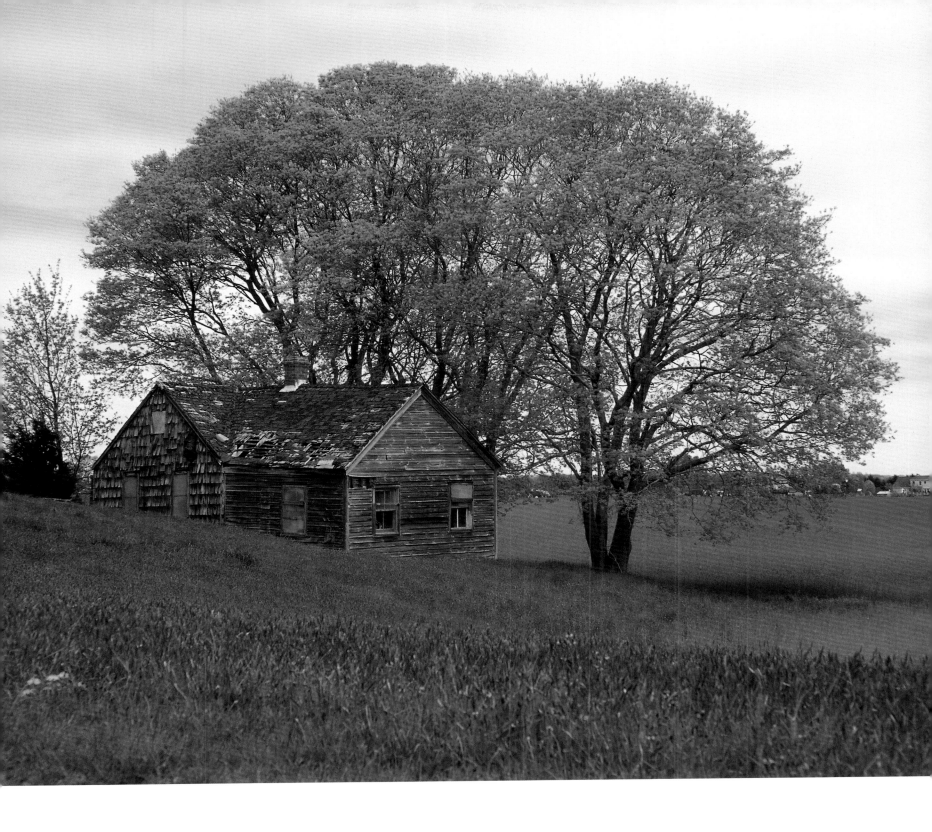

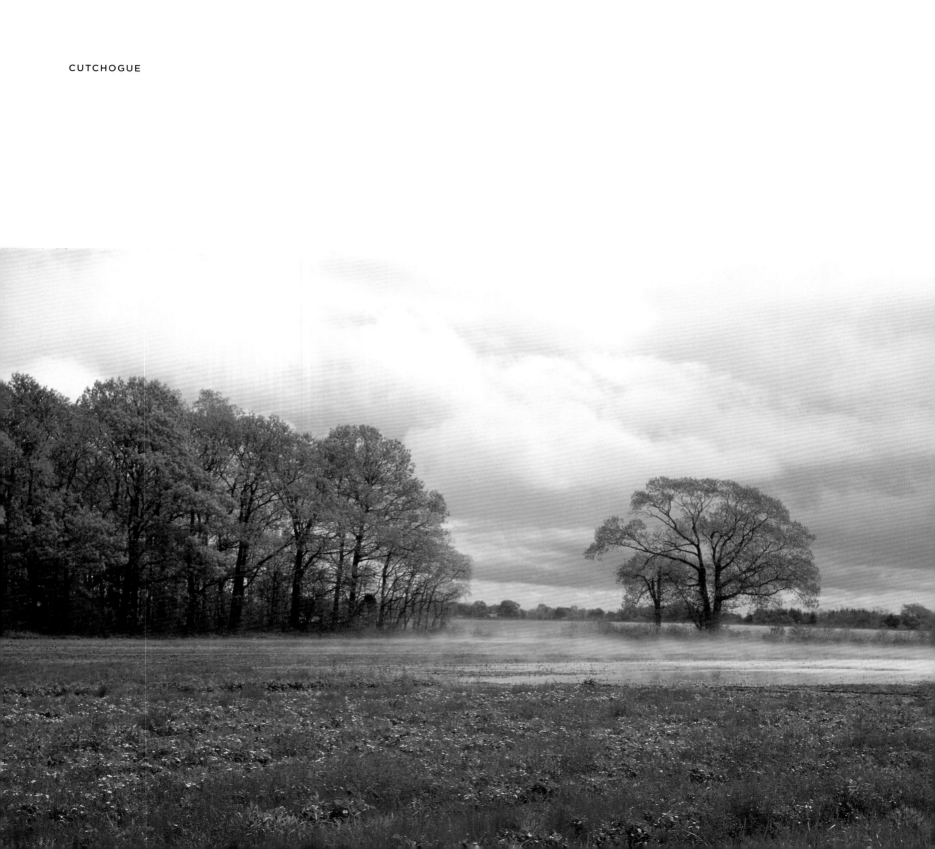

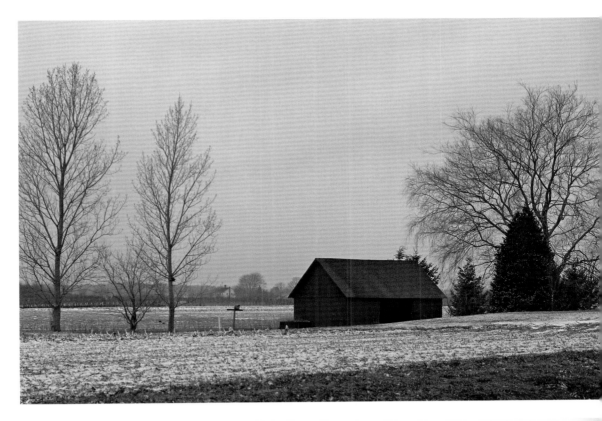

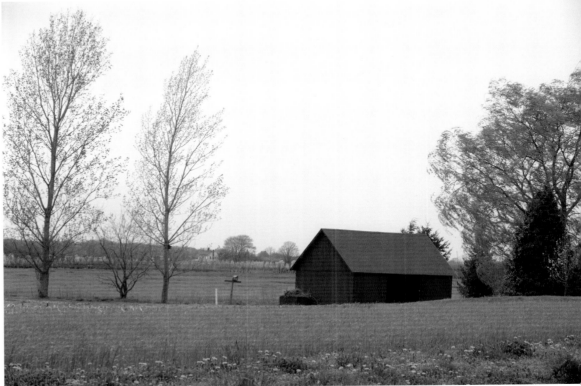

CUTCHOGUE

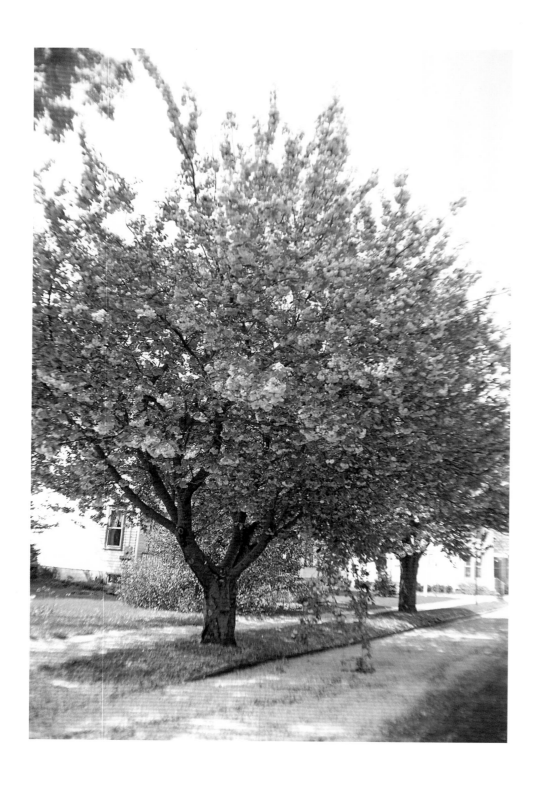

OPPOSITE: CUTCHOGUE

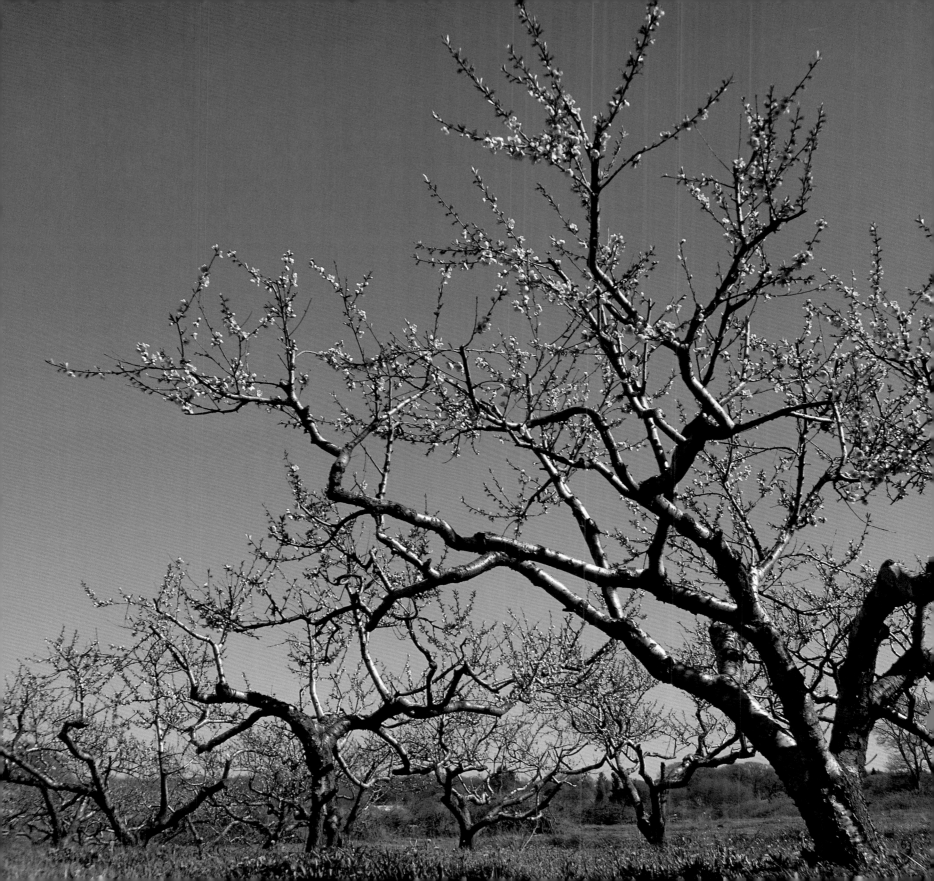

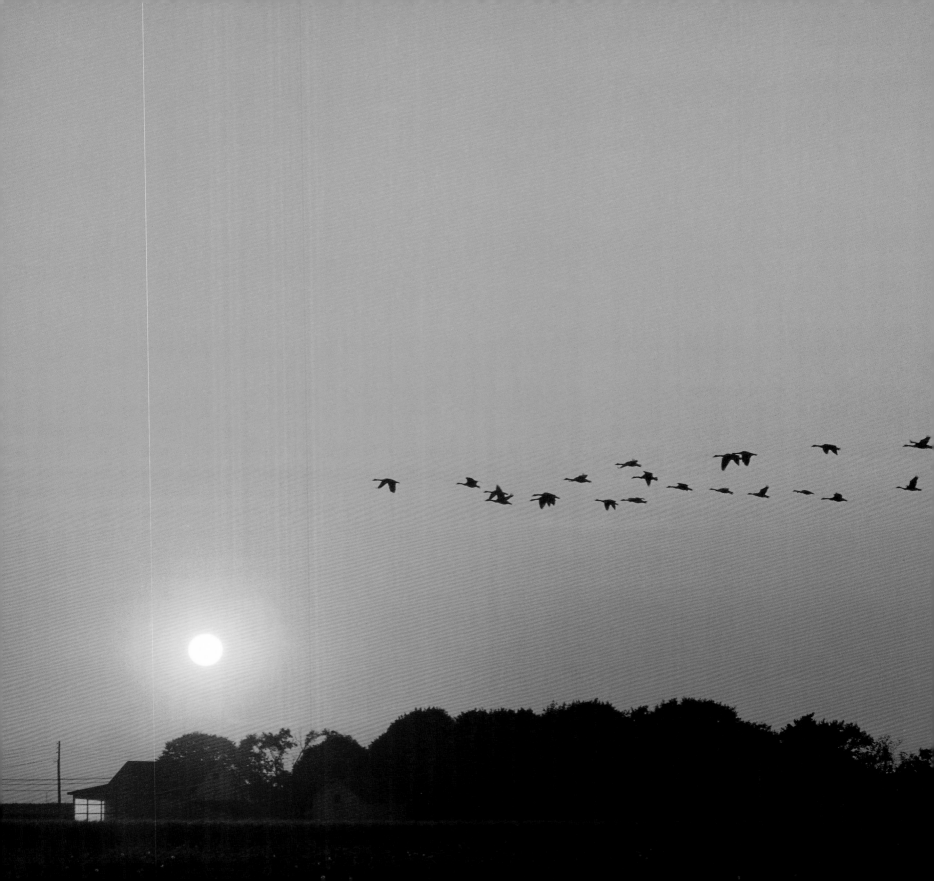

LIFE IN THE COUNTRY is defined by the changing seasons. In autumn, when there is a chill in the air, the Canadian geese go through the motions of migration. I say "go through the motions" because they actually stay here year-round. Nevertheless, this change of seasons prompts them to fly in the characteristic chevron formation and honk boisterously as they fly ever so close to the roof of my house. It's an amazing sight and sound: you can hear the power of their wings dispersing the air around them with a "whooshing" sound as they head to the nearby creek for landing. Their honking can be heard in the darkness. I once saw them in flight, silhouetted by a full moon. Sadly, the only picture I captured of that is in my mind.

SOUTHOLD

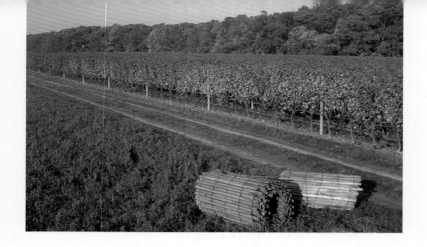

MATTITUCK

Autumn is the time of year when the farmers put up the wooden snow fences. One day they're rolled up, lying on their sides, the next day they're erect and stretched along the perimeters of someone's property. Snow fences are everywhere and make wonderful photo subjects. This year, to my great disappointment, I noticed that some farmers had switched to hot-orange plastic fences.

Autumn is the time for fresh cauliflower, cabbage, Brussels sprouts, and Wickham's freshly pressed cider made from apples grown in his orchards. On cold, brisk afternoons, Wickham sometimes offers his customers the fragrant cider, piping hot.

The North Fork is sleepy and quiet in the winter. My garden, by that time, has been put to bed. There is nothing more exhilarating than waking up in the morning to a landscape covered with freshly fallen snow. It's magical! There is a heavy silence, as though a blanket were dropped on us, broken only by the scattering of birds as they hop from feeder to feeder. The snow delicately clings to the branches of the trees. Here and there it falls as the birds scurry about with their bounty of sunflower seeds.

Winter on the North Fork is one of my favorite times of the year, especially to photograph. What you see in the winter is a spare, black-and-white, stripped-down version of the land. The leafless trees expose the hidden patterns and contours of the landscape.

You see contrasts, but very little in between. The grapevines in the vineyards are lush and full in summer, but in the winter the bare vines are reduced to lines that form wonderful patterns against the snow, very much like pen-and-ink drawings (see page 124). Rows of winter vegetables add another dimension to the fields, especially against a backdrop of snow.

In the spring, rye grass is planted for commercial purposes and to replenish the soil. It lends an lacy, delicate quality to the surface of the land as it dances and bends with the wind. This is the time to watch the landscape come alive again. Trees begin to leaf and there is an uplifting of energy and a sudden busyness and intensity found everywhere you turn. Rows and rows of flowering trees in bloom with puffs of color line the nurseries. From a distance, they resemble a Monet painting. Scattered in the fields are the zigzag patterns of trees bagged in burlap (see page 133).

The quality of light in the East End rivals that even of the south of France. In the summer there is a special, almost shimmering quality to it, casting its soft pink glow over everything. The best time is just before twilight. The autumn afternoon light, by contrast, is crisp and brings out more textures highlighted by deeper shadows. It is this light that has attracted artists and photographers to the North Fork for a hundred years.

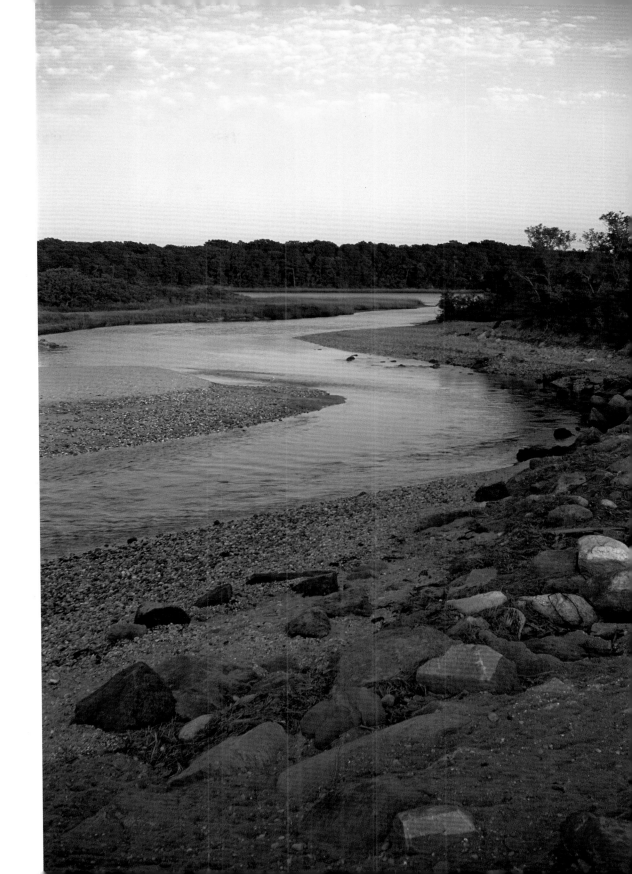

GOLDSMITH'S INLET, PECONIC

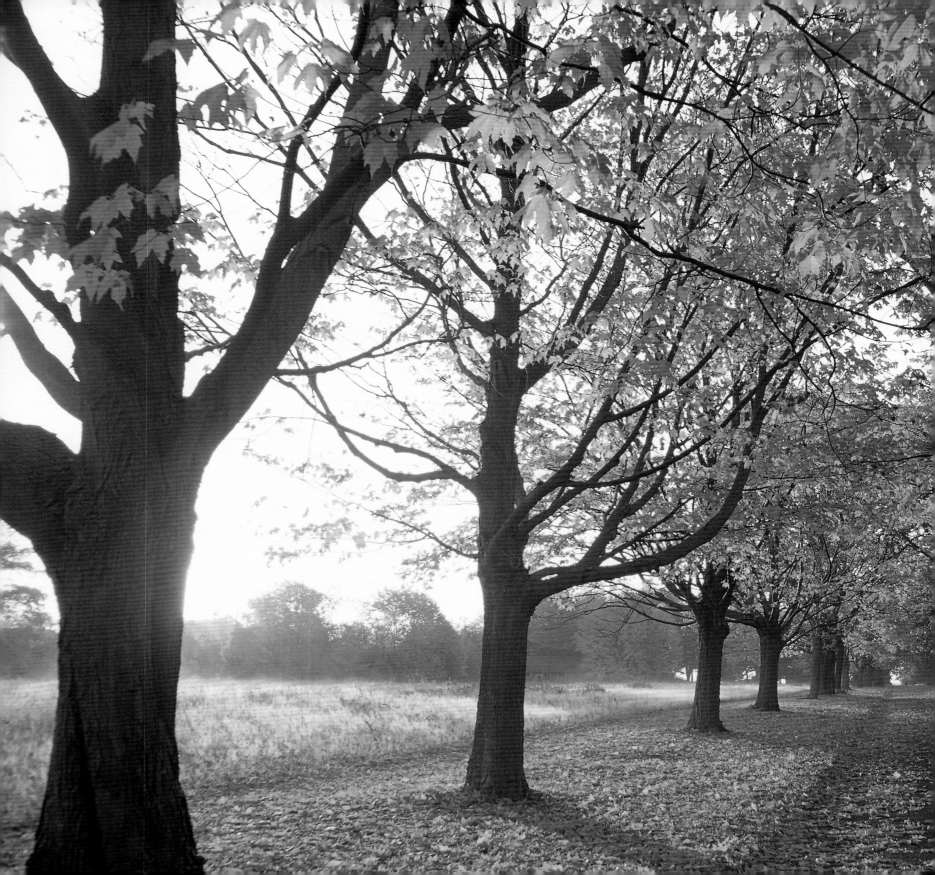

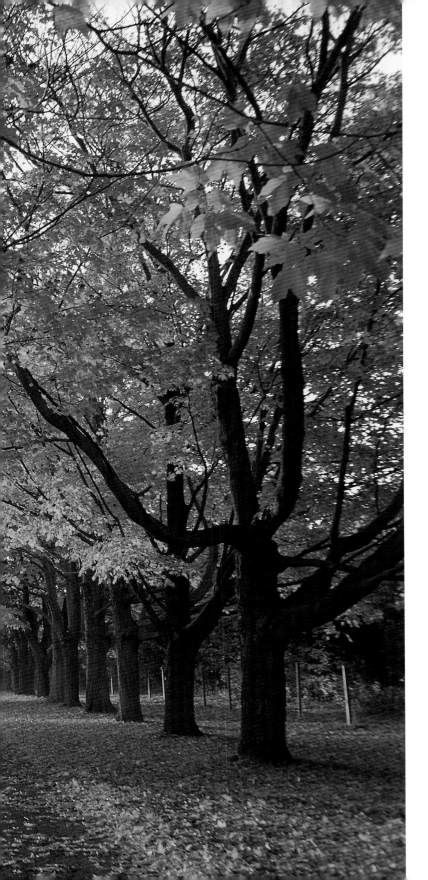

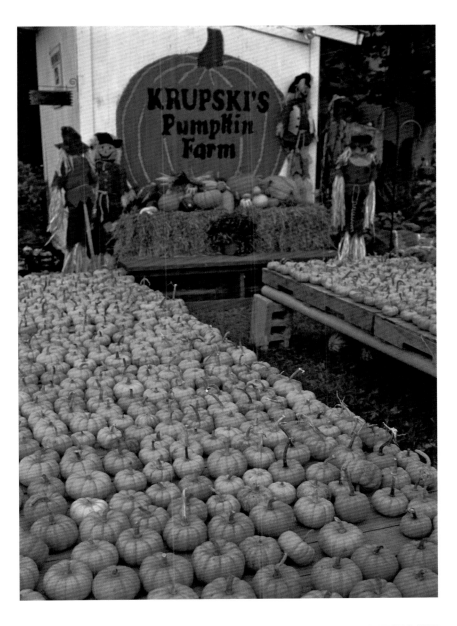

CUTCHOGUE

EAST MARION

69

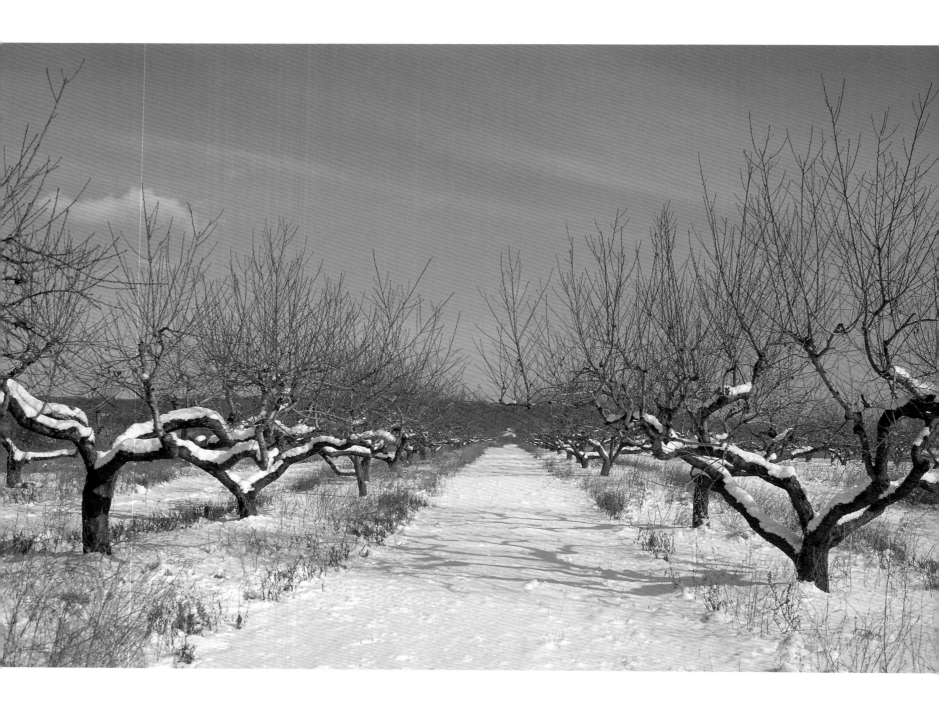

THE ORCHARD AT WICKHAM'S FRUIT FARM, CUTCHOGUE

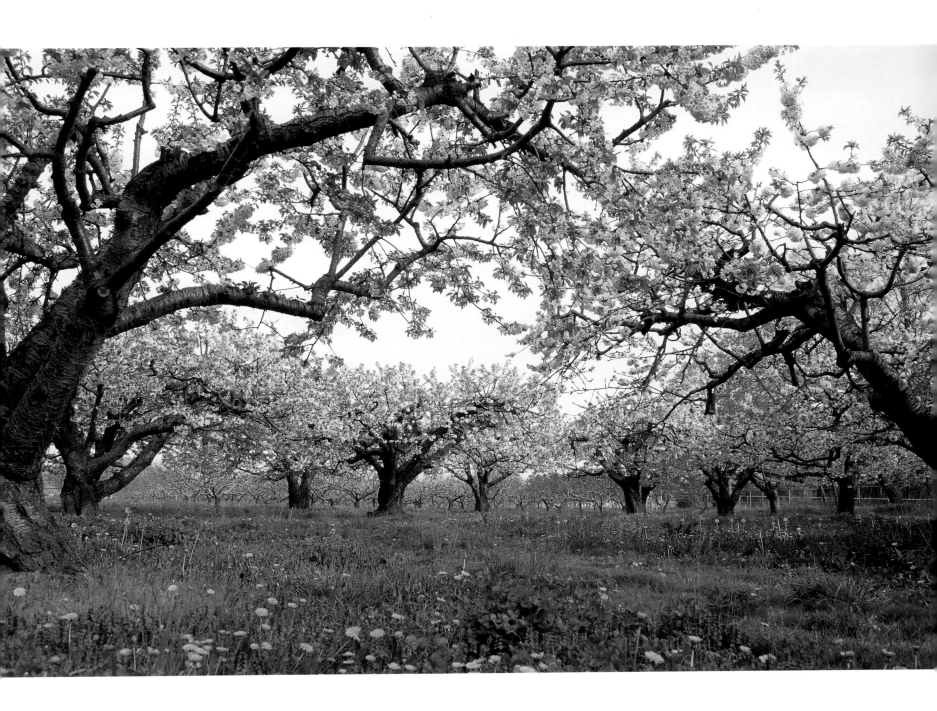

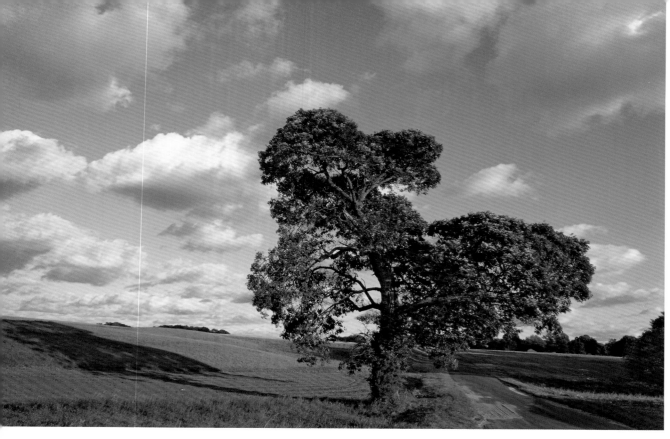

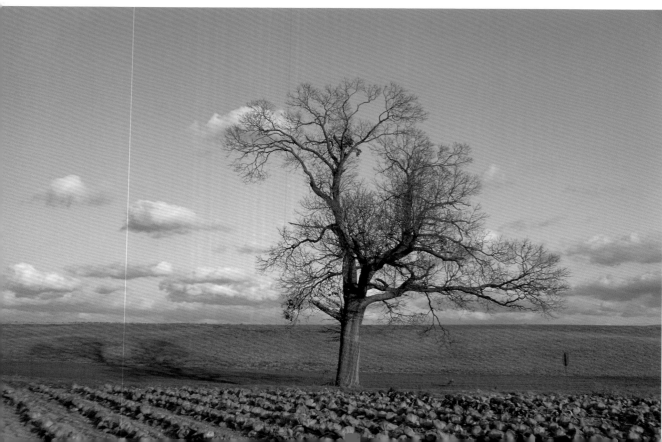

MATTITUCK

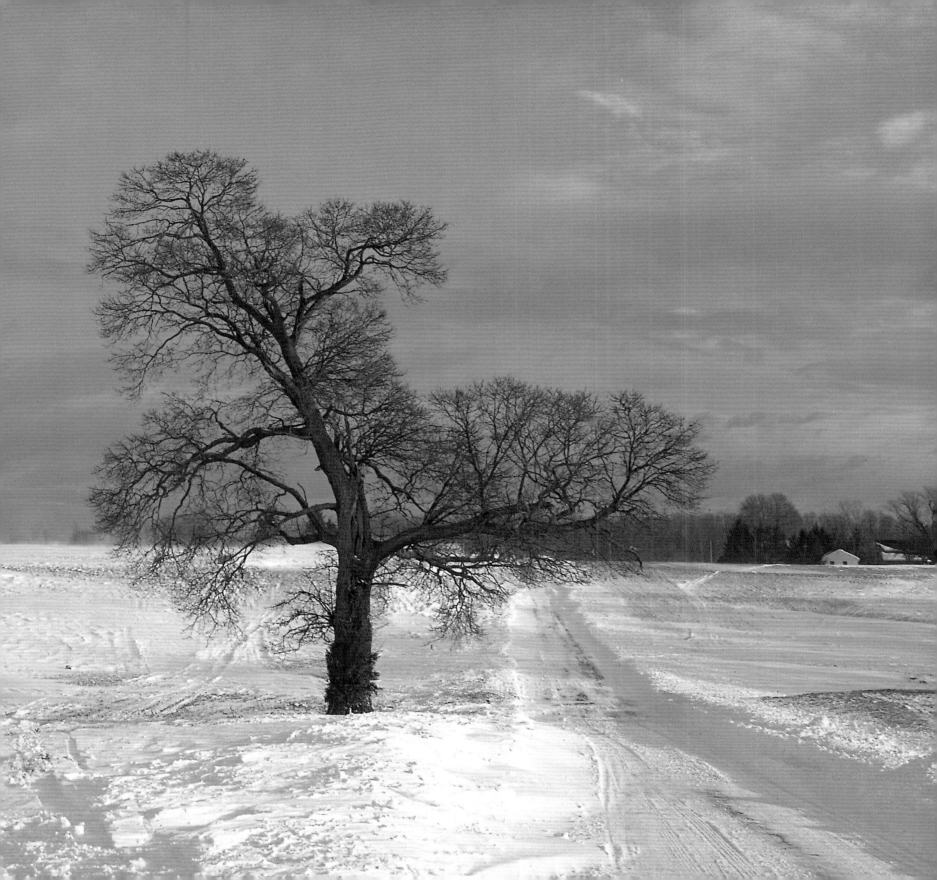

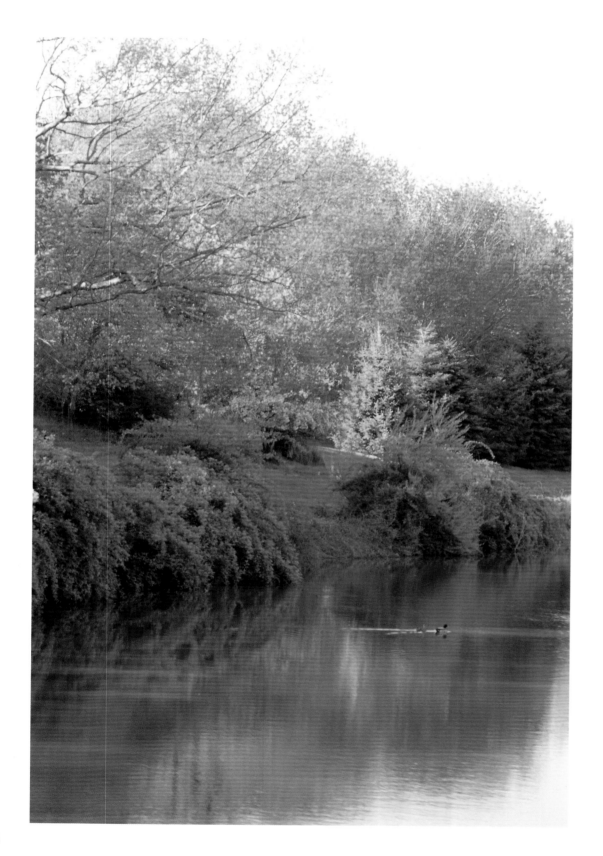

MATTITUCK

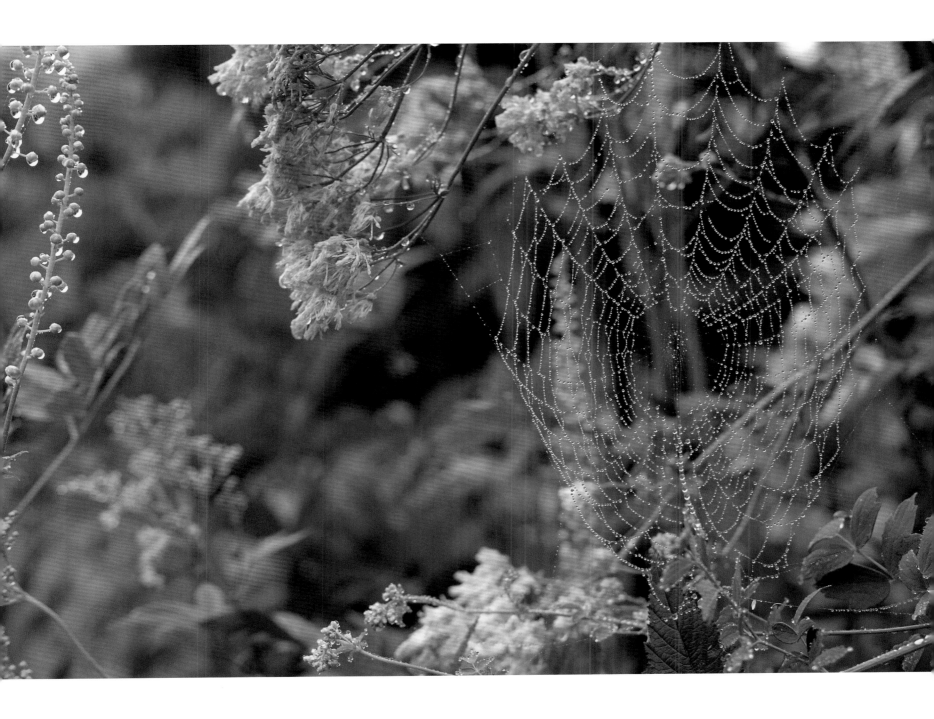

AUTHOR'S GARDEN, PECONIC

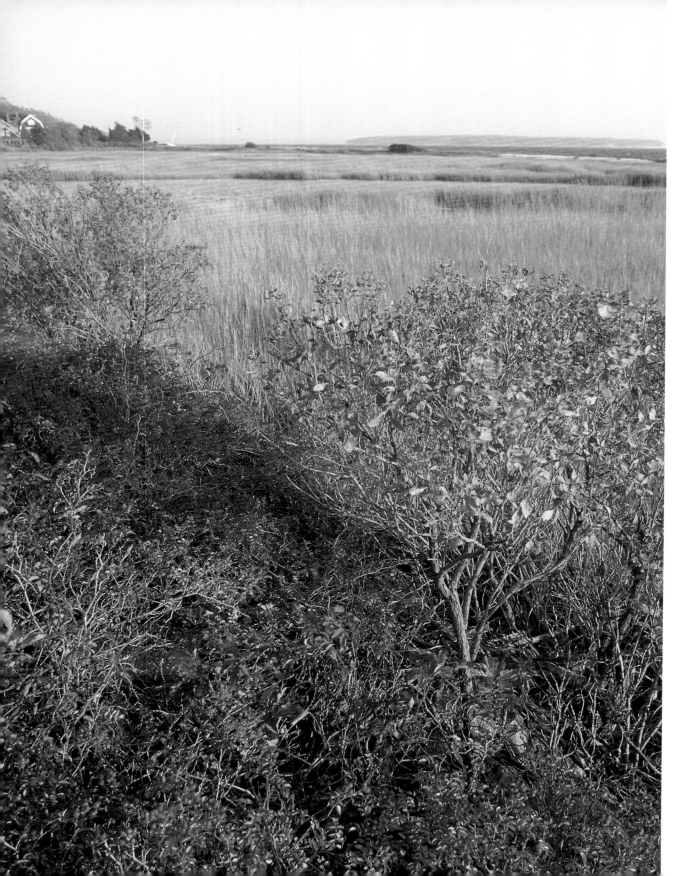

CUTCHOGUE

ORIENT

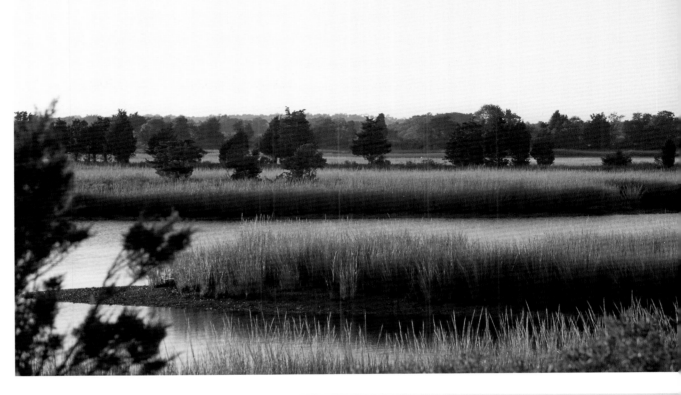

PECONIC

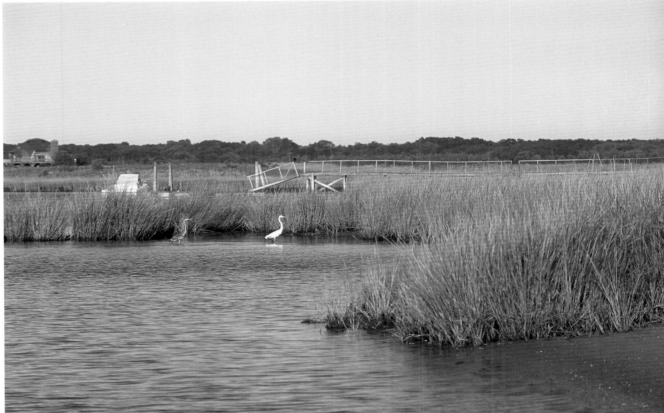

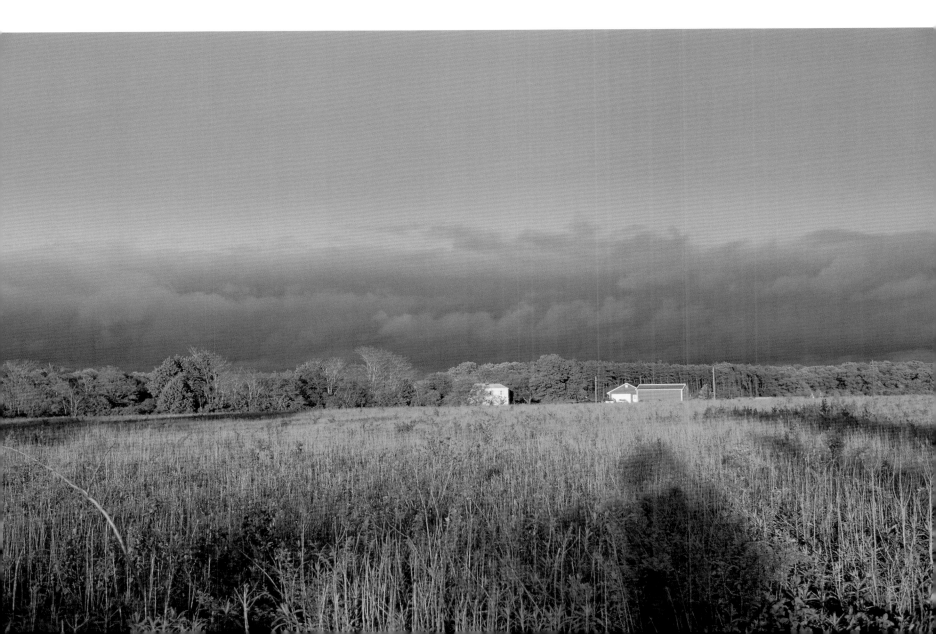

PAINTER WHITNEY M. HUBBARD'S
HOUSE, GREENPORT

OPPOSITE: PECONIC

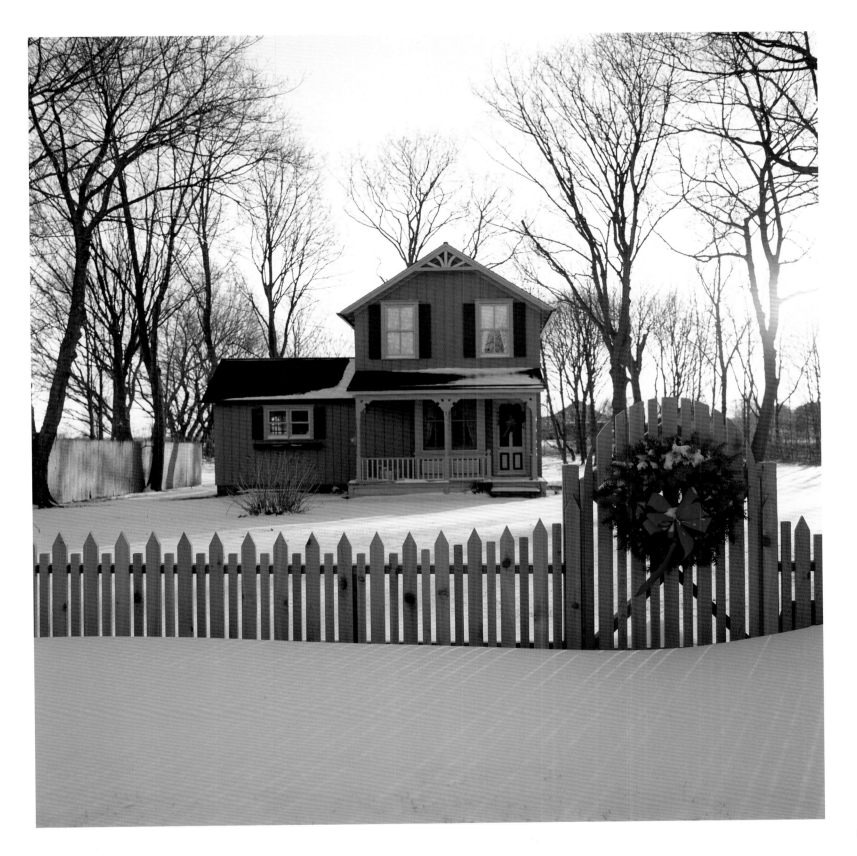

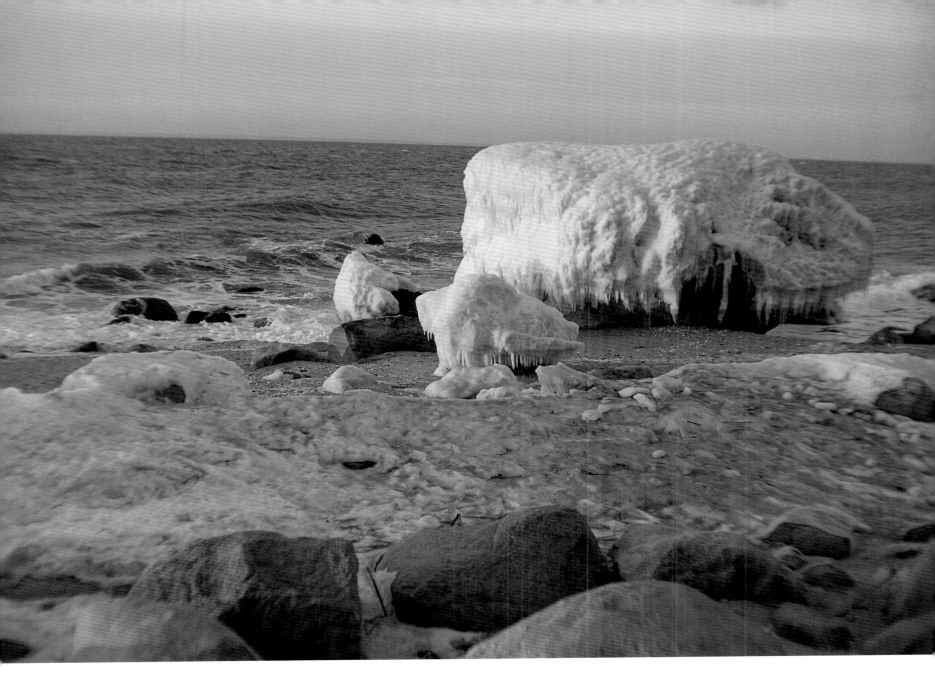

SOUTHOLD

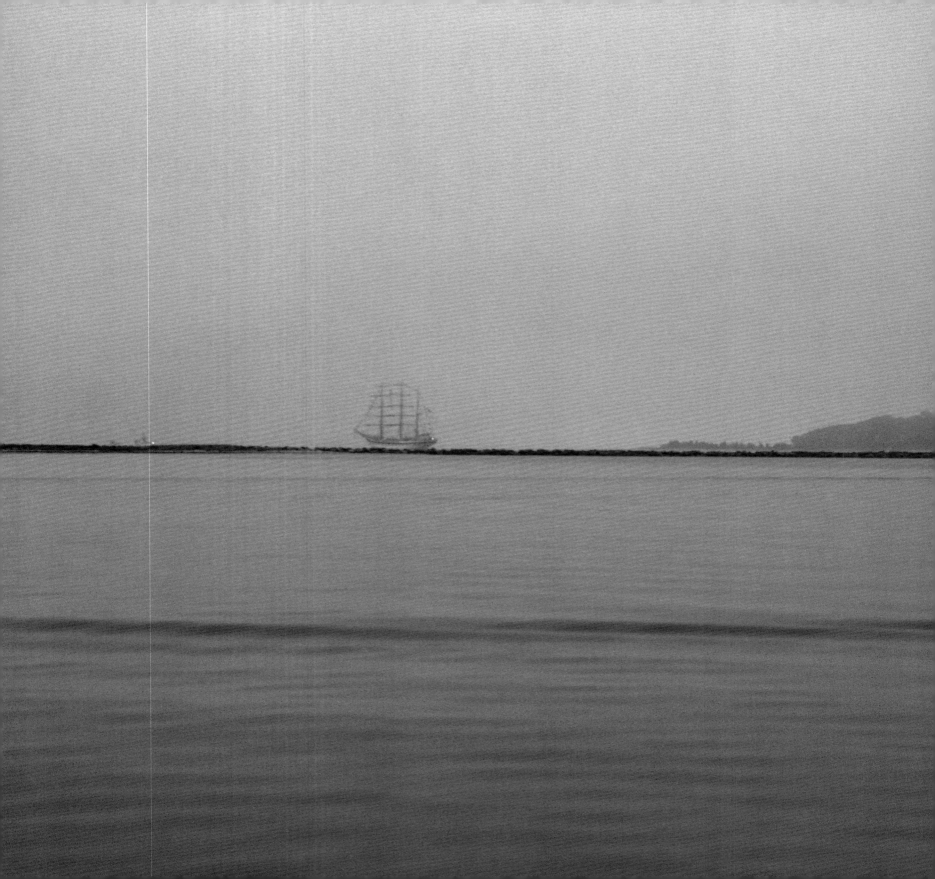

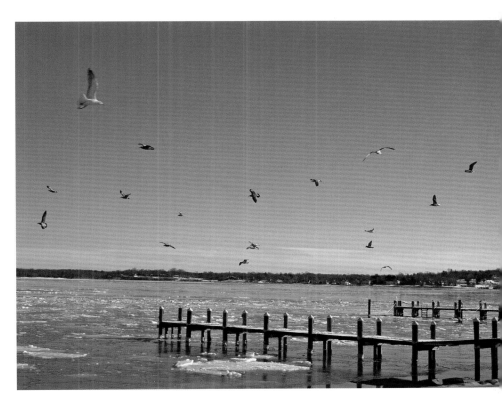

GREENPORT

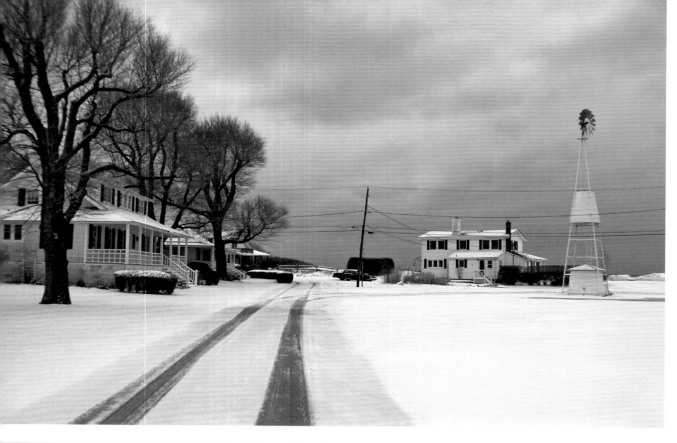

KIMOGENER POINT,
CUTCHOGUE

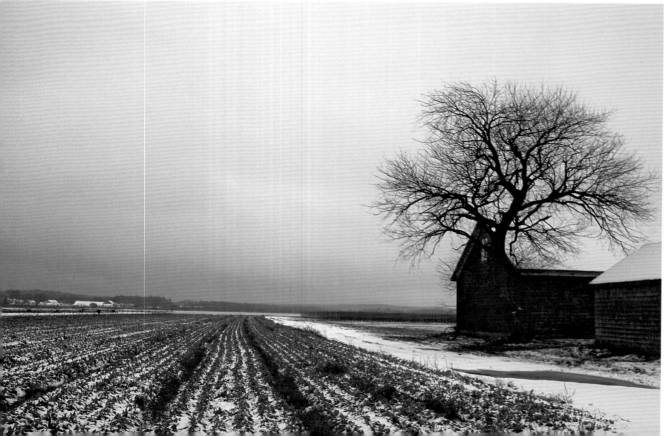

RIVERHEAD

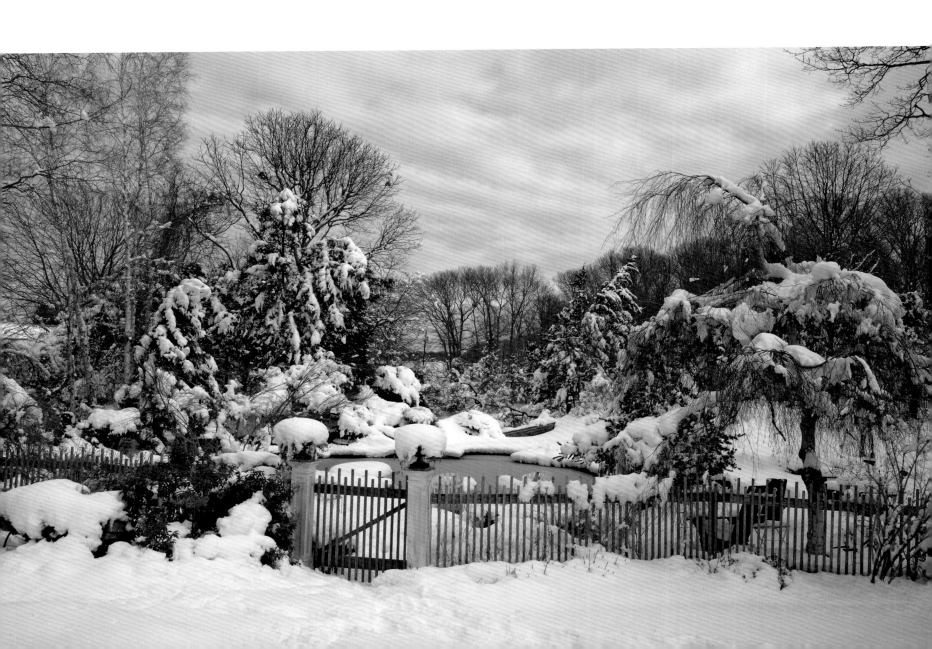

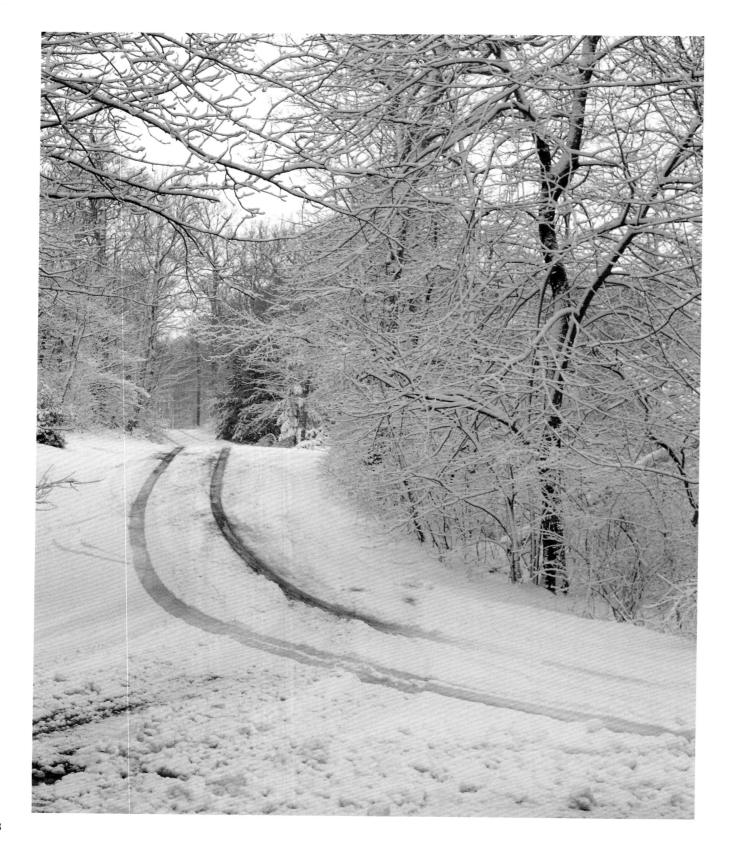

OPPOSITE:
PECONIC

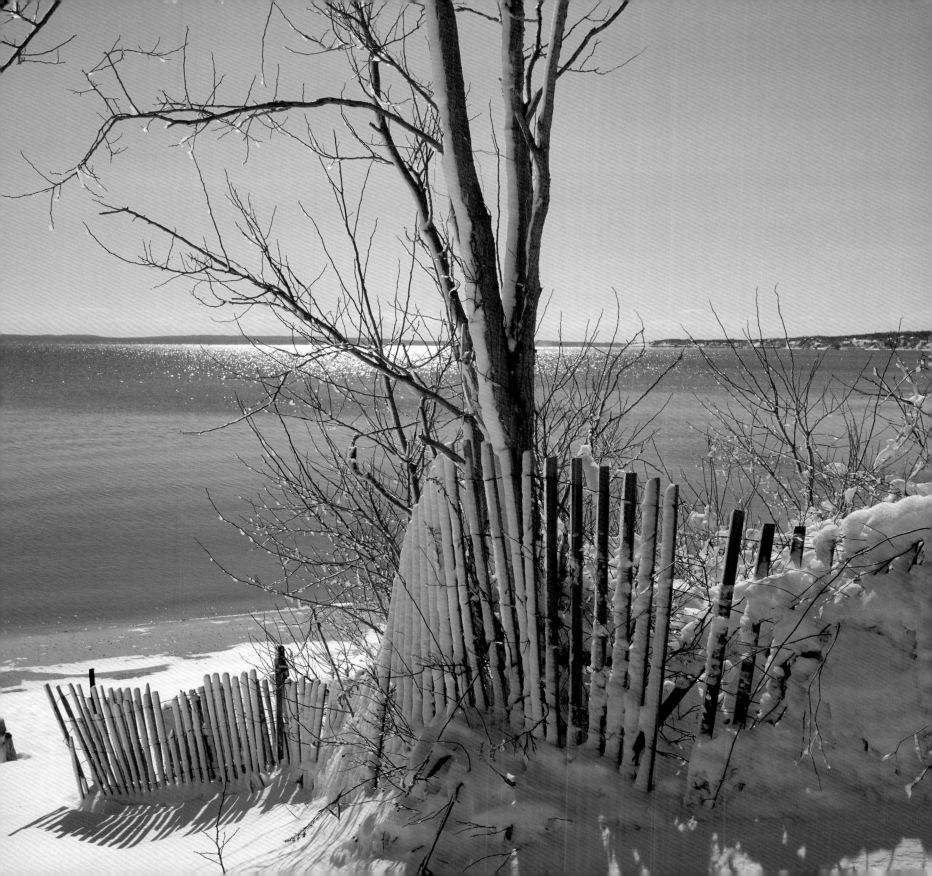

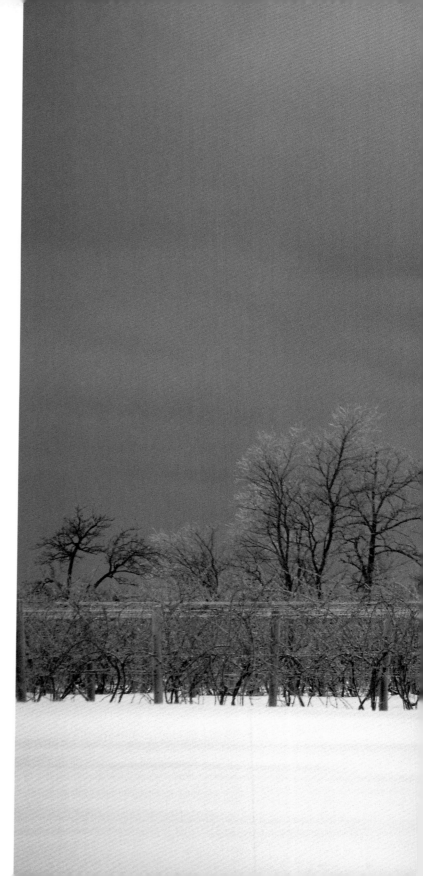

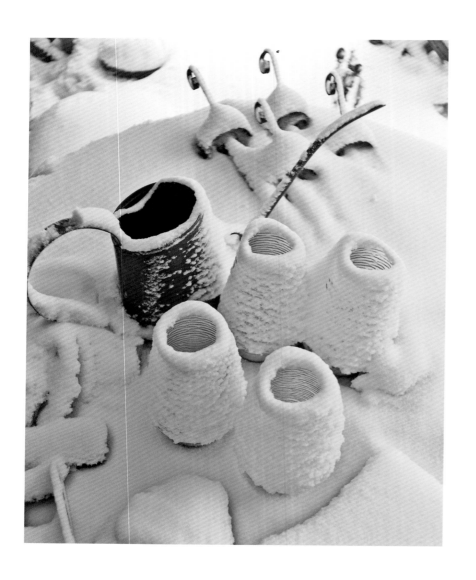

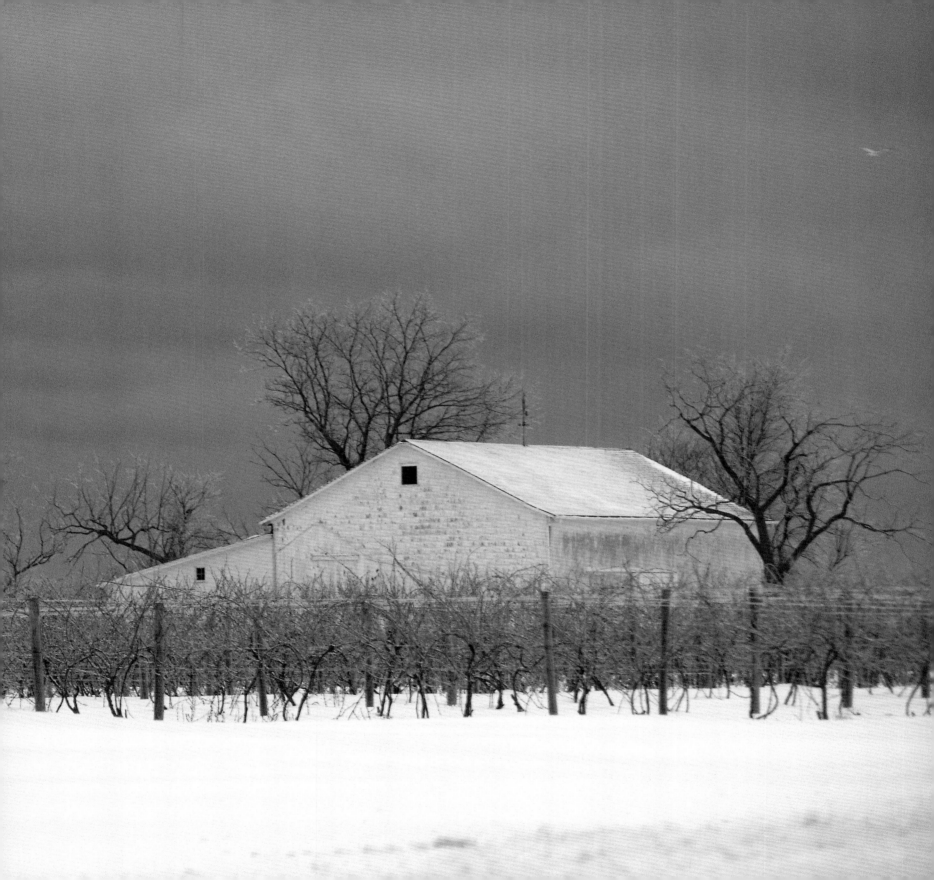

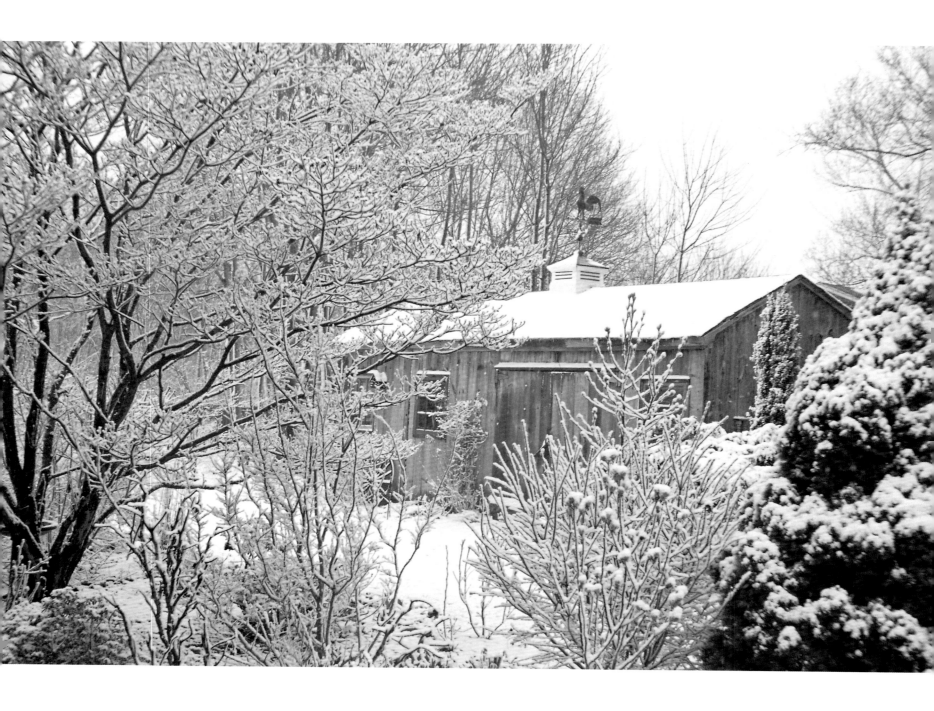

AUTHOR'S GARDEN, PECONIC

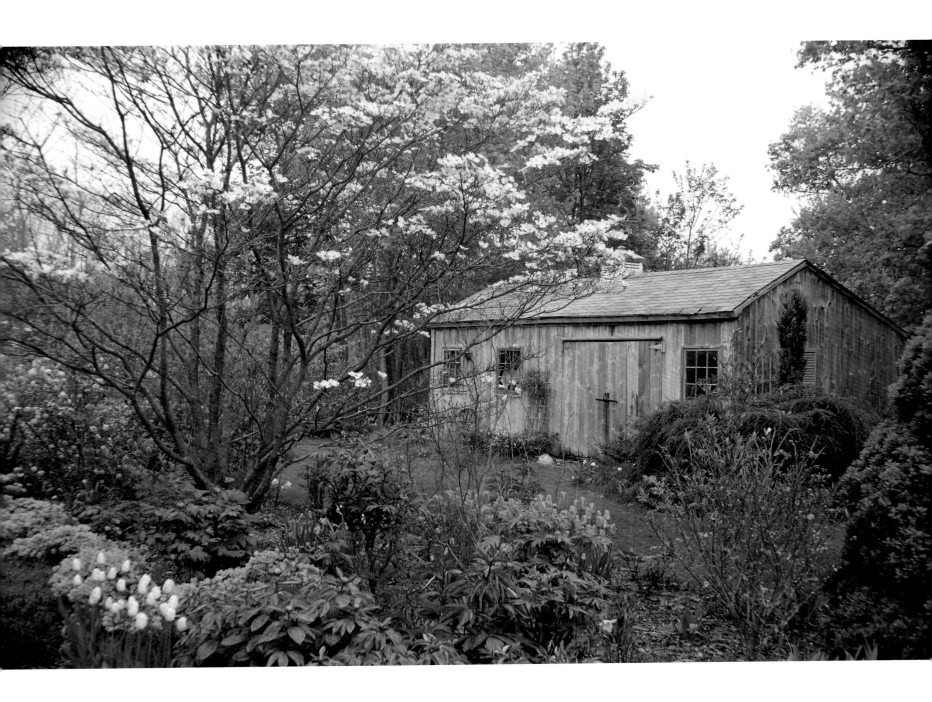

CUTCHOGUE

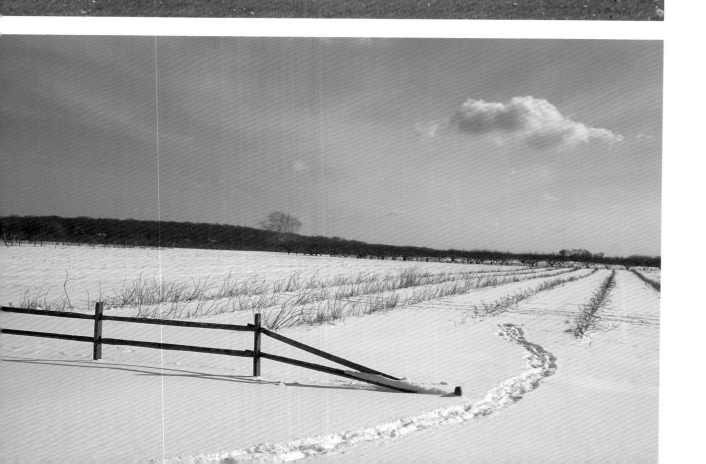

OPPOSITE: WILLIAM
WELLS FARM, THE
OLDEST FAMILY-
OWNED FARM IN NEW
YORK, CIRCA 1661,
RIVERHEAD

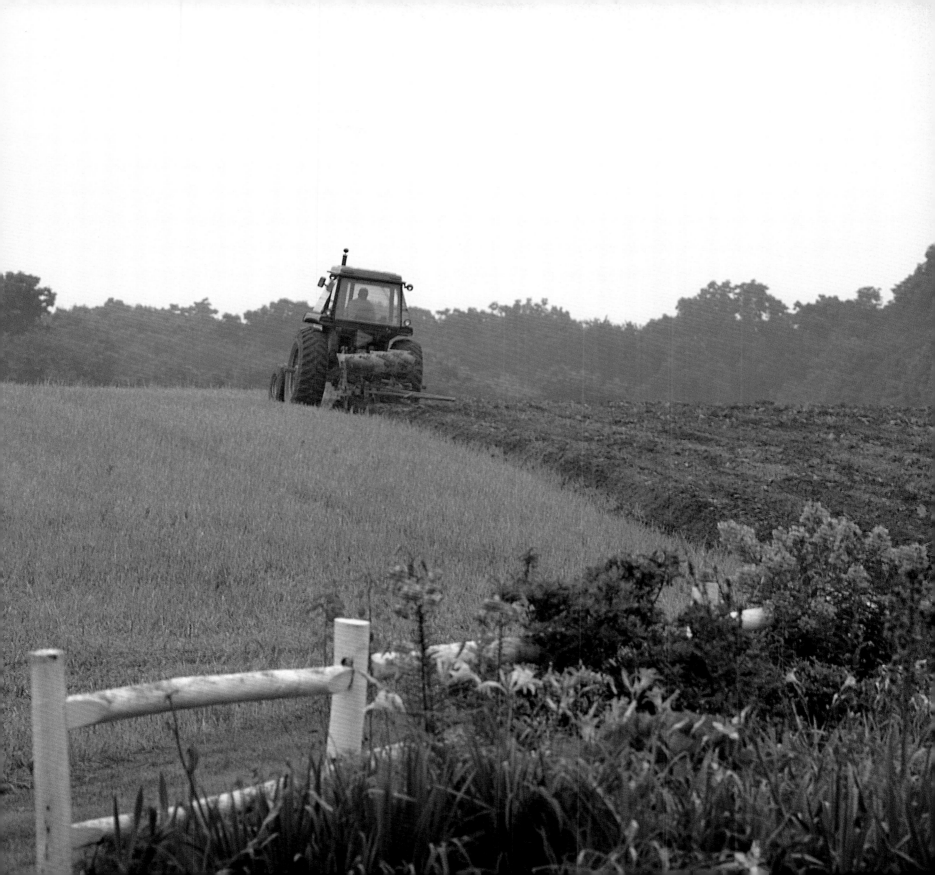

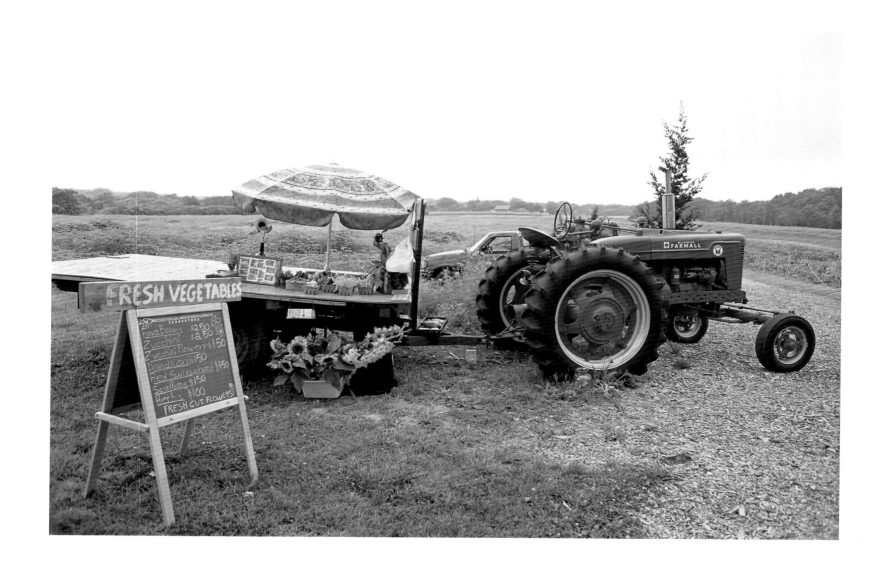

OLD NORTH ROAD, SOUTHOLD

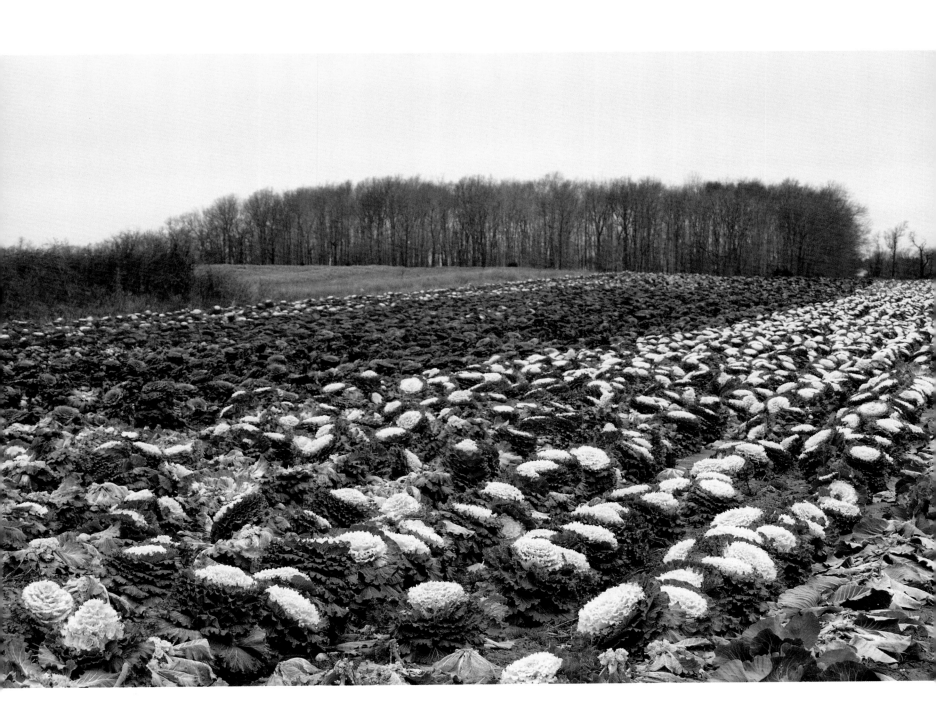

PECONIC

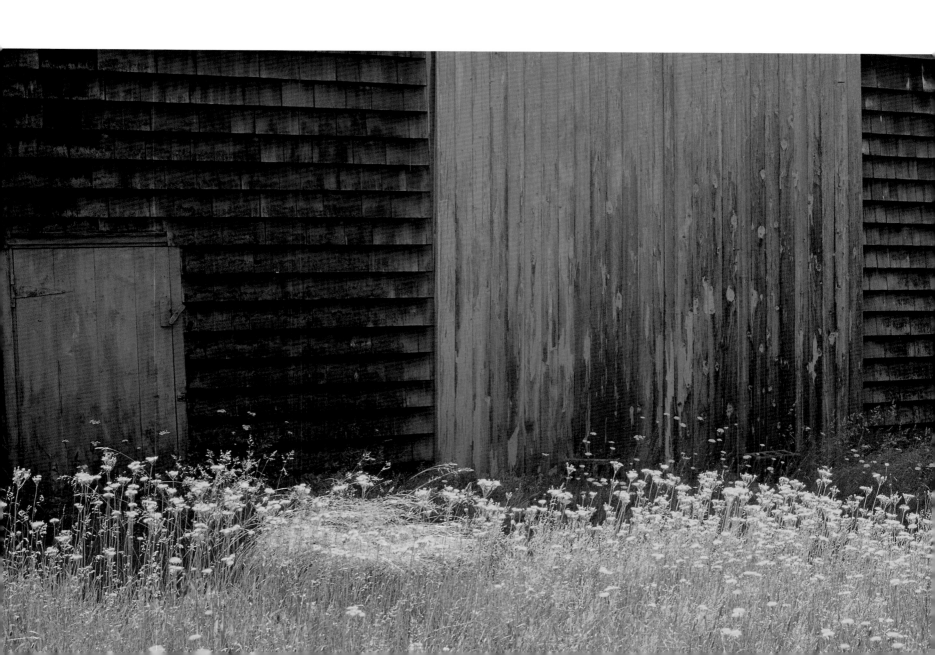

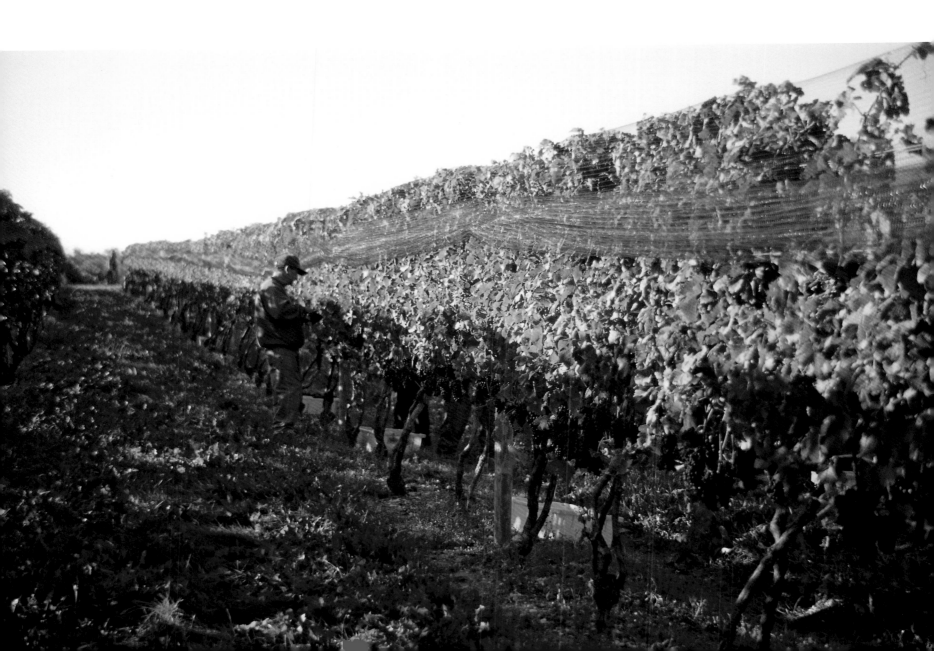

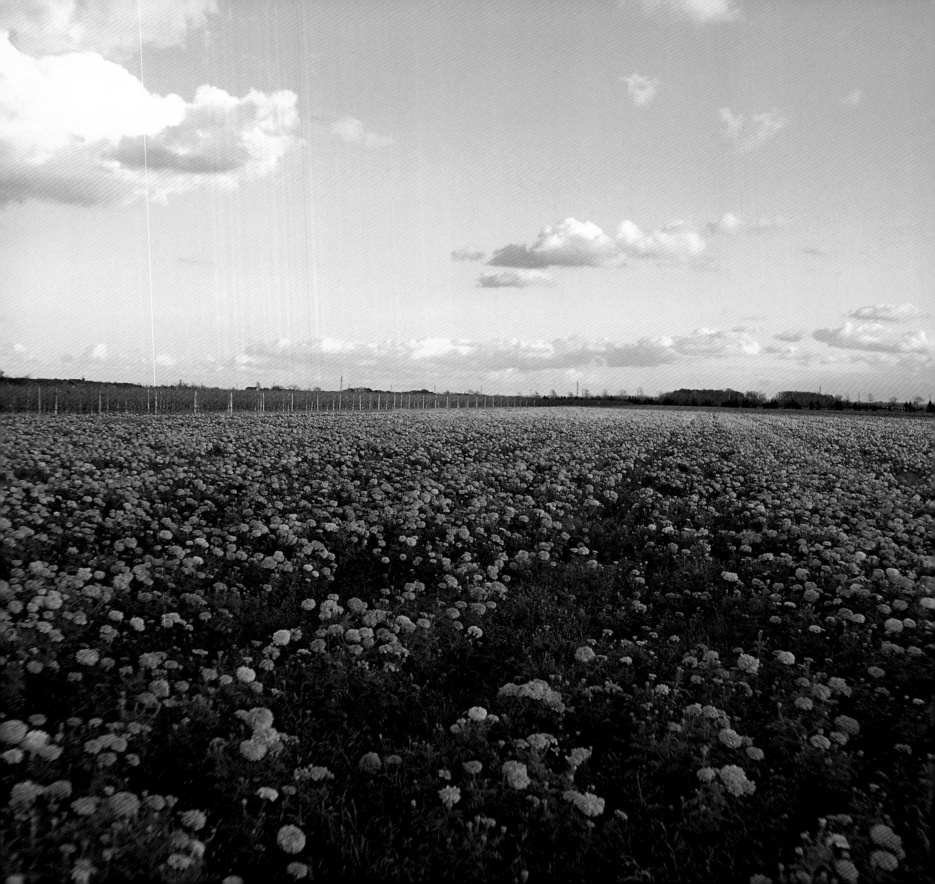

COOPER'S FARM,
MATTITUCK

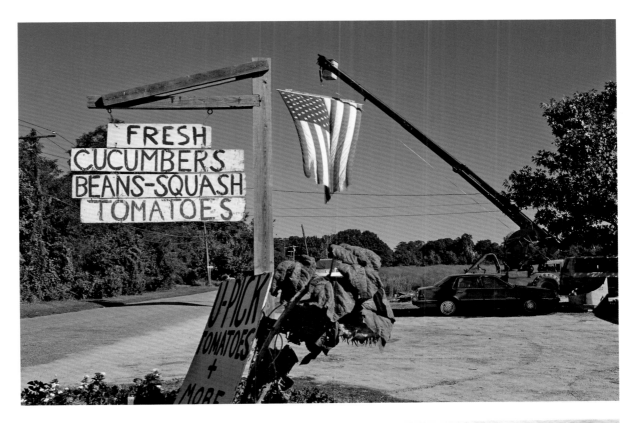

LETTUCE FIELD,
RIVERHEAD

OPPOSITE: MARIGOLD
FIELD, CUTCHOGUE

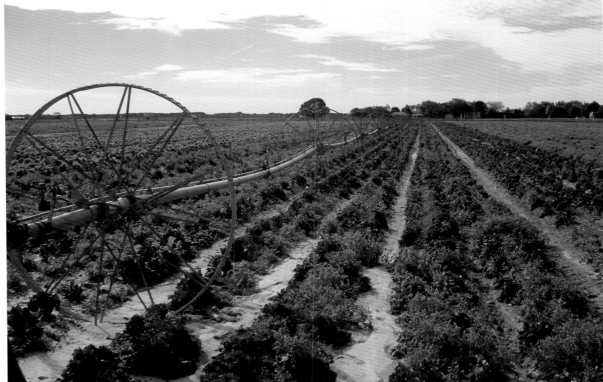

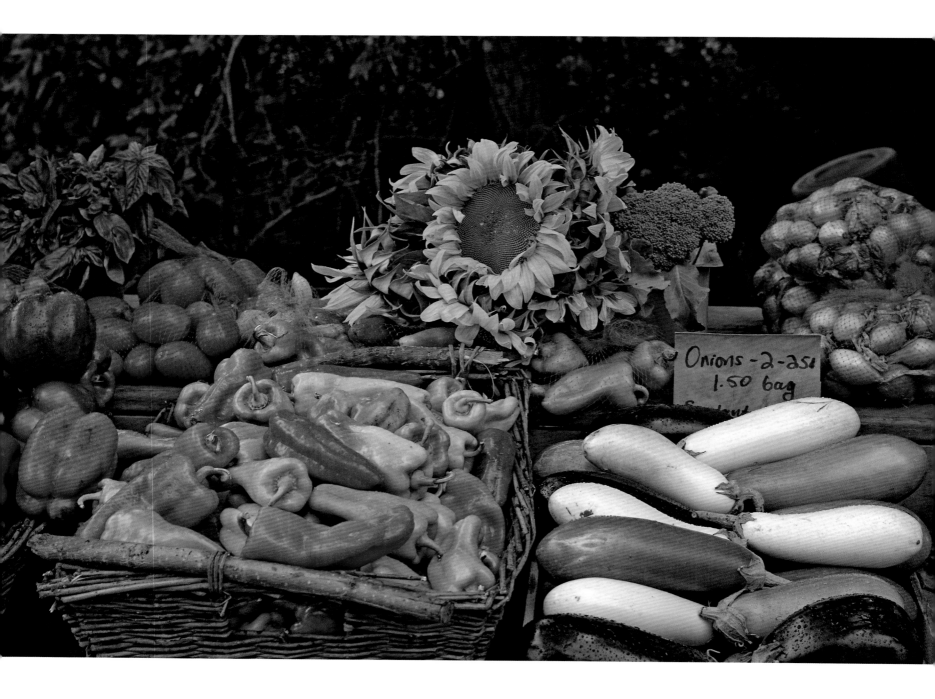

The sign in the photograph reads:

Onions - 2 - 25¢
1.50 bag

CUTCHOGUE

THE NORTH FORK OF THIRTY-FIVE YEARS AGO was known primarily for its potato and cauliflower farms, mostly Polish-owned. Today, the acreage planted in potatoes for all of Suffolk County has dropped from forty-five thousand at its peak in 1952 to six thousand today. The North Fork's economy, formerly strictly agriculture-based, has evolved into a complex mix of agriculture, vineyards, and tourism, much of which is focused around the vineyards. Lately, farms have been capitalizing on tourists' nostalgic perceptions of farms through "agri-tainment," whereby they provide enticements beyond fresh vegetables, such as hay rides, corn mazes, live music, pick-your-own opportunities, and petting zoos.

The pressures for development on the North Fork have become enormous. Property values have increased dramatically since the Invasion, and farmers are sorely tempted to sell to developers. Thankfully, there are incentives offered by the government to discourage farmers from selling their land. The Farmlands Preservation Act buys the development rights from the farmers, which allows their land to be farmed forever. The Peconic Land Trust, a not-for profit organization, was established in 1983 to protect Long Island's farmland and open space. Through a revolving trust fund, it purchases properties that are in imminent danger of being developed. Since 1983, the Peconic Land Trust has preserved more than 7,500 acres of working farms, unspoiled land, and watersheds. Most recently, two parcels of farmland in Cutchogue, totaling 26.7 acres, were saved from developers through the Land Trust's efforts. Developers approached Anne Marie Krupsky, whose family bought her land in the early part of the twentieth century. Because of her fondness for the North Fork, she decided to work with the Peconic Land Trust instead. The Land Trust bought the property and then sold the development rights to the town of Southold, thus protecting the farm from development. Southold then sold the now protected land, except for one acre, to a private owner who will maintain it as a farm. Thanks to the Land Trust, open space is expanding.

When I was a graduate student at Baruch College in 1975, my thesis was about the preservation of open space in Suffolk County and the many issues surrounding that movement. Only in recent years have we finally begun to realize that without open space and farmland, the quality of life on the North Fork would be drastically reduced. Vineyards and wineries have become one solution to the problem of preserving farms and land, but never in my wildest dreams could I have guessed that the vineyards would have such a huge impact on the development of the North Fork.

Alex and Louisa Hargrave were the first to explore the possibilities of growing viniferous grapes, which are commonly grown in California and France. In 1973, the Hargraves bought a potato farm and planted about fifty acres of vinifera grapes. In 1976, Hargrave Vineyard produced its first bottle of wine. Now there are more than two thousand acres of vineyards on the North Fork and thirty-eight wineries on Long Island producing about five hundred thousand cases of wine per year. There are more than sixty vineyards ranging in size from two acres up to five hundred acres and the variety of grapes that are being grown is substantial, including cabernet franc, cabernet sauvignon, chardonnay, chenin blanc, dolcetto, gewürztraminer, malbec, riesling, merlot, pinot blanc, pinot noir, and sauvignon blanc.

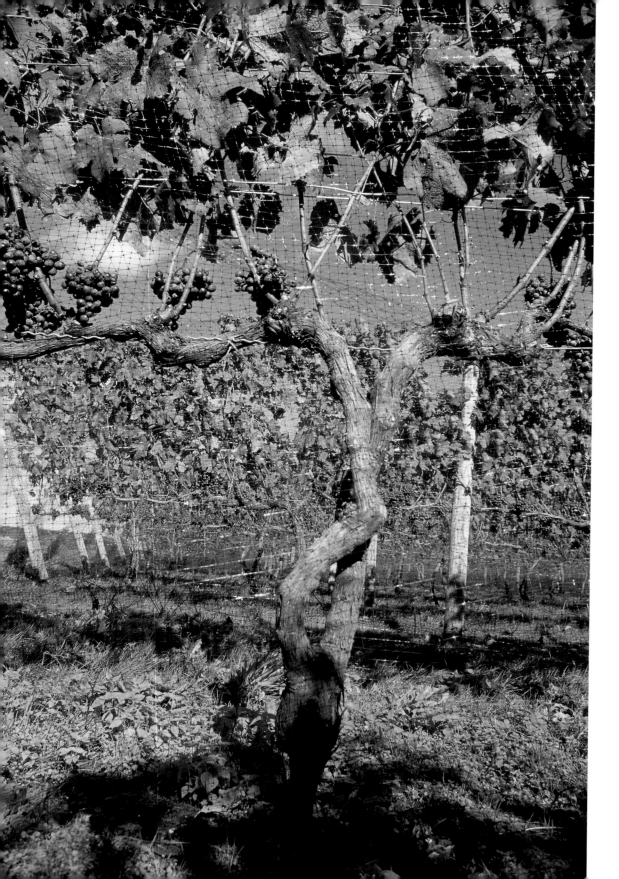

MERLOT GRAPES, PECONIC

Now, Long Island wineries are winning awards at the New York State Wine & Food Classic. In 2005, the New York Grape and Wine Foundation named the North Fork's Osprey's, Dominion winery of the year. As my friend and colleague, Theodore James Jr., says, "It is the first time the environment was saved by the bottle." Ironically, the very thing that saved much of the farmland from development is now contributing to the development of the remaining area. The vineyards have put the North Fork on the map.

Most of the vineyards are relatively new and the quality of their wines can vary, but the wines are improving as the vines age and the techniques of winemaking evolve. The winemaker plays a significant role in the final product. The decision of when to harvest and when to stop the fermentation process and whether to use new or old oak barrels can alter the taste of the wine. When one talks about good years and bad years in winemaking, it usually means the growing conditions of that year. A fair amount of rain during the growing period and through the early stages of grape formation is good; too much rain during the latter stages when the grapes are to be harvested will make them swell, diminishing the sugar content, which is bad.

The Long Island Wine Council is doing a splendid job promoting local wines. Vineyards that have wineries on the premises lure customers through live music, art exhibits, lectures, hosting wedding receptions, and, of course, wine tastings. One vineyard, the Galluccio Family Wineries, formerly Gristina Vineyard, encourages people to go cross-country skiing through their vineyards. Due to zoning laws, vineyards are not allowed to maintain restaurants, but this may change soon. Nevertheless, many vineyards provide areas for picnics and allow customers to bring their own food. The proof of the pudding is in the taste, of course, so I suggest that you allow yourself an afternoon or two to visit the wineries and decide for yourself. (See page 173 for a complete list of the wineries and vineyards of the North Fork.)

Today, the North Fork is a melding of the old and rustic with the new and trendy. Many farmers and old families are still here. Certainly the beauty of the landscape and waterscape is still here, but there are also many new faces, new blood, and new interpretations of the North Fork. We now have more diversity — more sophisticated restaurants, art galleries, and venues for classical music and opera. The Castello di Borghese, formerly Hargrave Vineyard, stages concerts and opera in an outdoor setting.

What makes the North Fork of Long Island a magnet for city dwellers? It was the beauty of its nature and the quiet that drew me out here initially, and the simple fact that it is the exact opposite of the city. It is a place to get away to for a day or a week or a

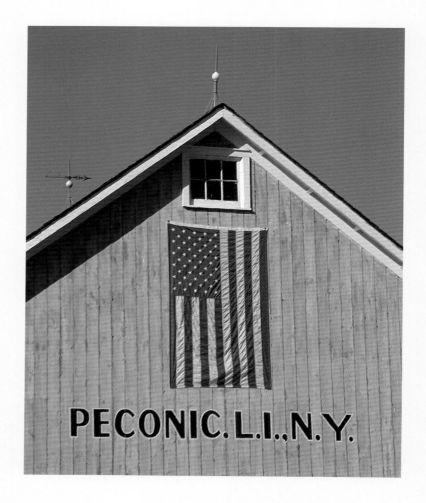

summer, a place to slow down and unwind and enjoy the scenery, a place where one can interact with nature, a place to buy fresh farm produce and local seafood. All of these components draw people to the North Fork. But the desire to slow your life down is not new. In her book *Cabin Paradise*, Ella B. Hallock writes about the need to get away from the hustle and bustle of towns and the responsibilities and obligations that go with it. That was in the summer of 1900. She wanted to simplify her life, if only for a few months out of the year. She found her paradise a few miles outside of Southold on a peninsula called Paradise Point. There she built a cabin on the wooded bluffs overlooking the bay.

In many ways since the Invasion, the North Fork has become a commodity, a product that is packaged and sold, but the persona of the North Fork depends on the seller. The Long Island Wine Council is aggressively promoting it as "wine country." A sign announcing that message appears by the side of the road as you enter the area on Route 25 just east of Route 105. The North Fork is also associated with the fresh produce and other foods available at the local farm stands and pumpkin farms, as well as Christmas tree farms and nurseries. When you think of the North Fork, open space, relaxation, fresh air, and fishing come to mind, but vineyards and fine restaurants are now part of that list. And thanks to various organizations and PR people, it has become a well-developed concept and a state of mind.

I can't help but chuckle when I see new people in the neighborhood who have only recently purchased a house and have immediately become extremely territorial and protective of the area. They act as if they have lived here all their lives. But I smile because they remind me of myself—they do as I did all those years ago. They discourage others from moving out here, become involved in local politics, and join efforts to maintain the beauty and integrity of the environment and slow down development. They want to keep things as they are. Things today are quite different from when I moved out here in the seventies, but at least they are like-minded about preserving the region.

THE OLD HOUSE, CIRCA 1649,
VILLAGE GREEN, CUTCHOGUE

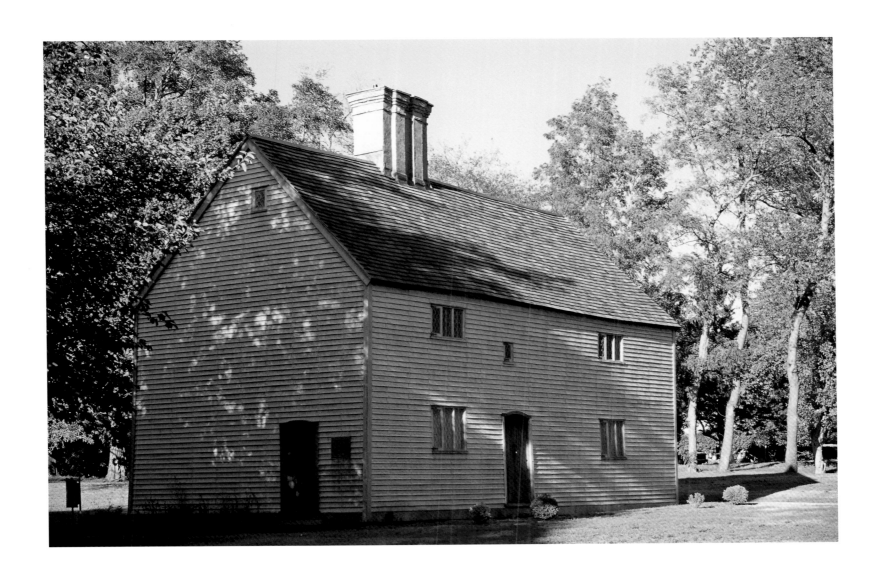

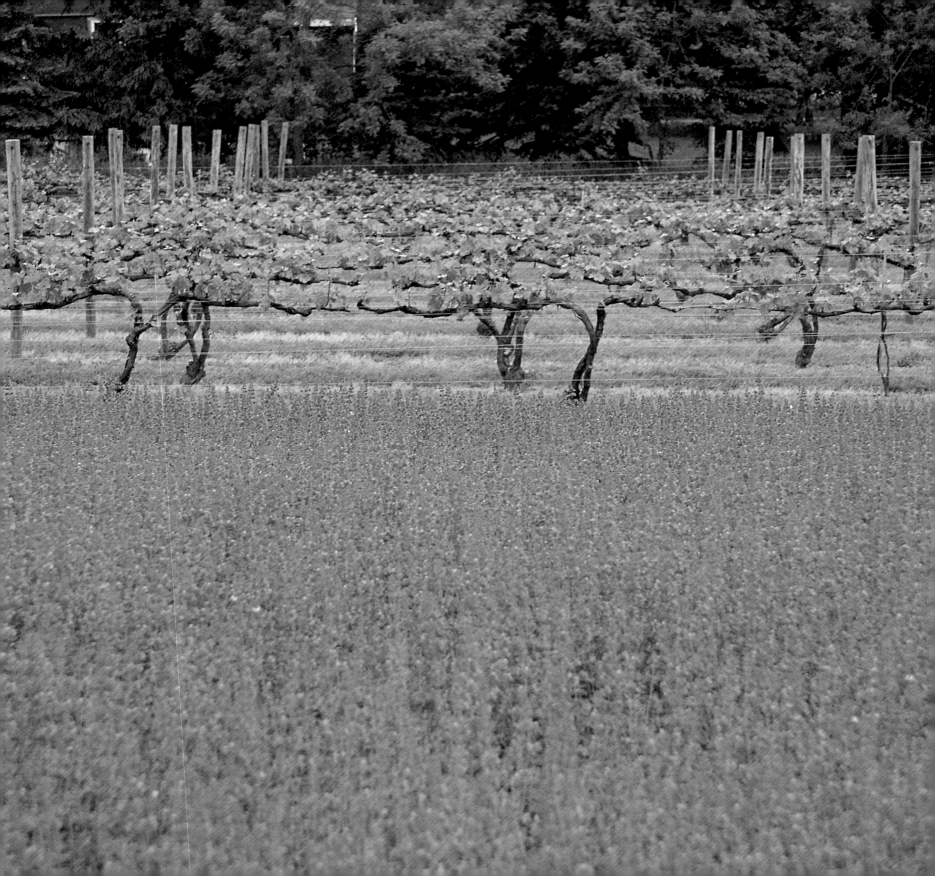

OPPOSITE: LAVENDER FIELD AT
BEDELL CELLARS, CUTCHOGUE

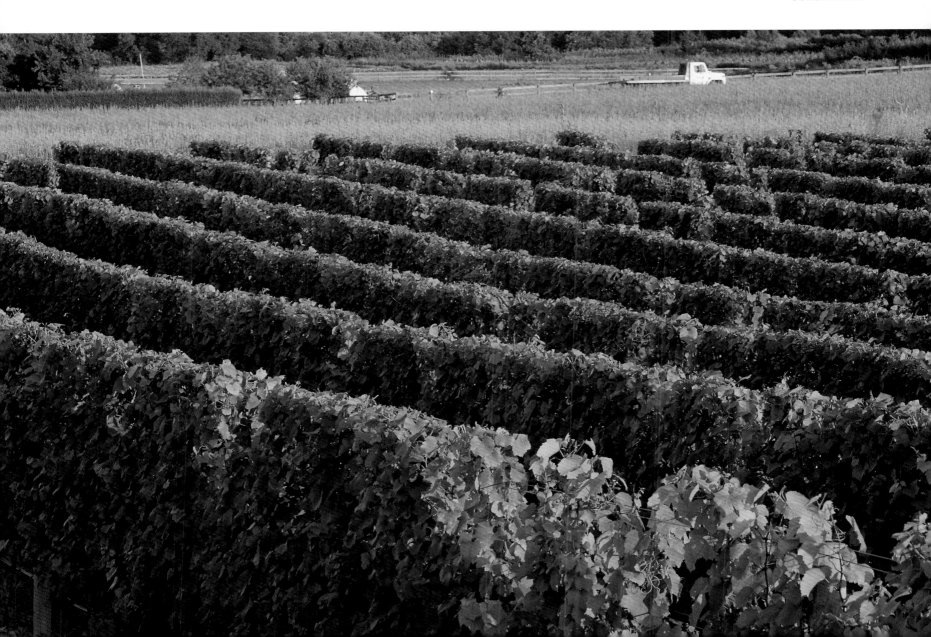

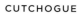

CUTCHOGUE

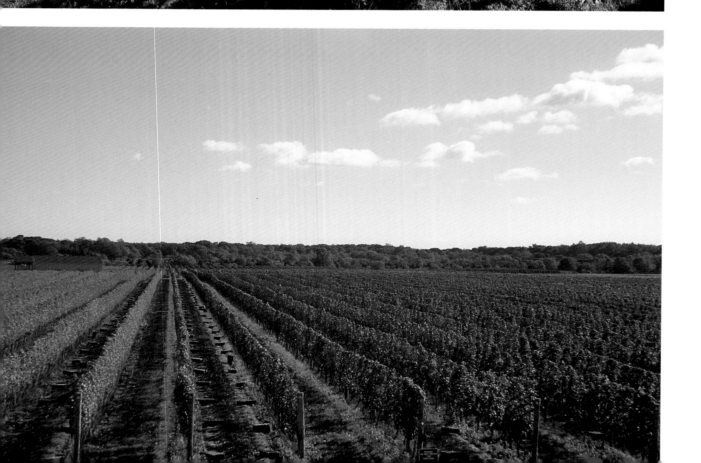

PECONIC

OPPOSITE: CUTCHOGUE

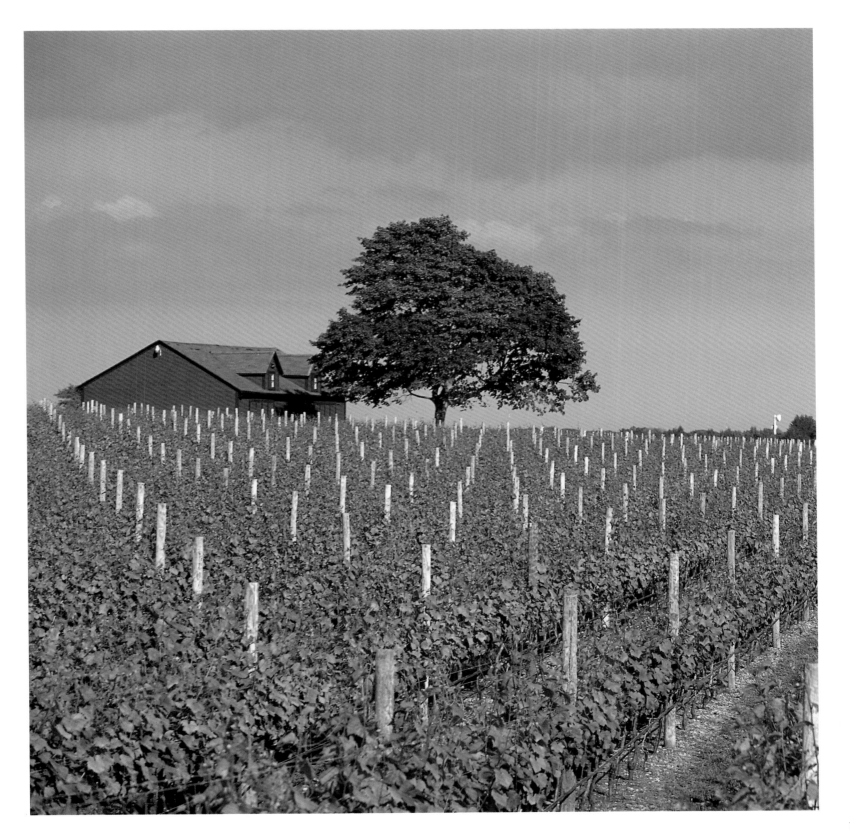

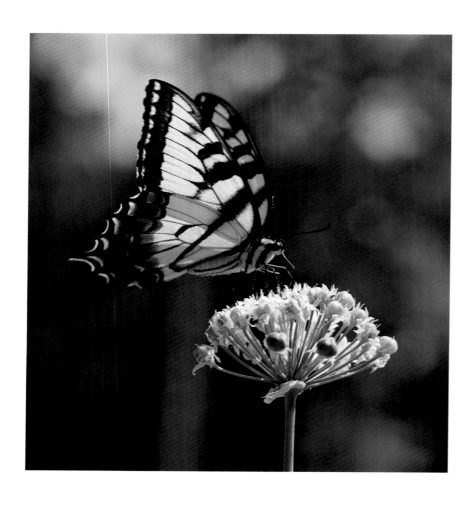

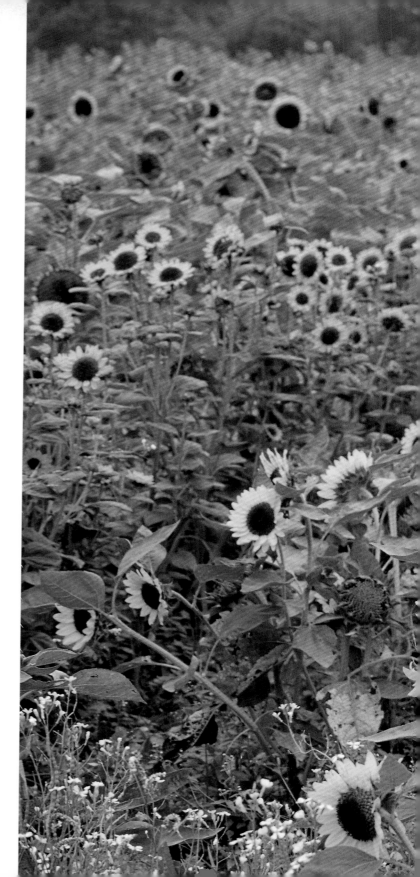

ORIENT

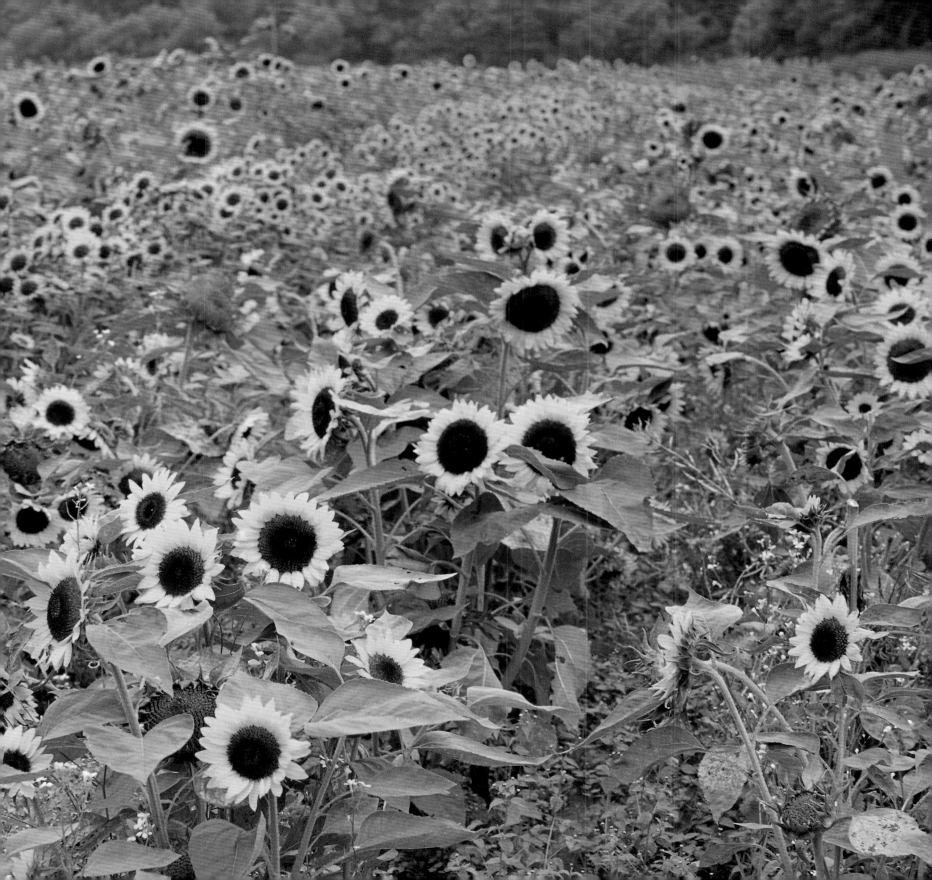

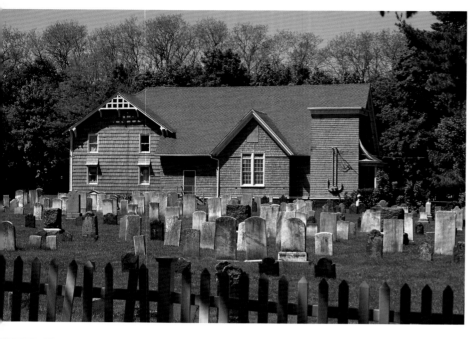

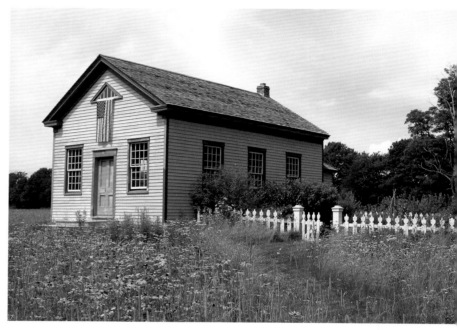

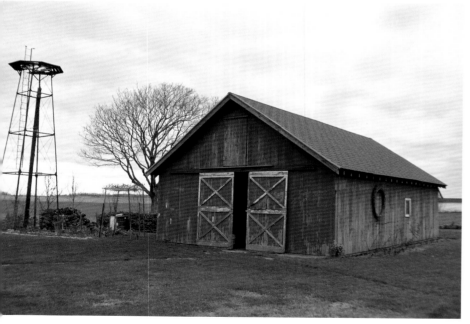

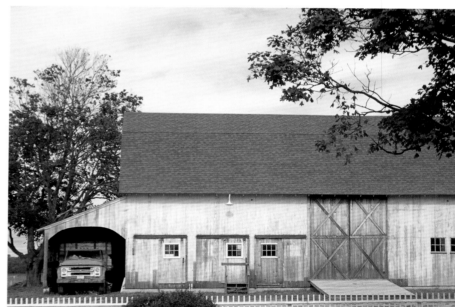

ABOVE: NORTH FORK COMMUNITY THEATRE, MATTITUCK
BELOW: CUTCHOGUE

ABOVE: SOUTH JAMESPORT
BELOW: RIVERHEAD

OPPOSITE:
AUTHOR'S GARDEN, PECONIC

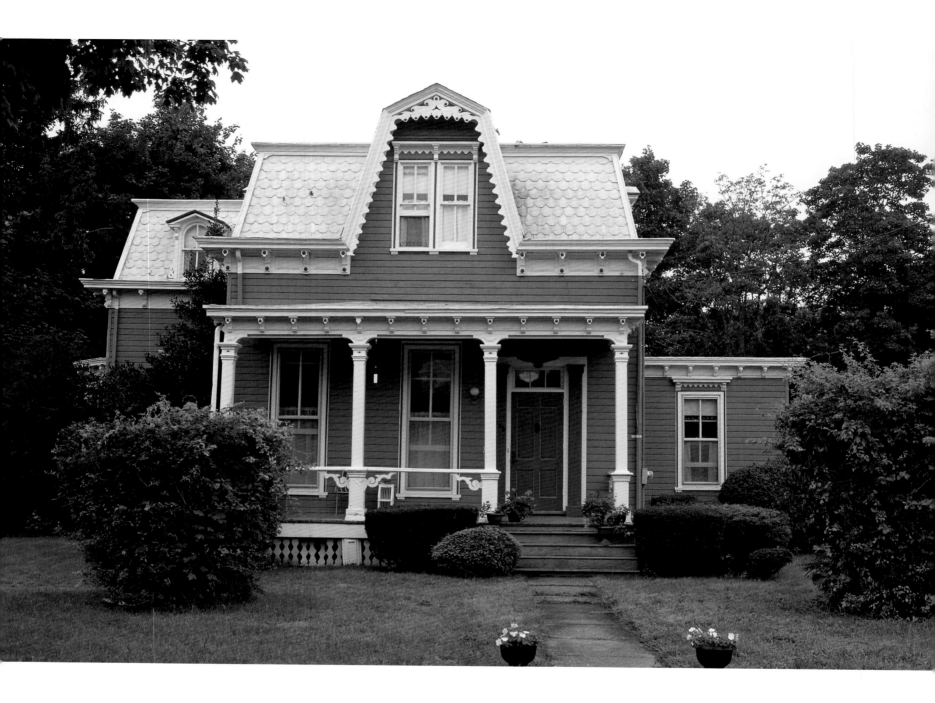

GREENPORT

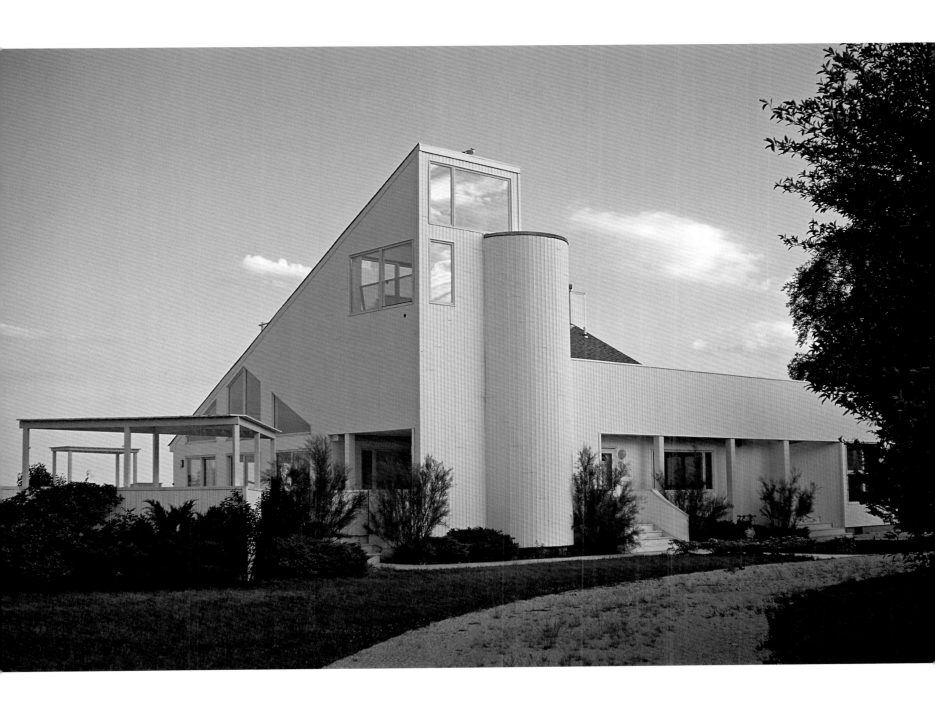

GREENPORT

GREENPORT

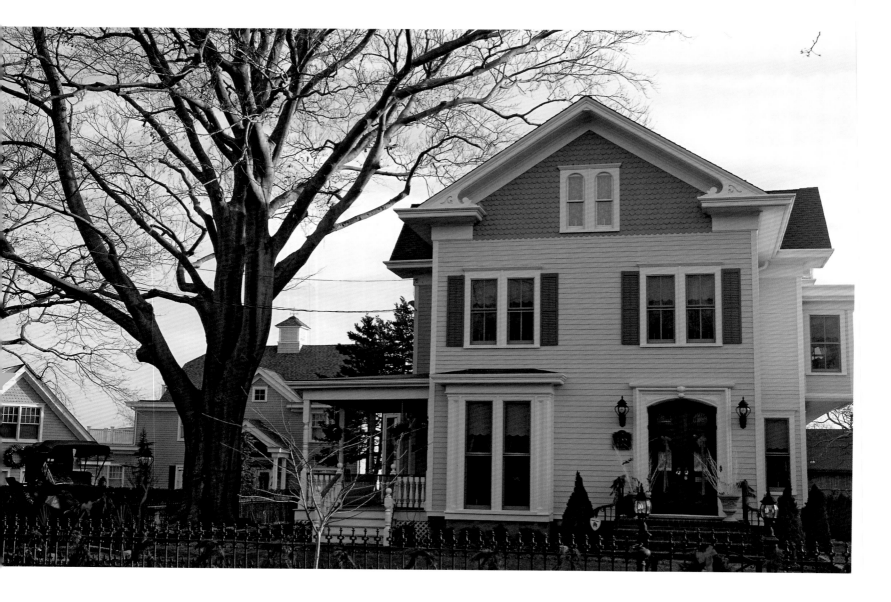

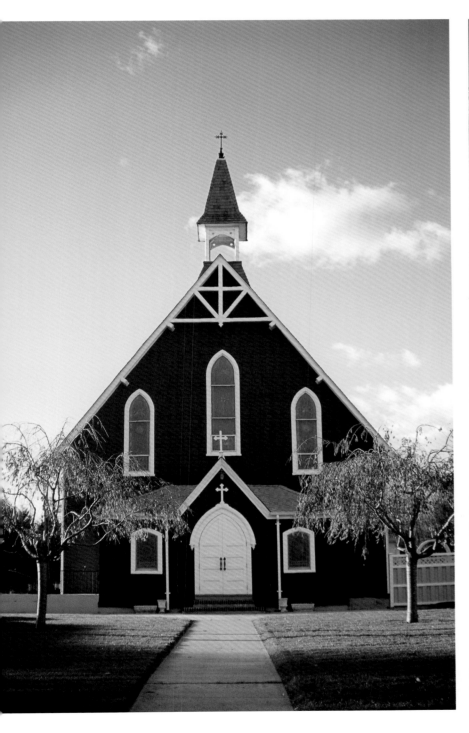
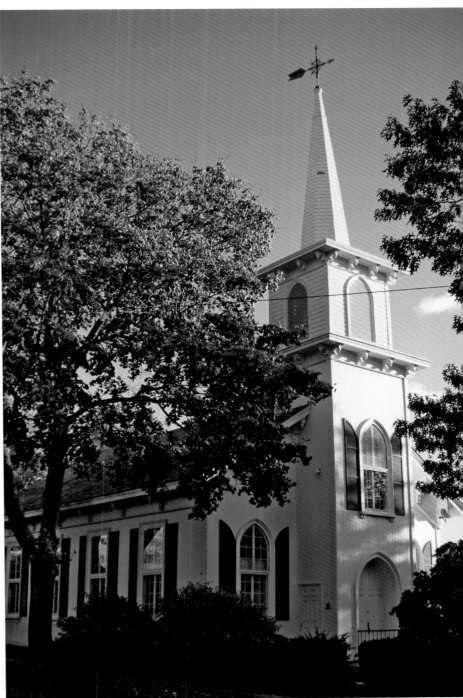

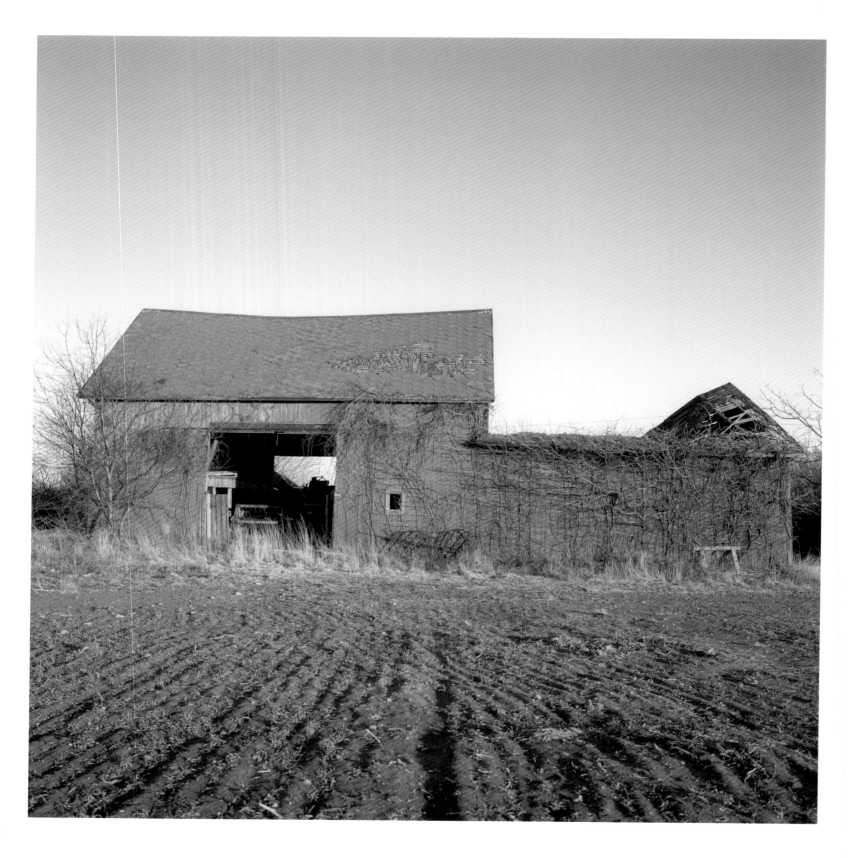

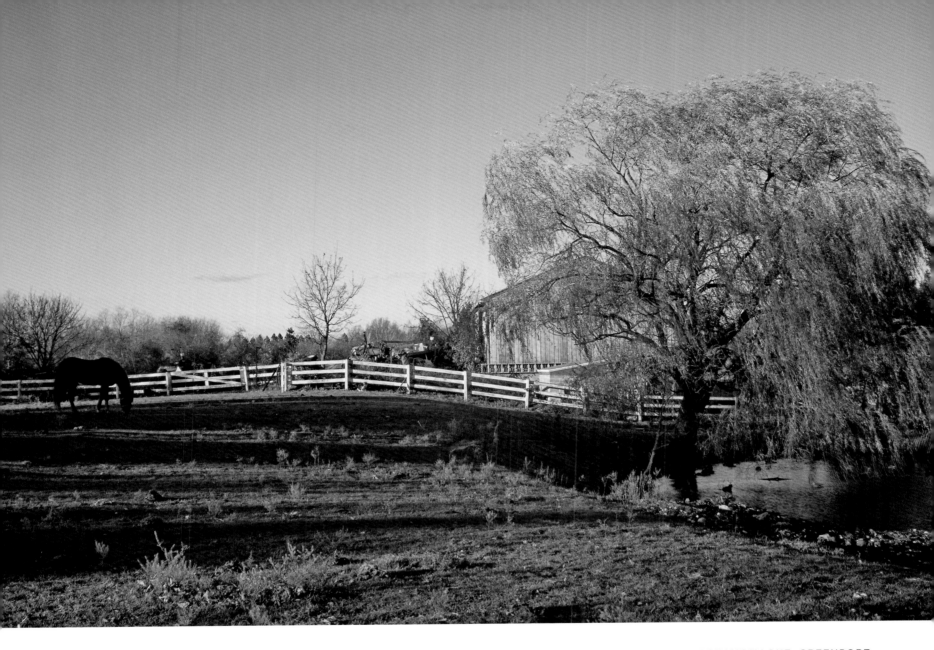

ARSHAMOMAQUE, GREENPORT

OPPOSITE: CUTCHOGUE

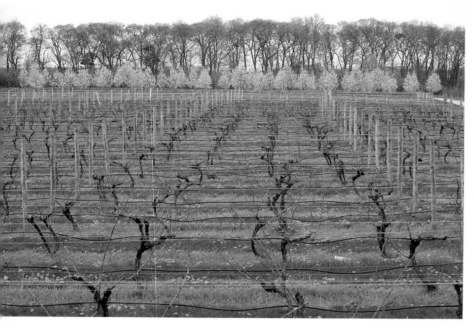

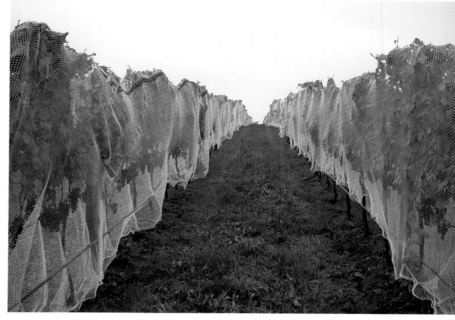

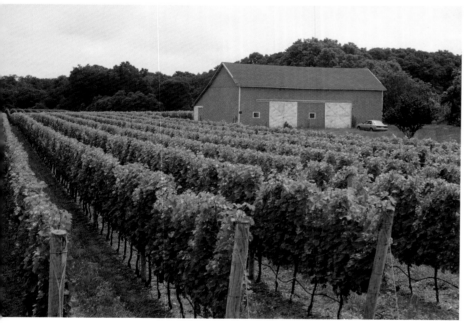

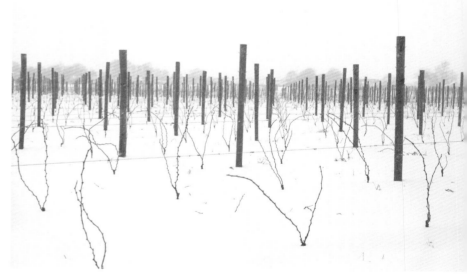

ABOVE: CUTCHOGUE
BELOW: CUTCHOGUE

ABOVE: CUTCHOGUE
BELOW: RAPHAEL, PECONIC

OPPOSITE: RAPHAEL
TASTING ROOM, PECONIC

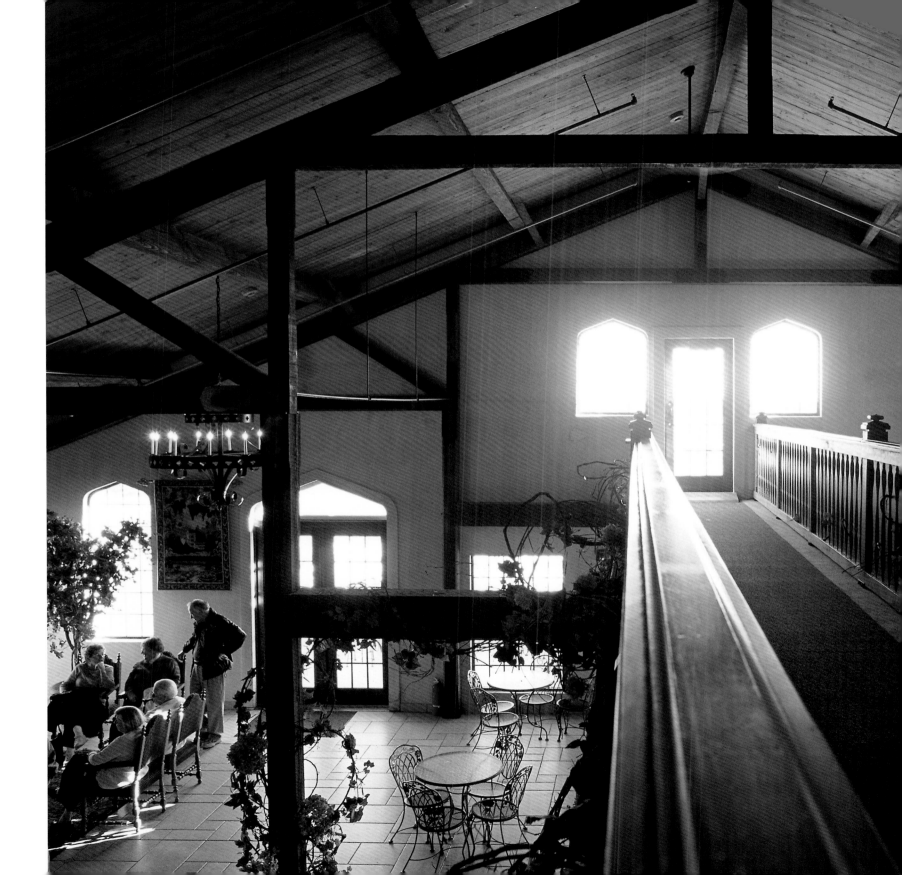

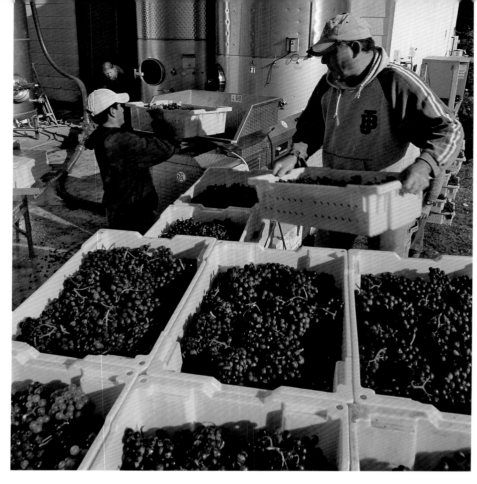

OPPOSITE: MATTITUCK

THE LENZ WINERY, PECONIC

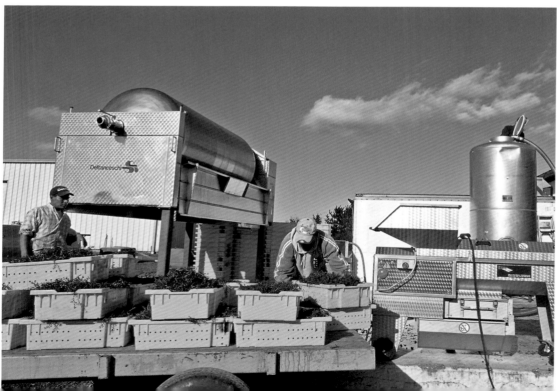

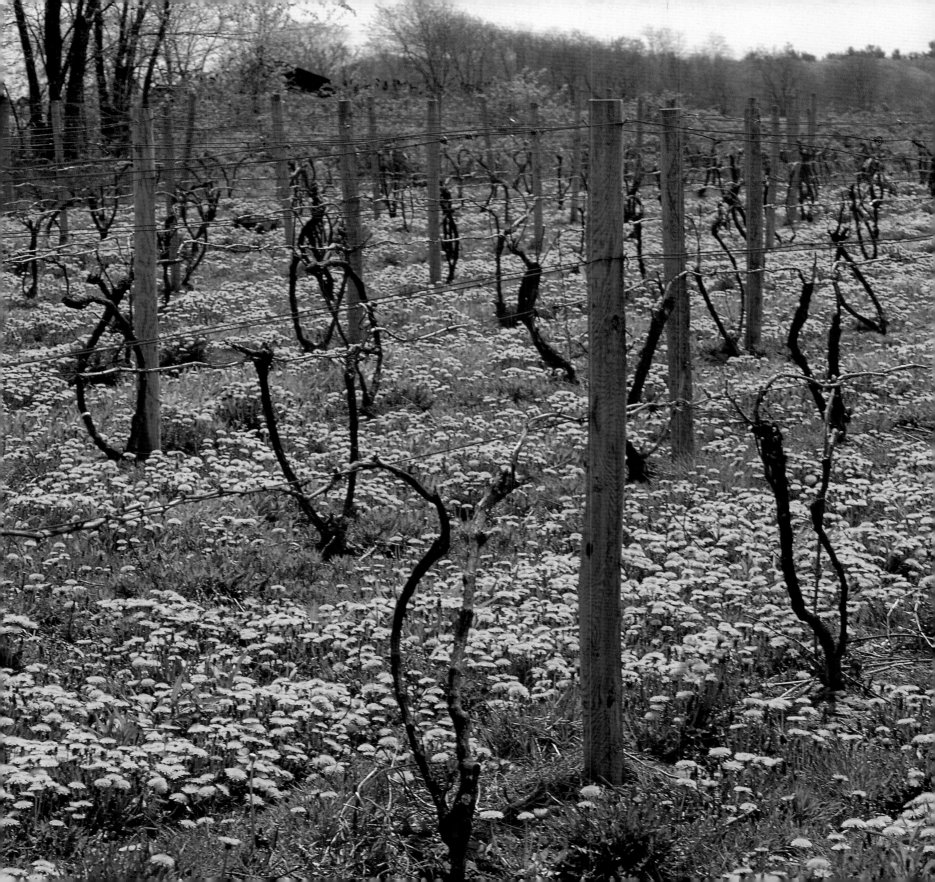

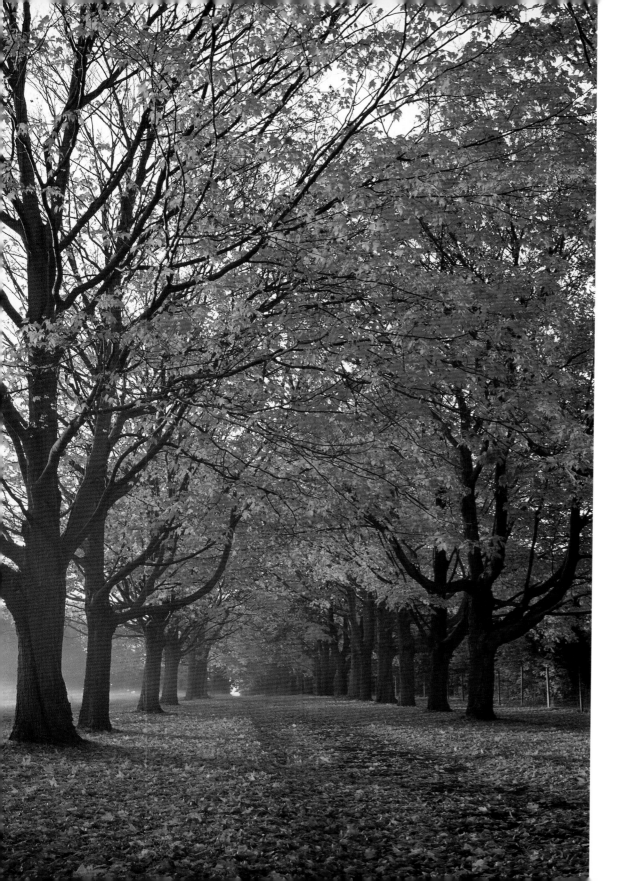

GREENPORT

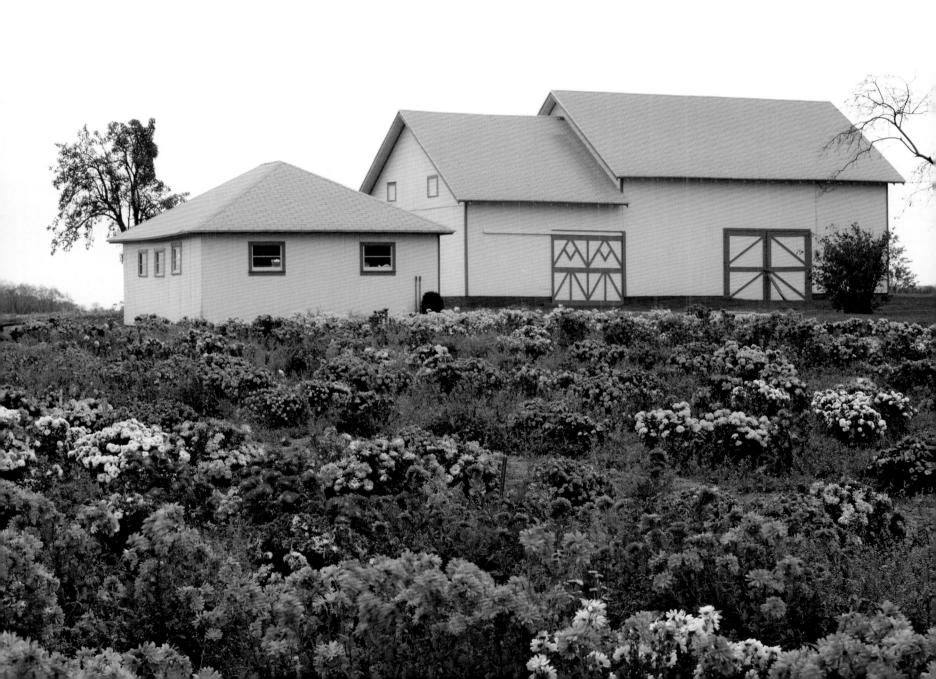

OPPOSITE ABOVE: ORIENT
OPPOSITE BELOW: CUTCHOGUE

ABANDONED TRUCK, PECONIC

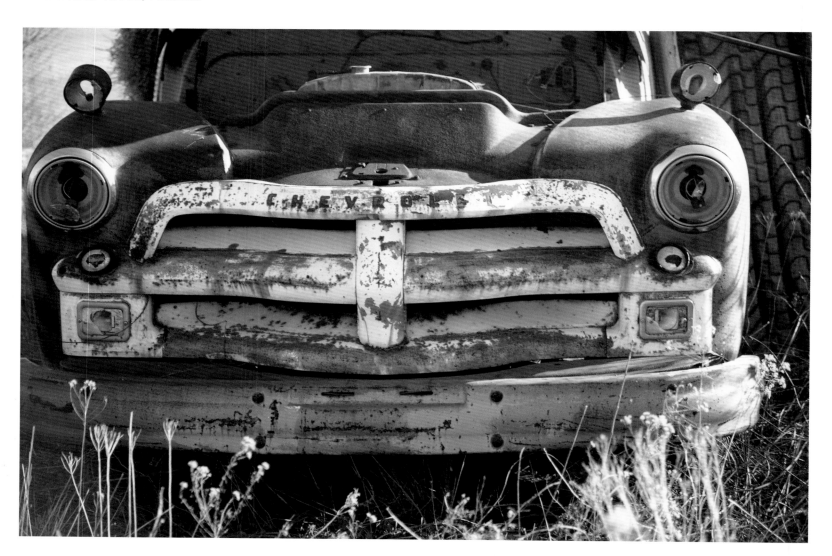

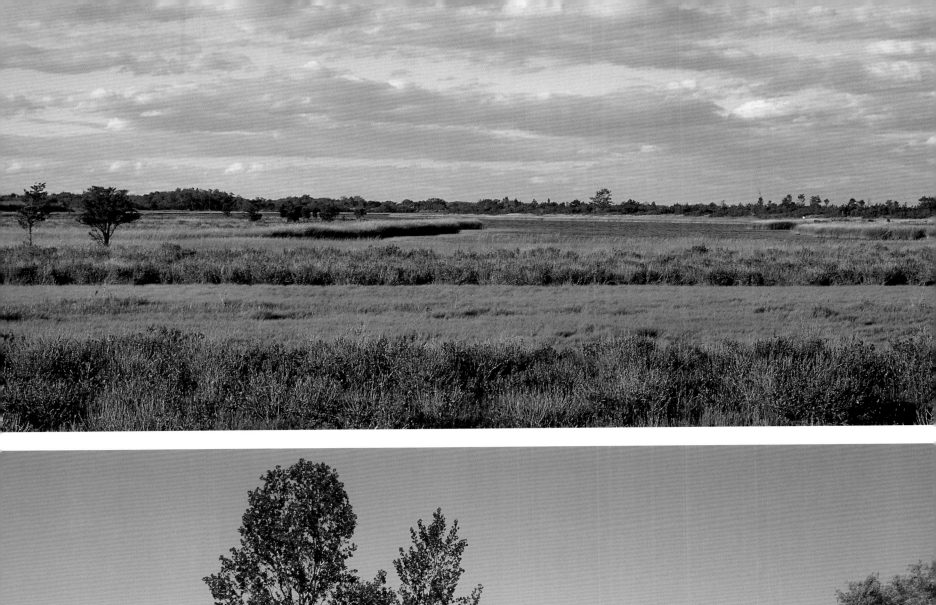

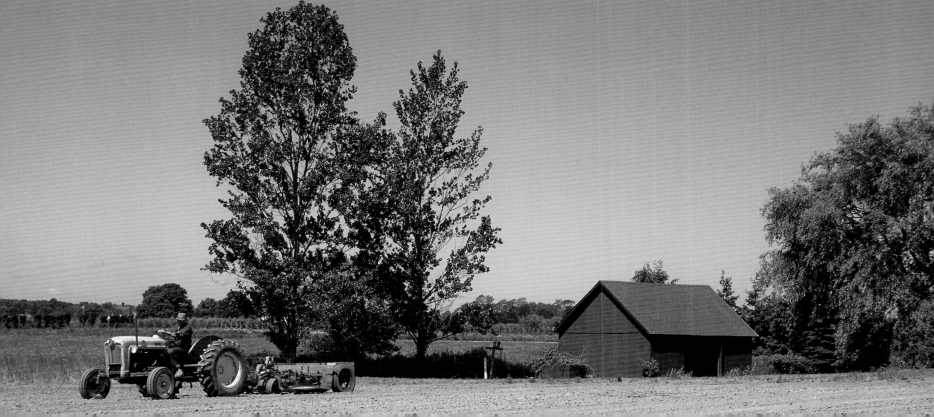

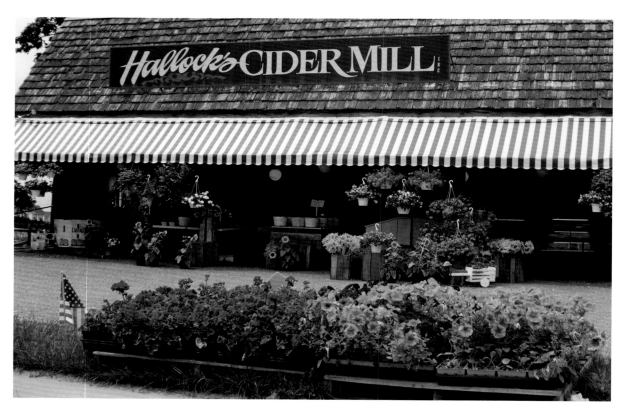

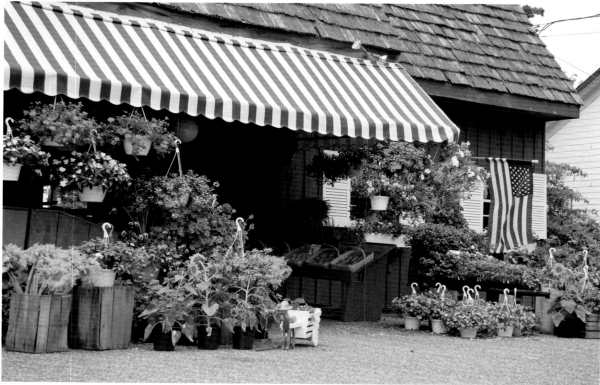

MATTITUCK

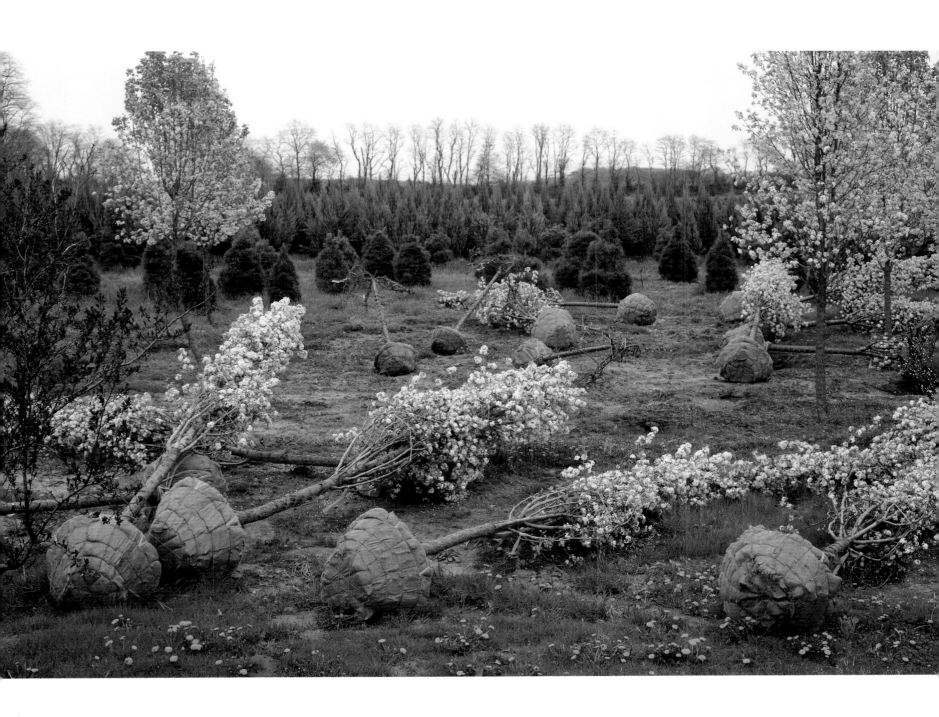

TREE NURSERY, CUTCHOGUE

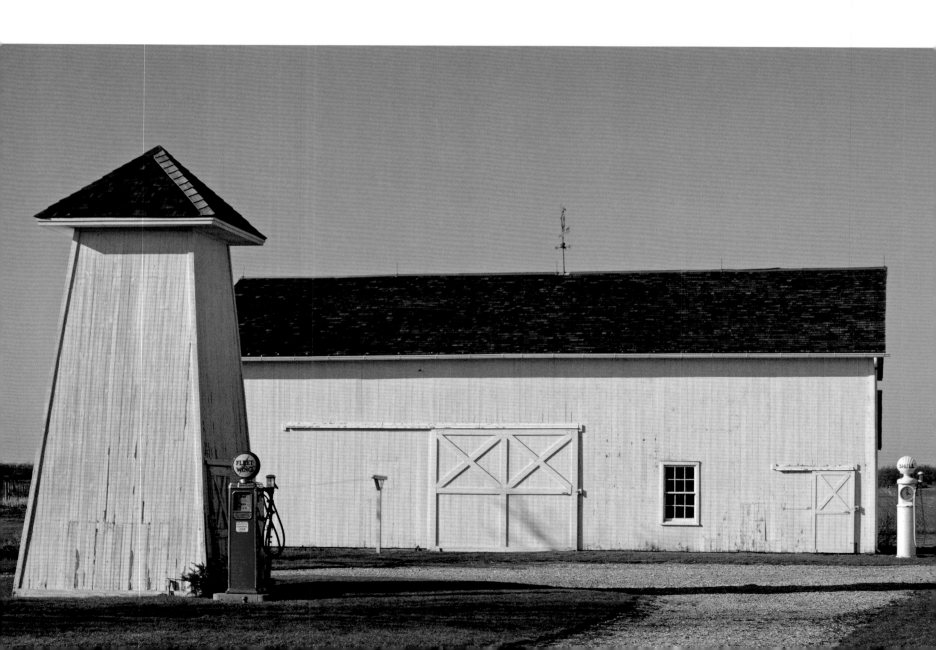

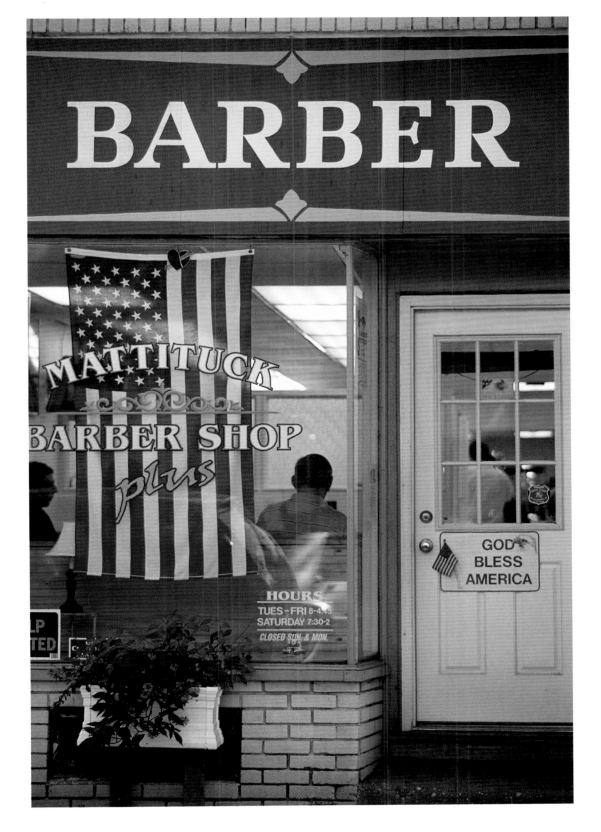

MATTITUCK

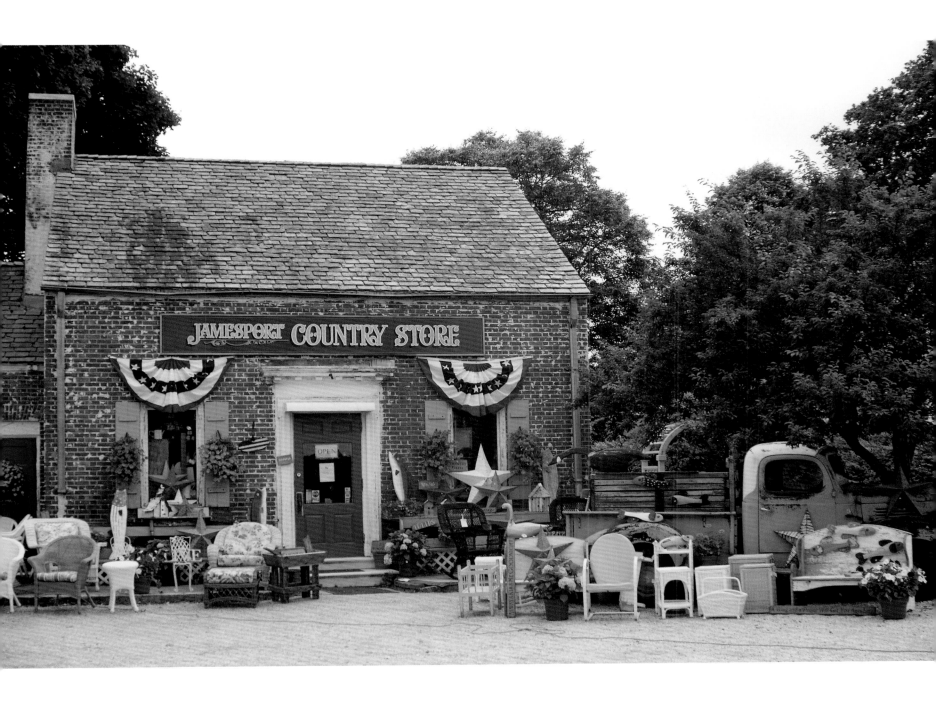

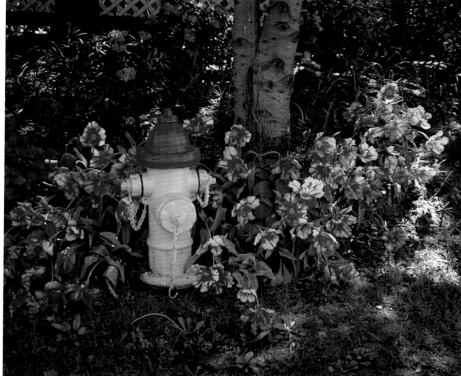

GREENPORT

138

36

GREENPORT

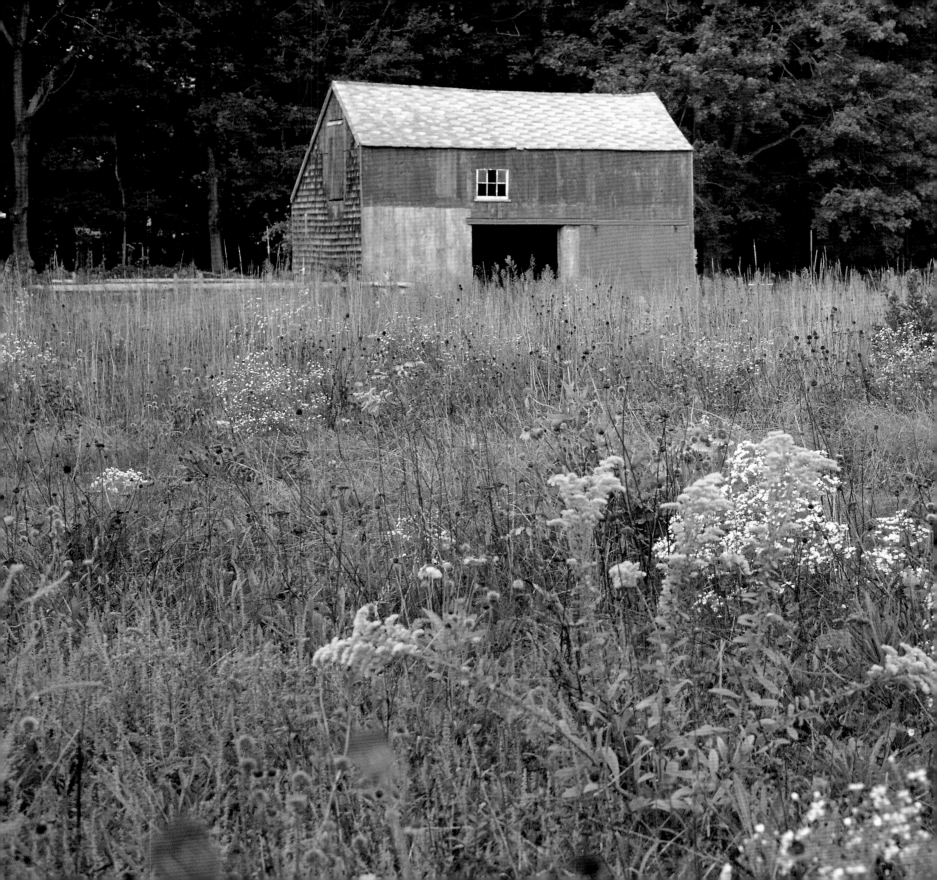

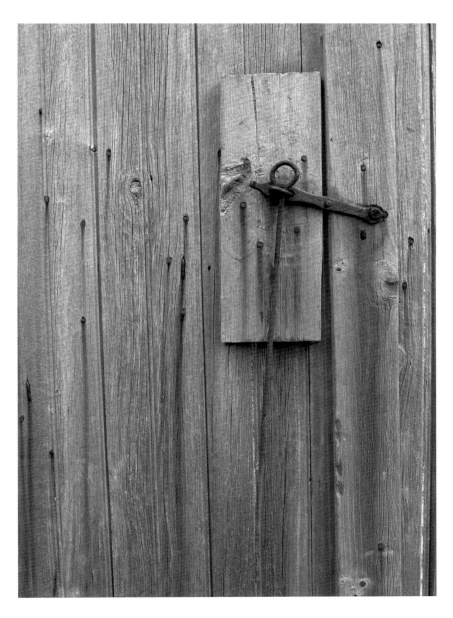

SOUTH JAMESPORT

THERE IS HISTORY EVERYWHERE YOU LOOK on the North Fork, whether it be in the architecture, the simple or elaborate barns, or the local residents whose families have lived here for generations. Thirty-five years ago, life among the old timers was not much different from that of their fathers and grandfathers. I had an awareness then of a "living" history, much of which is gone now, but I still appreciate it to this very day.

BAY-SCALLOP FISHERMEN, ORIENT

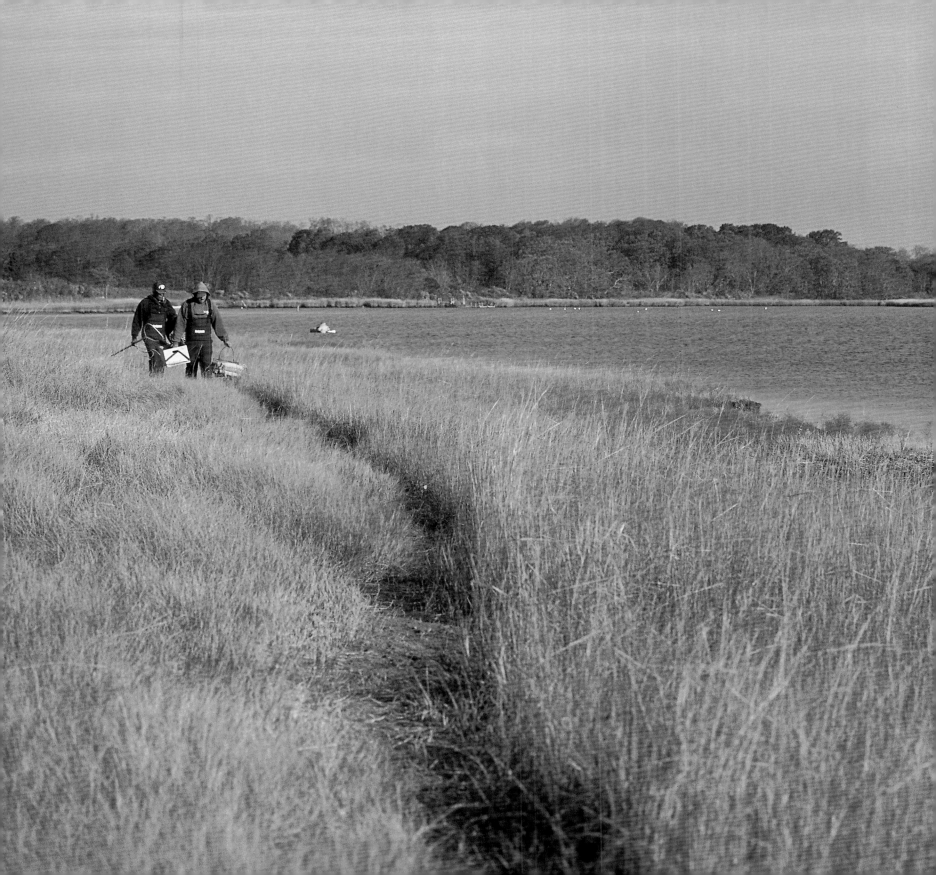

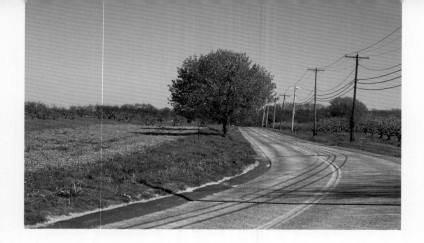

CUTCHOGUE

In the early 1900s, a group of artists from New York were lured here and formed the Indian Neck Artist Colony. Irvine Wiles started the school. Among the group who maintained summer studios here were Henry Prellwitz, whose house still stands; Benjamin Fitz, a painter who lived in Peconic whose works are in the collection of the Metropolitan Museum of Art; and Edward August Bell. Bell's cottage, named Bell Buoy, still stands at the end of Indian Neck Lane. Such a beautiful spot! I once photographed from its terrace the splendor of dawn breaking over Peconic Bay. The spirit of that moment has never left me (see page 160).

William King played host to many parties attended by these artists in his house on Indian Neck Lane. Isadora Duncan danced on his lawn and Archibald McLeish wrote poetry there. McLeish was a boyfriend of my neighbor, Miss Hazel King, back then. Before she died, Miss King passed on to me a poem that he wrote while in college. I noticed there were handwritten changes on it. I asked her if McLeish had made the changes. Miss King, with a twinkle in her eye, said, "No, I did, and don't you think I improved it?"

Whitney Hubbard, who lived in Greenport at the time, attended the Art Students League in New York City along with some of the other artists of the Peconic group. In 1914 he had his first exhibition of his paintings, which was a success. He went on to have exhibitions at the National Academy of Design in New York, the Art

Institute of Chicago, and the Brooklyn Museum. Although he achieved national acclaim, by the 1930s he was all but forgotten. He died in 1965. A dear friend of mine, who is a relative of Hubbard's, remembers that when the family tried to sell his paintings in a yard sale in order to pay for his funeral, they couldn't collect even $5.00 for them. It's fortunate that they didn't—now they're worth thousands of dollars.

Change is rarely easy, no matter which generation you grew up in. When streetlights were introduced to my little lane in the 1970s, my ninety-year-old neighbor, Miss King, came to me in a panic and asked, "Do you suppose it is all right to put streetlamps on our lane?" Miss King, as she liked to be called, lived to be 106. She had lived through the birth of aviation, watched the moon landing in 1969, and had witnessed all the extraordinary advances in modern science and medicine, and yet she had a major problem with the introduction of streetlights on her lane. To her, change was fine, as long as it wasn't too close to home! Miss King was born in the late 1800s, her father in the mid-1800s, and her grandfather in the early part of that century, and they all lived here on the North Fork. Her grandfather may have known people who lived during the American Revolution. She shared with me her father's account of

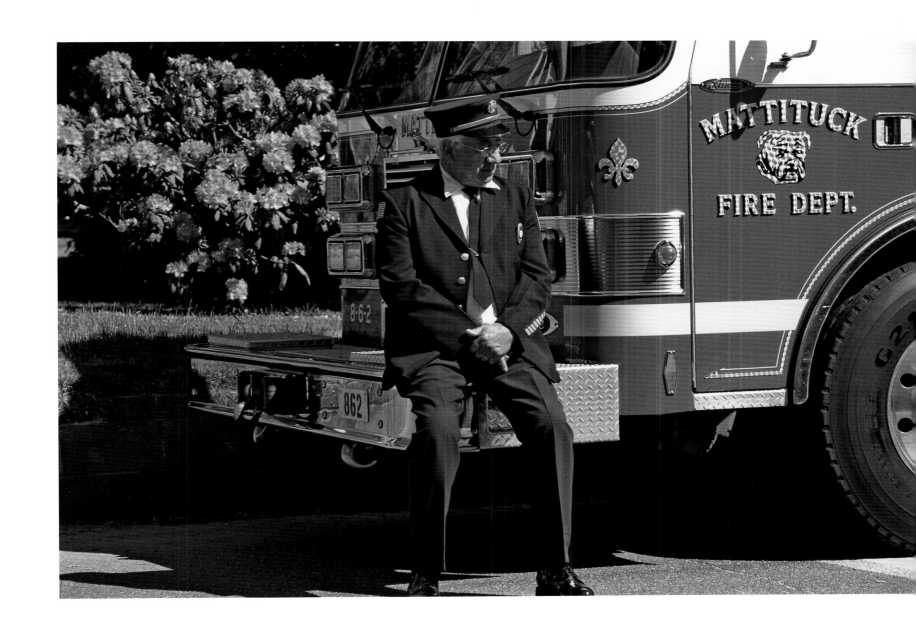

RETIRED FIREMAN, MEMORIAL
DAY PARADE, MATTITUCK

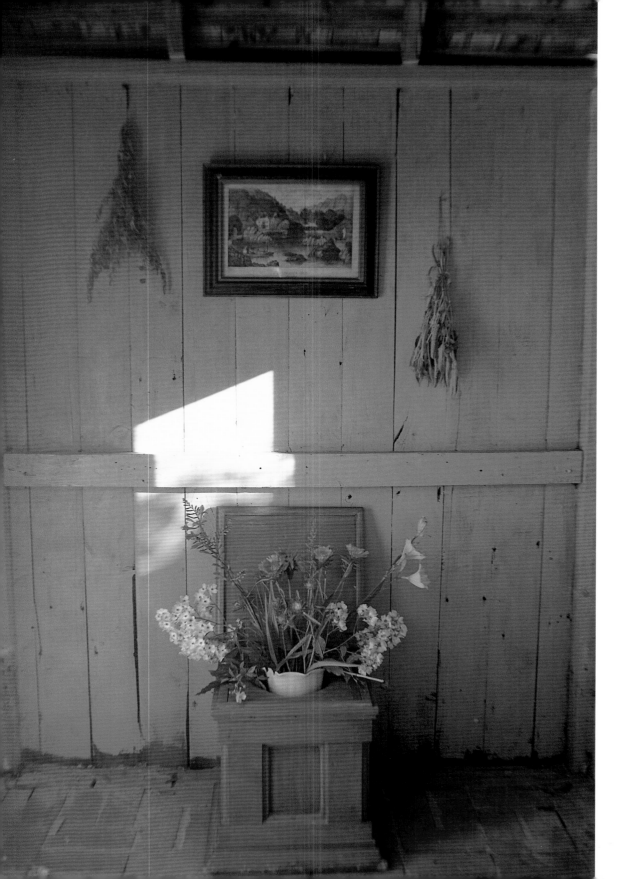

AUTHOR'S OUTHOUSE, PECONIC

the assassination of President Lincoln and how farmers in the area painted their mantlepieces black in mourning for the president. (When I was stripping away the many layers of paint on my own mantelpiece, I came across a layer of black, of which I saved a small patch as a reminder of Miss King's story.) The North Fork used to be full of characters like Miss King.

Miss King had a friend named Francis. Francis was rebellious and bohemian, with something of a past. One day I saw Francis in the post office, and she said to me, "Darling, do you know what day it is today?" Before I could answer, she said, "It's my birthday, and I am eighty-nine." Naturally, I wished her a happy birthday. Later that very day, I saw Miss King and I told her that I had just seen Francis and that today was her birthday. With a grunt Miss King said, "How old did she say she was?" I told her. Miss King replied, "She's a damn liar. She's ninety-two."

Another character was Sophie. Sophie lived in Southold where she converted part of her downstairs farmhouse into a pizza restaurant/bar. Only the locals knew about it and Sophie would make you pizza only if she liked you and only if she was in the mood to make it. The bar was literally in her living room, where she loved to watch television with the front door open. I was there once while she was watching *Wheel of Fortune* from her recliner, and so I had to wait for the puzzle to be solved before pizza was served. People went to Sophie's place more for the experience of Sophie

than for the pizza. Sophie's old farmhouse had a history. Walt Whitman once spent a summer teaching there. He left town rather unceremoniously after a scandal involving a young local lad, or so the story goes. According to Sophie, he was tarred and feathered before he left!

There is also the story about a New York City woman who went to the local seafood market and ordered some lobsters. When she saw them, she rejected them and insisted on having the red ones "like you get in New York." She was shown the door.

Yard sales are fun to explore in summertime on the North Fork. Avid yard-salers buy the local paper, which comes out every Thursday, look up the listings, and map out the ones they want to check out the night before they head out. Most yard sales are on Saturday and usually begin at 8:00 a.m. Some people specify "no early birds," but that doesn't stop a few from trying. If you're not a serious yard-saler and just want to browse, look for signs on the road—you never know what you may find. I've discovered areas of the North Fork I never knew existed while seeking out yard sales.

If you want to get rid of stuff in your house, consider conducting a yard sale of your own. For a small fee, you can obtain a permit from the town. Whenever I've had a yard sale, I've tried to

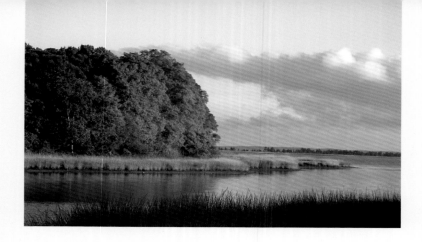

RICHMOND CREEK, PECONIC

make it as entertaining for myself as for those attending. For one yard sale, I invited friends from the city to help me and suggested they bring whatever they wanted to sell. Elaine, who is an artist with a rather statuesque figure, wore shorts that were rather too short with spiked heels and a T-shirt depicting the American flag. Old Glory was never more prominently displayed. She brought her mink coats to sell. She would say, "Hi, I'm into erotica like everyone else—what are *you* into?" and usually followed that with, "I'm recording my entire summer in Polaroid—may I take your picture?" I can imagine what went through locals' minds when they heard that. To make the situation even more comical, next to Elaine sat my eighty-year-old neighbor selling her homemade pickles to benefit her church! Another friend brought her collection of Chinese erotic drawings. And we had lots of books. One of them was an illustrated edition of the Kama Sutra, which I priced rather high. An elderly woman, accompanied by what appeared to be her daughter, picked up the book, leafed through it, and handed the book to her daughter, saying, "Here. I'll buy this for you. Maybe it will help." We played music throughout the day and we managed to get rid of a lot of junk. Needless to say, Elaine's mink coats did not sell.

Albert Einstein summered on Old West Cove Road in Nassau Point in 1938 and 1939. A friend of mine who was born in New Suffolk remembers seeing him there. My friend's mother, not realizing who he was, would warn her son not to wander off to the beach because a strange-looking man with wild, white hair had been spotted walking barefoot there. Another Einstein-related story concerns a Southold hardware store owner, Mr. David Rothman. I met Mr. Rothman while doing a story for the *New York Times* shortly before he died. According to Rothman, Einstein came into his store to buy sandals, but Rothman mistook his pronunciation of sandals as sundials, and so Rothman proceeded to show him several sundials that he had on hand. After they straightened that out, they began to chat and discovered that they shared a common interest in playing the violin. Rothman invited Einstein to his house to play, and they soon became friends. One summer evening, while relaxing on the porch with Einstein and another scientist, Einstein proclaimed that his theory of relativity was so simple that even a simple store merchant like Rothman could understand it. Rothman showed me the piece of paper Einstein used to explain his theory—not surprisingly, it's filled with scribbled diagrams and notations. The Southold Historical Society has on display a group of letters from Einstein to Rothman in which he talks about their musical activities; physics; his boat *Tineff*, which in Yiddish means "worthless"; as well as the desperation of Dr. Elfenbein, a physicist who was stuck in Nazi Germany.

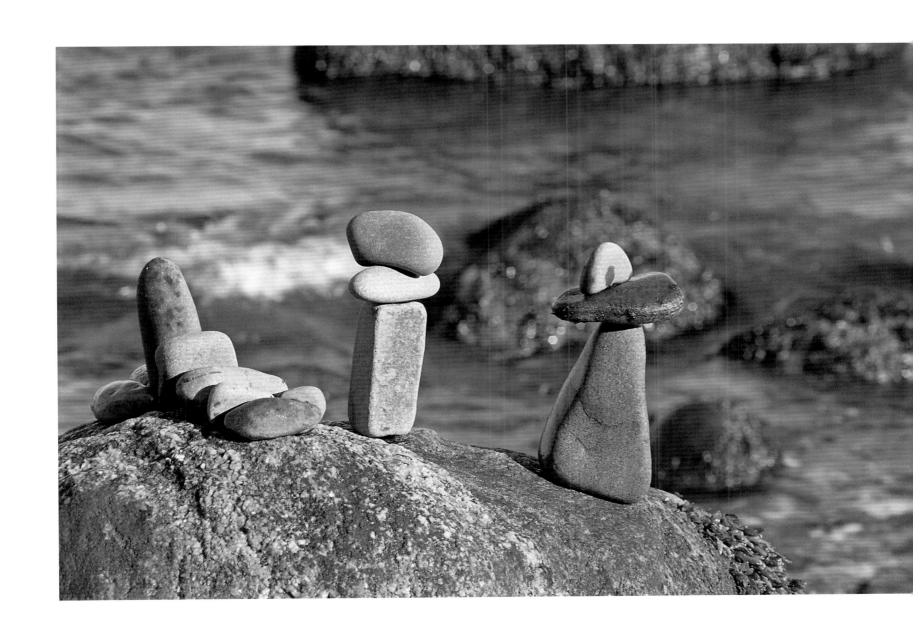

STONE SCULPTURES, SOUTHOLD

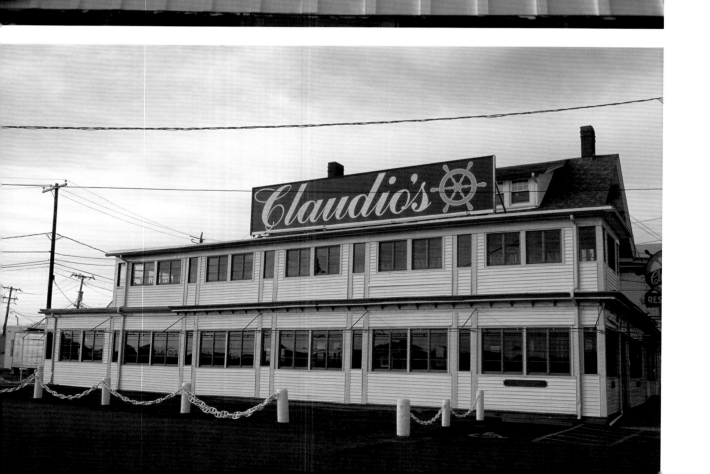

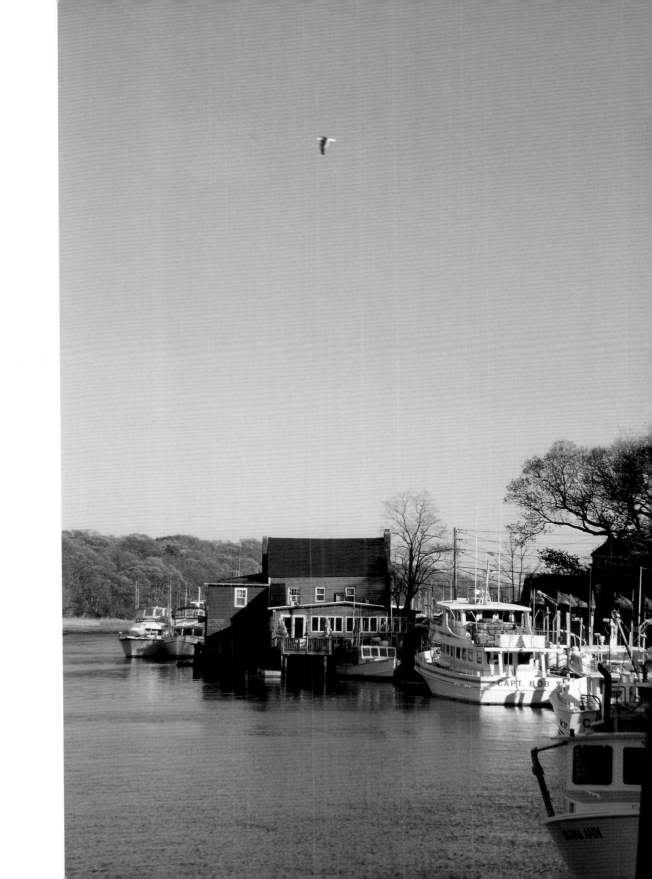

THE OLD MILL INN, MATTITUCK

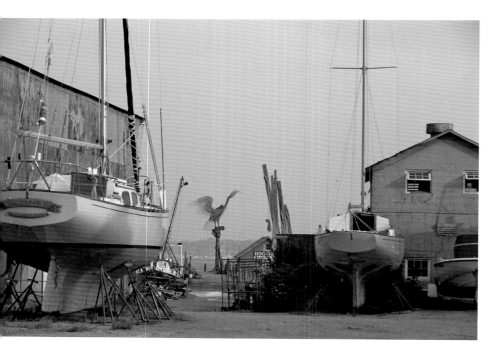

GREENPORT

GREENPORT

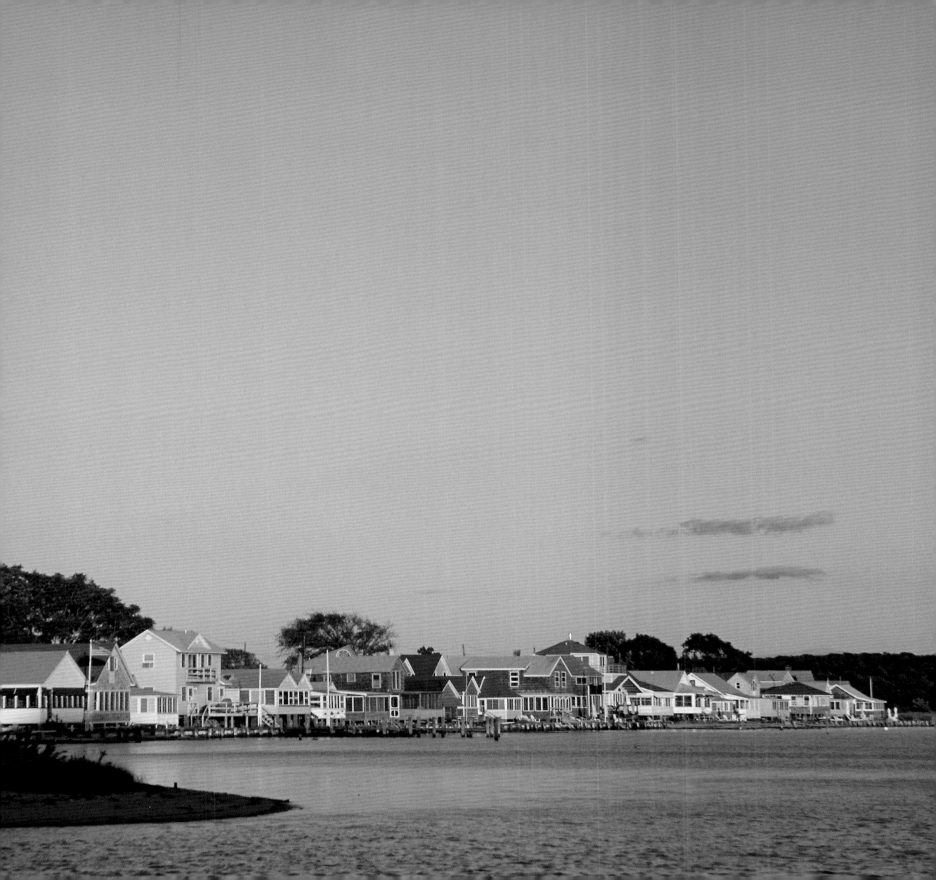

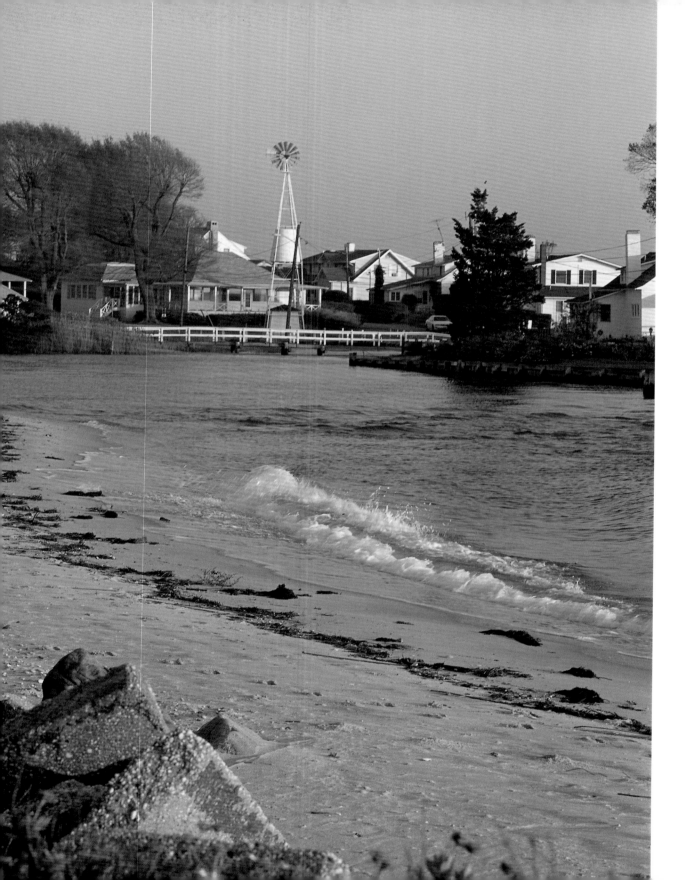

KIMOGENER POINT,
CUTCHOGUE

OPPOSITE: SCALLOPING
NEAR ORIENT

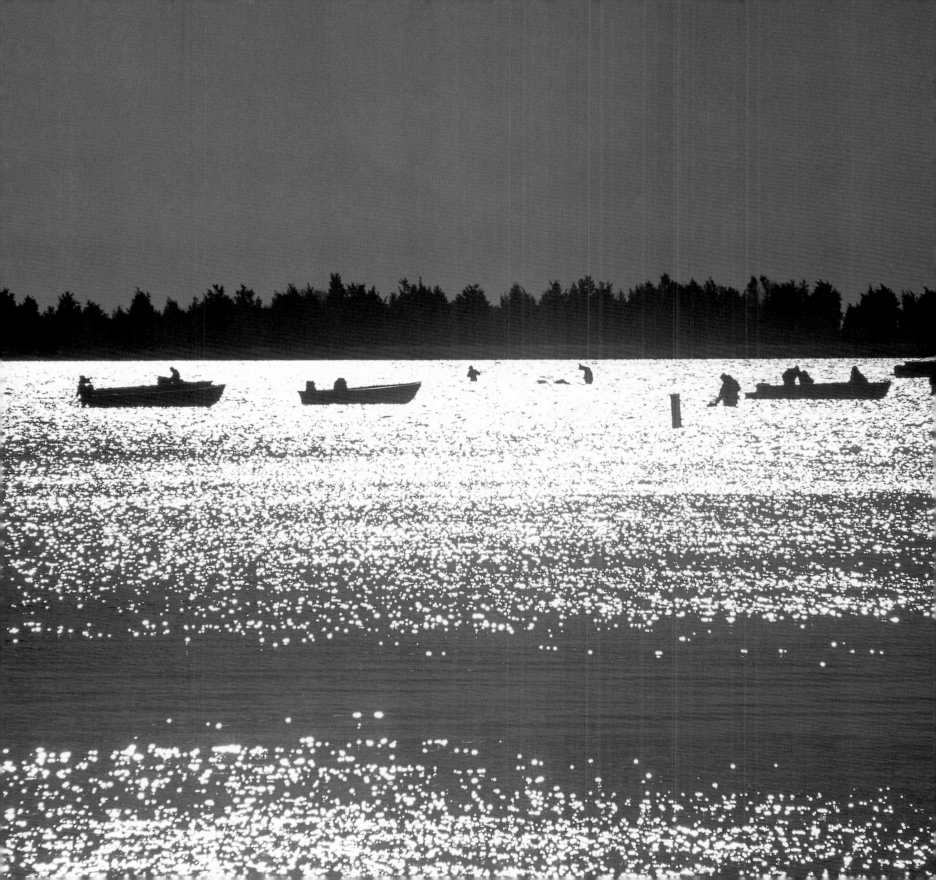

AQUEBOGUE

MATTITUCK

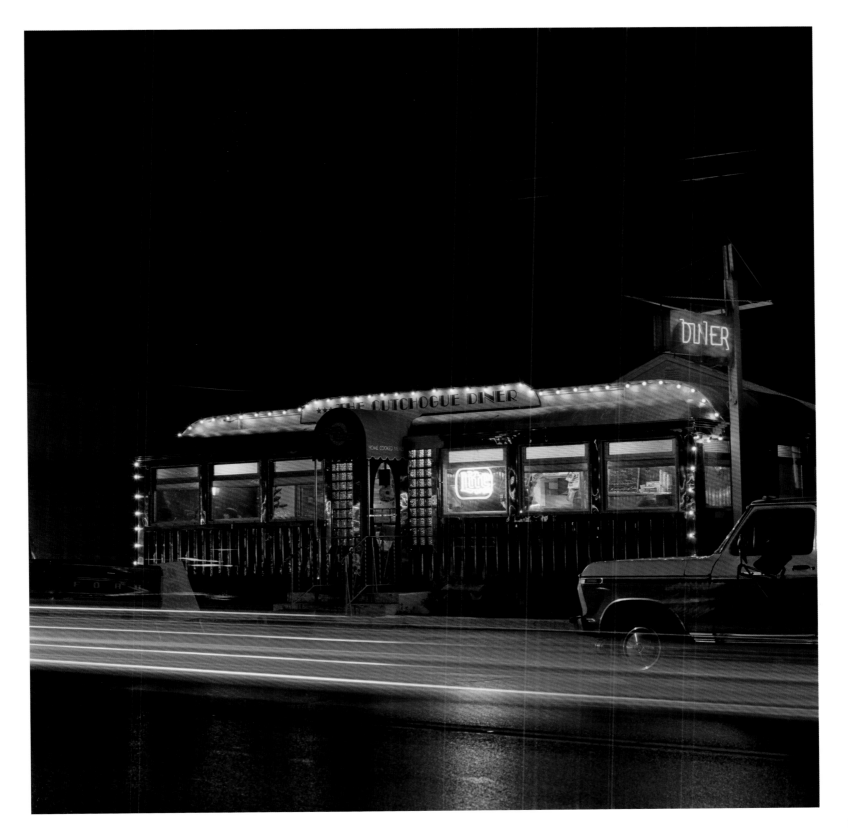

157

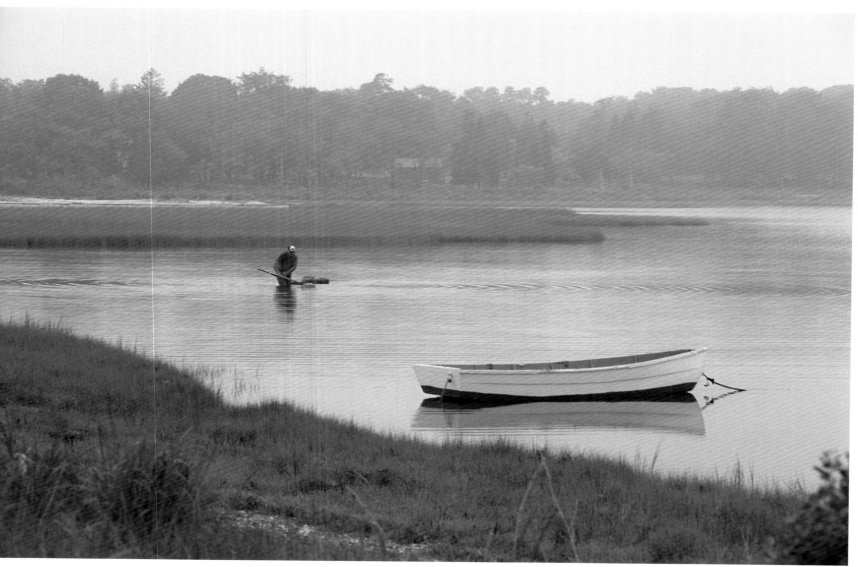

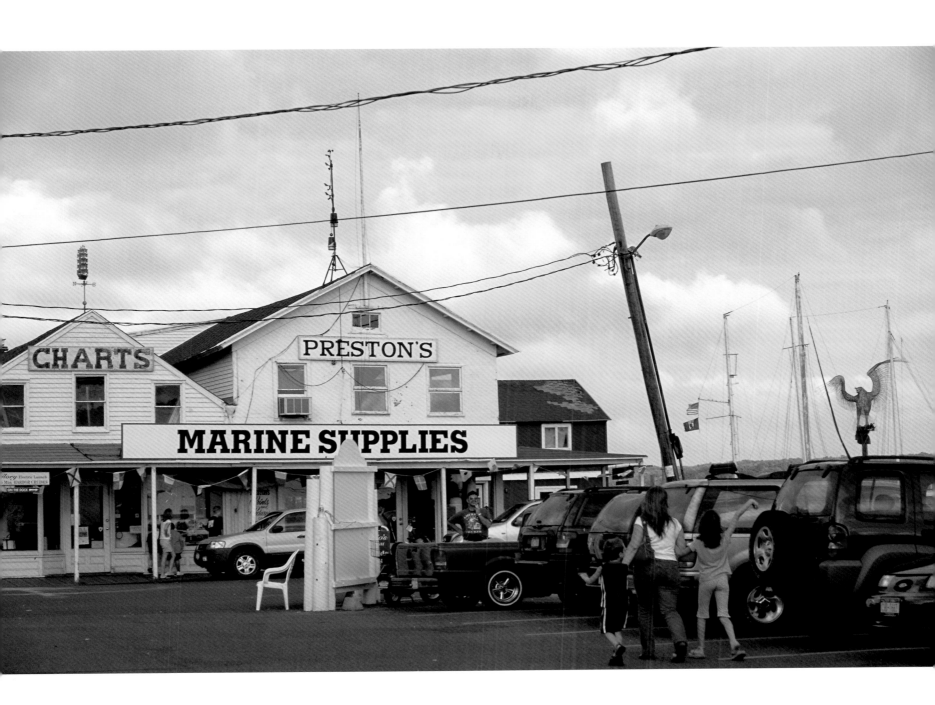

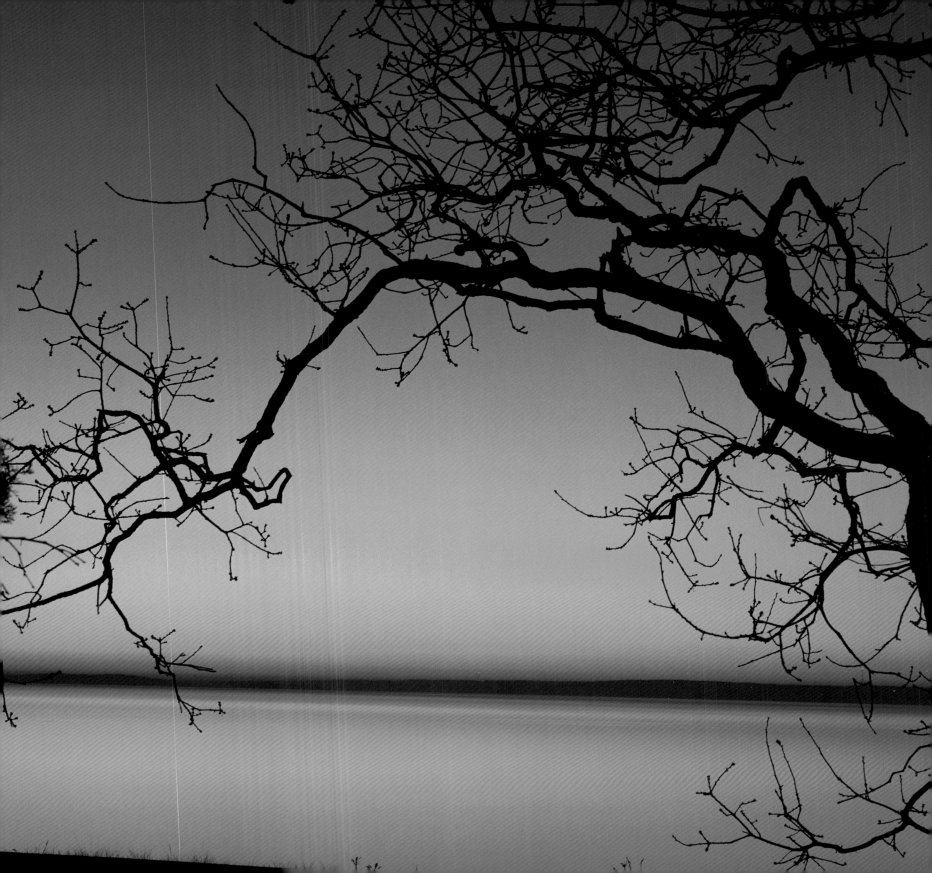

KIMOGENER POINT,
CUTCHOGUE

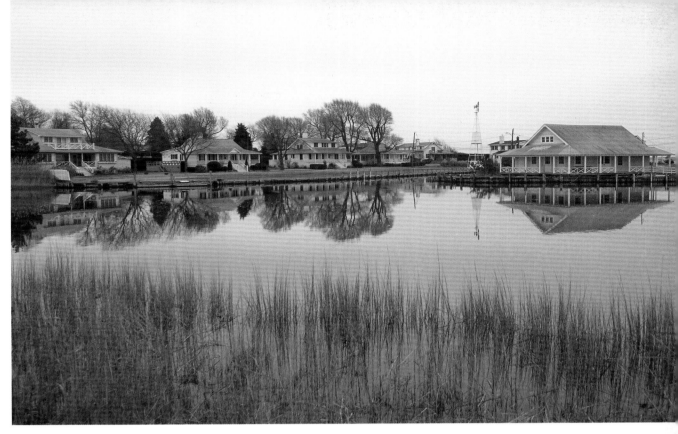

AQUEBOGUE

OPPOSITE: PECONIC BAY

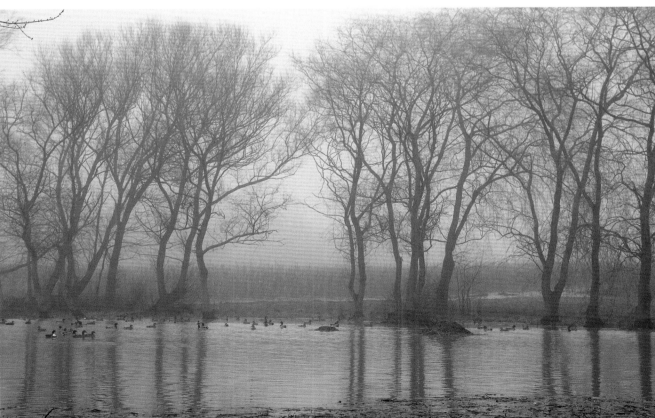

GREENPORT

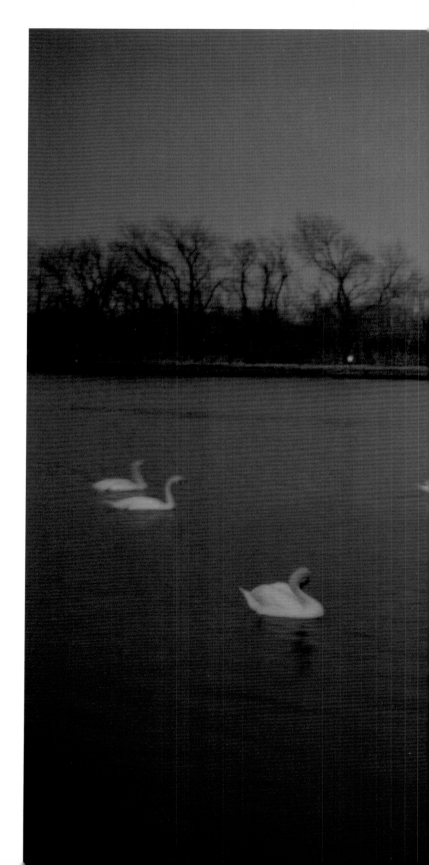

ORIENT

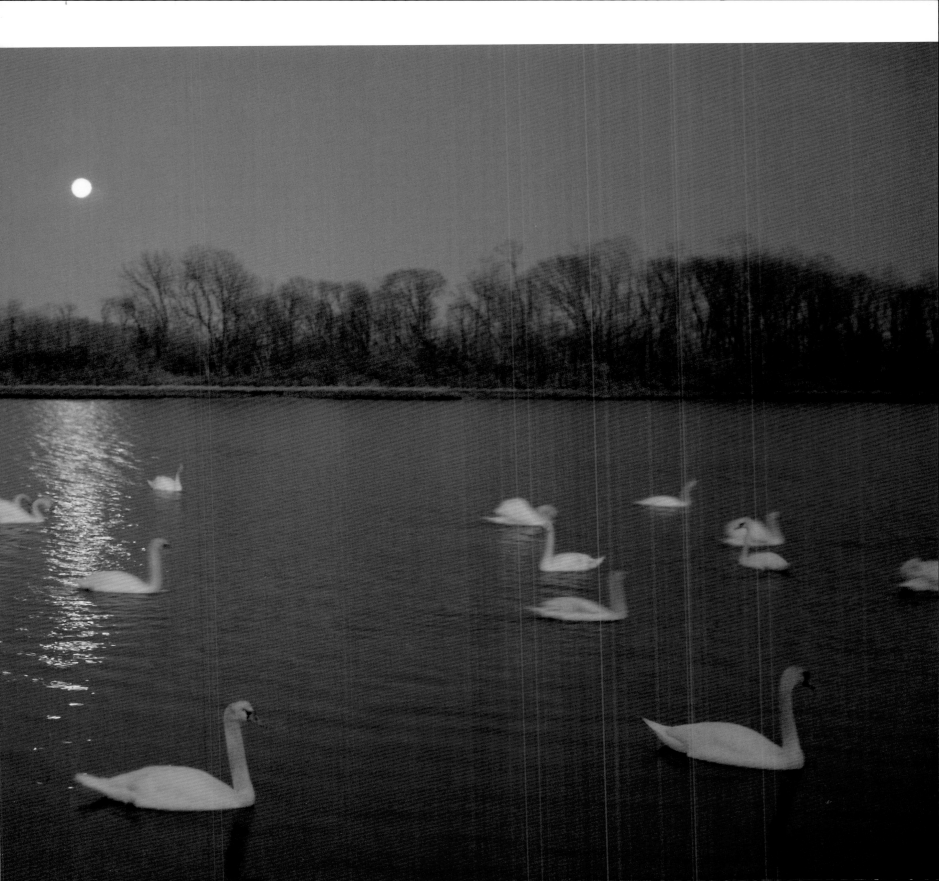

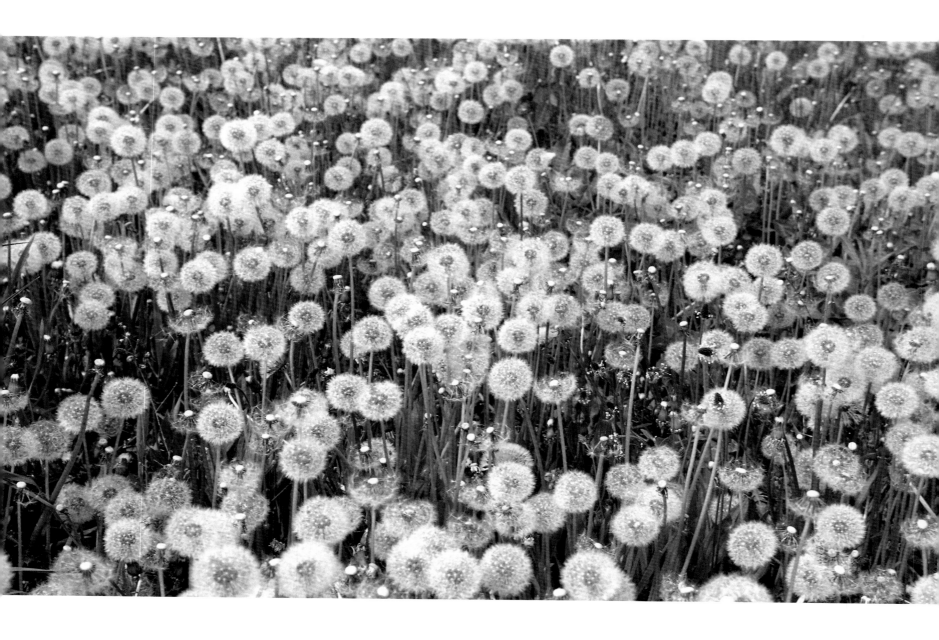

NEW SUFFOLK

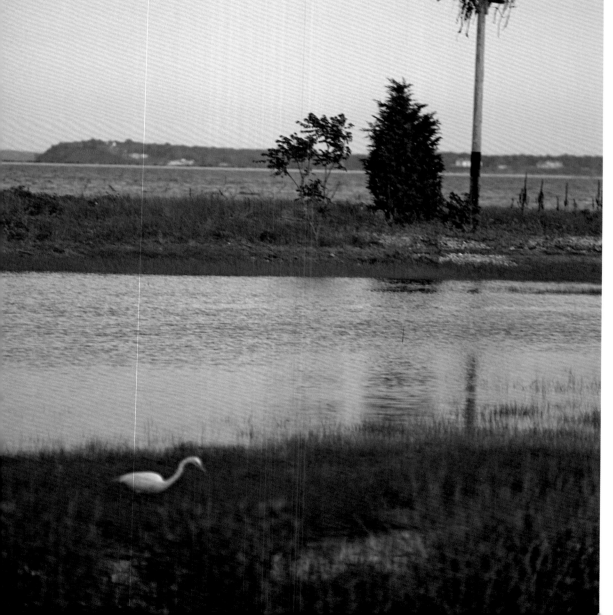

OPPOSITE: GREENPORT

POINTS OF INTEREST
A BRIEF GUIDE TO THE NORTH FORK

Although the North Fork is a picturesque region, there are a few special points of interest that one should visit whether by car, bicycle, or on foot.

HORTON POINT LIGHTHOUSE AND NAUTICAL MUSEUM

The Horton Point Lighthouse is located off of Lighthouse Road in Southold. For the most scenic route, I suggest taking Route 48 to Mill Lane (Peconic) as a starting point. Head north to Sound Avenue, and then go east on Soundview Avenue (this road is parallel to Route 48). The locals call this road the Humpty Dumpty Road because of its undulating characteristics. This is a pretty tree-lined road (see page 2) that continues east and eventually intersects

with Route 48 (North Road) further east in Southold. Before you go to Horton's Point Lighthouse, I suggest that you take a little detour. From the intersection of Soundview Avenue and Mill Lane, head east on Soundview Avenue for approximately three miles. Look for a small parking area on the left where you will find the entrance to a reserve. Park your car and take the right path into the woods. This will take you across a small bridge and up a hill where you will get a glimpse of the Long Island Sound and the point where the Sound meets Goldsmith Inlet. This area is particularly beautiful during the peak fall display. Allow about forty-five minutes to enjoy a leisurely walk.

Continue east on Soundview Avenue. On the left you will pass two ponds — Great Pond and Lily Pond, respectively. The second street on the left will be Lighthouse Road. Make a

left (north) onto Lighthouse and take it to the end. Horton's Point Lighthouse is on the left (see page 27).

George Washington commissioned the construction of the lighthouse in 1790, but it was not until 1857 when the fifty-eight-foot lighthouse was finally built and activated. The lighthouse was deactivated in 1933, as it had become very run down. In 1976 restoration of the lighthouse began, and in 1990 it was activated once again. It is now open for tourists (weekends in the summer). Climb up to the top for a great view of the Long Island Sound and Connecticut. For information, call (631) 765-5500.

On the grounds of Horton's Lighthouse, near the parking lot, there is an entrance that leads you to a series of steps descending to the beach on Long Island Sound. Take the wooden steps to the rocky beach

below and walk along the water's edge among the huge boulders scattered along the shore. This is a wonderful place from which to view the magnificent sunsets, and chances are you won't see another soul while you're there (see pages 18–19).

ORIENT AND ORIENT POINT STATE PARK

Take Route 48 East, which becomes Route 25 when you reach Greenport. Continue east, first passing East Marion and then crossing over a narrow strip of land with the Long Island Sound to the north and Gardiners Bay to the south. When you reach the town of Orient, make a right hand turn at the Civil War monument onto Village Lane. This will take you through the village of Orient, a picturesque village that has

a feel of the Old World and a population of eight hundred. It's like stepping back in time. Orient is an outdoor museum of seventeenth-, eighteenth-, and nineteenth-century architecture. In 1977, the Orient Historic District was placed on the National Register of Historic Places by the United States Department of the Interior. The most notable historic buildings include two nineteenth-century schoolhouses: the Village House, built in 1790, and the Web House, built in 1720. Be sure to see the Slave-Buying Grounds located on Narrow River Road. The plot contains the graves of twenty slaves as well as the graves of their owners, Seth and Maria Tuthill.

Take Narrow River Road heading north. This is a beautiful road winding through woods with tree nurseries on one side and unspoiled wetlands on the other. This is a good place for birdwatching. Halfway down the road there is a short but scenic trail worth taking with views of the wetlands (see page 131, top). Continue on Narrow River Road heading north and then east, make a right turn at the intersection of Route 25 and look for the

entrance to Orient State Park, just before the New London Ferry terminal.

The entrance to Orient State Park is just west of the New London Ferry terminal on Route 25. The drive from the entrance to the beach is spectacular. The landscape, which covers 357 acres, is both unspoiled and diverse. This maritime forest is made up primarily of majestic Blackjack oak trees with a scattering of red cedars and prickly pear cacti. The manmade platforms for Osprey nests are the only hint of the presence of humans. There are wetlands and marshes and ten miles of beachfront with views of Gardiner's Bay and Shelter Island Sound. Nature trails give you glimpses of the interior, as well as breathtaking views of marshes, another excellent place for bird watching. Look for Ospreys either perched on platforms or diving for fish. Environmental tours are offered, as well as bicycle rentals. The park is open seven days a week, sunrise to sunset. Call (631) 323-2440 for more information.

NEW SUFFOLK

New Suffolk Avenue is one of the most scenic roads on the North Fork. I suggest taking Route 25 to Cutchogue and then heading south on New Suffolk Road. Almost immediately after you pass the Cutchoque Firehouse on the right, you will see acres of fruit orchards. In May, the peach and apple blossoms are gorgeous and the fields along the winding road are ablaze with color. Continue on this road and turn left (east) on Harbor Road for a quick detour. At the end of the road you will see the Old Cove Yacht Club with views of Peconic Bay and Nassau Point. Continue on New Suffolk Road heading south again and look for the New Suffolk Ship Yard on the left, where there is another view worth seeing. Further down the road is the Old New Suffolk School, in continuous use as a one-room schoolhouse since it was built in 1907. Make a left turn at the blinking light a few yards down the road and go to the end. At your left is the waterfront area of the charming fishing village of New Suffolk situated on Peconic Bay.

After exploring the area, go back to New Suffolk Avenue and head west. You will go over a series of three bridges. At the foot of the first bridge you will see the landmark Kimogenor Windmill (see page 86). It was built in 1906 and has survived the wrath of hurricanes Belle, Gloria, and Bob, and even the Great Storm of 1938. In the year 2000, a freak tornado bent its top like a pretzel, but it has been restored.

On the right side of the bridge is Frank A. Kawaski Jr. Preserve at Downs Creek. It is a breathtaking spot year-round. A wide variety of bird species inhabit the area; it's also a good place to kayak or canoe. In the summer you often see people fishing off the bridge. On the power lines, dangling above the bridge you see fishing hooks and lures left behind by inexperienced fishermen. Continue on that road and go over the next bridge. Take in the spectacular scenery and vistas of Great Peconic Bay and Robins Island. Continue on the same road west, passing through farm fields. You will eventually meet Route 25 in Mattituck. If you're looking for bike routes, I suggest you park your car

at the railroad station in Mattituck and cycle the route described above in reverse. You will finish at Route 25 and New Suffolk Road.

Head east (right) on Route 25 to Cox Lane, only a short distance away (0.7 miles), and go north (left). You will pass through tree nurseries, farms, and vineyards. At a T intersection is Oregon Road. Head west (left). Oregon Road is mostly farmland and vineyards, and you'll encounter very little traffic. Oregon Road becomes Mill Road at its completion. Take Reeve Road only a short distance south (bear to the left) and Reeve Road will become Grand Avenue. This will take you to Route 48. From there, head west (right) to Love Lane and make a left on Love Lane, just over the railroad tracks; on the right you will find your car. There are fifty-seven miles of bicycle routes to take that are outlined in the Southold Town Transportation Commission's pamphlet and map. You can find it at Town Hall. The various routes cover the hamlets from Mattituck to Orient.

CUTCHOGUE–NEW SUFFOLK FREE LIBRARY

Located on the corner of Route 25 and Cases Lane in Cutchogue is the Cutchogue–New Suffolk Free Library, built in 1862. Originally an Independent Congregational church, which broke away from the Cutchogue Presbyterian Church, it was converted into a library in 1914. In the 1980s, the library was both expanded and renovated. This work was done over the period of a few years and in 1994 it was completed. The charm and character of the building was maintained while the expansion provided all of the amenities of a modern library.

CUTCHOGUE VILLAGE GREEN

Five buildings are maintained by the Cutchogue/New Suffolk Historical Council, among them the Benjamin Horton House, built in 1640 and moved much later to its present location; an 1840 schoolhouse; and an 1890 barn. The Benjamin Horton House is the centerpiece of the com-

plex and is one of the oldest frame houses in America. Free tours are offered in the summer months. Be sure to attend one of their summer evening band concerts under the stars, held on the green.

Through the efforts of government and organizations, such as the Peconic Land Trust, and private donations, tracts of land and waterways are now preserved for not only wildlife and plant life but for future generations. Below are some of the more notable ones.

DOWNS FARM PRESERVE AT FORT CORCHAUG

Fort Corchaug is a Native American Indian site that dates back to the early 1600s. It was built by the Corchaugs, whose culture can be traced to 1000 BC. It encompasses fifty-one acres, was acquired by the Town of Southold in 1997, and is considered to be a significant archaeological and educational site. There are peaceful woodland trails lined with some white oak and hickory forests and tidal wetlands. Efforts are

made to remove invasive plants in order to restore it to its natural floral and faunal state. To the east is Downs Creek and to the north Route 25. The development rights to the farmland west of this site were sold to the Suffolk County Farm Program, ensuring that the land will not be developed.

ARSHAMOMAQUE PRESERVE

The Town of Southold and the Peconic Land Trust made this 128.4-acre preserve possible. It was opened to the public in 2004. There are three trails that wander through a variety of ecosystems, including forests of oak, hickory, maple, white pine, and American beech; freshwater marshes; and salt marshes, all of which harbor an abundance of wildlife. The trails have not been discovered by tourists yet, so you're not likely to see many people. Bring your binoculars and cameras for the abundance of birds to be seen here. The trailhead can be found on the west side of Chapel Lane in Greenport. For more information, call the Town of

Southold at (631) 765-5711 or (631) 765-1892.

RIVERHEAD

Downtown Riverhead has gone through a metamorphosis in the last six years. A large number of vintage buildings have been renovated, and old neglected treasures such as the Vail-Leavitt Music Hall in downtown Riverhead are now in the process of being restored. In 1998 the town established an art district in the downtown area and has allowed residential apartments to exist above storefronts as long as an artist occupies the space. The East End Arts Council is located here as well and acts as a forum for these artists-in-residence to exhibit their work.

The riverfront area of Riverhead is also undergoing a major revitalization. The Atlantis Marine World aquarium, which opened in 2000, was the first step in this process. Located on Main Street in Riverhead, it's a small but impressive aquarium, boasting the largest live coral reef in the United States, an 120,000-gallon shark tank, and seals. It is also a

research facility with interactive exhibits to both entertain and educate the public. Contact Atlantis Marine World at (631) 208-9200.

GREENPORT

There are many charming villages and hamlets on the North Fork, but there are only three, in my opinion, that have a distinct flavor. They are Greenport, Riverhead, and Orient. Greenport is the largest village in the Township of Southold. Colonists from New Haven, Connecticut, settled here in 1640. During the colonial period, Greenport became a commercial fishing center carrying goods across the sound to Connecticut. Greenport was known by various names throughout its early history: first as Winter Harbor, because its deep harbor was accessible to ships even in winter, and later as Stirling, in honor of Lord Stirling, a prominent landowner. In 1831, it was changed to Green Port since there were other settlements named after Lord Stirling, and soon after that combined to Greenport. In 1838, Greenport was incorporated as the Village of

Greenport. The areas where Front Street and Main Street now exist were the first to be settled.

The colonists learned from the Indians that menhaden, or bunker fish, could be used as fertilizer. This sparked both the fishing and menhaden-processing industries, the latter of which lasted until the mid-1900s and impacted Greenport tremendously. More ships were drawn to New York City, and thus to New England, as a result of this industry. A strong shipbuilding industry began to emerge in 1770, and whaling was big from 1795 to 1860. By 1838, Greenport was considered a prosperous, commercial town. By the time of World War II, over five hundred ships were built there.

During Prohibition, Greenport was notorious for rum running. It seems like most establishments built over water had a trapdoor located in the floor, under which a boat could easily glide to deliver the liquor. Shellfishing was a major source of income in the early part of the twentieth century until the 1960s. At one time there were fourteen oyster-processing companies in Greenport. Pollution from insecticides ruined the

industry, but the government, through various volunteer programs, is now reseeding the creeks, and the wild oysters are making a comeback.

Today, Greenport is the centerpiece of the North Fork and its most popular destination. It is the only village on the North Fork where one has the feel of a bustling town. There is a splendid Art Deco movie theater on Front Street and a magnificent Victorian building on Main Street that used to be an opera house (but is now, sadly, a furniture store).

The remnants of the old Greenport are still here. You only have to look for them. Take some of the side streets and explore. You'll see old shipyards with their rusty facades and many restored Victorian houses. On the docks near one of the shipyards is a twenty-five-foot sculpture of an osprey made from bronze wire, titled *Morning Call* by sculptor RJ Bessim. He used a beam from the World Trade Center for the bird's perch. Walk up to it and view it up close. Be sure to visit the Railroad Museum and the East End Seaport Museum for a taste of maritime history.

One cannot speak of Greenport without mentioning Claudio's dock

and restaurant. Manuel Claudio, a Portuguese whaler, arrived in Greenport in 1854 and sailed from here for sixteen years before he finally settled down. In 1870 he established Claudio's Tavern in a circa-1845 building. The building is now a National Historic Registered Landmark.

Preston and Son, like Claudio's, is another institution, established in 1880 as a nautical department store. You can't miss the building: "Preston and Son" is written in huge letters on its roof; "Preston's" is painted above the entrance. It has its own dock where old schooners, fishing boats, and square-riggers pull in. Today, it provides just about anything and everything nautical for the serious yachtsman as well as tourists.

Greenport is a thriving village with many upscale restaurants, galleries, and specialty shops. It attracts tourists year-round with the many events that are held throughout the year. The Maritime Festival attracts thousands of people in autumn with tall ships anchored in the harbor and activities galore. The main streets are given over to vendors (many are not from the North Fork). It is all a bit tacky for my taste, but having

said that, I'm also glad to report that Greenport has managed to grow and evolve while maintaining its old charm. A popular T-shirt that is worn by locals highlights the difference between the North Fork and the Hamptons. It says, "In the Hamptons they call it sushi but here we call it bait."

HALLOCKVILLE

Hallockville Museum is located on the property of KeySpan, an energy company that acquired about 520 acres of land in the 1960s in Northville. In 1975 two nuclear power plants were to be built by the Long Island Lighting Company (LILCO) on this site. After an environmental-impact study was made, it was determined that one area on the southwest side of Hallock Pond was rich in archaeological artifacts dating to 1500 BC, and another area was filled with more recent Native American artifacts.

The nuclear plants were never built. In 1975 the entire Sound Avenue frontage of the site became part of the Northville Historical

District, and in 1981 the entire complex was put on the National Register of Historical Places. Hallockville is comprised of eleven houses, all owned by the museum and five of which stand on the Sound Avenue side of the property. All were built an inhabited by members of the Hallock family — hence Hallockville. Hallockville, according to Richard Wines, a local historian, is important because "together these houses tell a remarkable two-century-long story about family patriarchs who looked out for their children by providing them with homes and farms — generally at the time of their marriage — while at the same time keeping their offspring nearby and under parental control."

Today, Hallockville is open to the public and offers many educational and seasonal events throughout the year such as the Fall Festival. The Naugles Barn, which was built in 1938, is a venue for various events such as weddings and dances. For more information, call (631) 298-5292.

VINEYARDS AND WINERIES

ACKERLY POND VINEYARDS

ESTABLISHED: 1988

ACRES: 85

1375 Peconic Lane

Peconic, NY 11958

PHONE: (631) 765-6861

www.ackerlypondvineyards.com

BEDELL CELLARS

ESTABLISHED: 1980

ACRES: 57

36225 Main Road (Route 25)

Cutchogue, NY 11935

PHONE: (631) 734-7537

www.bedellcellars.com

BRIDGE VINEYARDS

ESTABLISED: 2001

ACRES: 32

8850 Bridge Lane

Cutchogue, NY 11935

PHONE: (917) 439-6592

www.bridgevineyards.com

No tasting room

CASTELLO DI BORGHESE

ESTABLISHED: 1973 (formerly Hargrave Vineyard)

ACRES: 85

Route 48 and Alvah's Lane

Cutchogue, NY 11935

PHONE: (631) 734-5111

www.castellodiborghese.com

CHANNING DAUGHTERS WINERY

1927 Scuttlehole Road

Bridgehampton, NY 11932

PHONE: (631) 537-7224

www.channingdaughters.com

COMTESSE THERESE

ESTABLISHED: 2000

ACRES: 10

Union Avenue and Route 105

Aquebogue, NY 11931

PHONE: (631) 871-9194

www.comtessetherese.com

No tasting room

COREY CREEK

ESTABLISHED: 1993

ACRES: 30

Main Road (Route 25)

Southold, NY 11971

PHONE: (631) 765-4168

www.coreycreek.com

DUCK WALK VINEYARDS

ESTABLISHED: 1994

ACRES: 130

231 Montauk Highway (Route 27)

Water Mill, NY 11976

PHONE: (631) 726-7555

www.duckwalk.com

JAMESPORT VINEYARDS

ESTABLISHED: 1981

ACRES: 60

Main Road (Route 25)

Jamesport, NY 11947

PHONE: (631) 722-5256

www.jamesport-vineyards.com

JASON'S VINEYARD

ESTABLISHED: 1997

ACRES: 20

Main Road (Route 25)

Jamesport, NY 11958

PHONE: (631) 926-8486

www.jasonsvineyard.com

No tasting room

LAUREL LAKE VINEYARDS

ESTABLISHED: 1994

ACRES: 17

3165 Main Road

Laurel, NY 11948

PHONE: (631) 298-1420

www.llwines.com

THE LENZ WINERY

Main Road (Route 25)

Peconic, NY 11958

PHONE: (631) 734-6010

www.lenzwine.com

LIEB FAMILY CELLARS
35 Cox Neck Road
Mattituck, NY 11952
PHONE: (631) 298-1942
www.liebcellars.com

MACARI VINEYARDS
ESTABLISHED: 1995
ACRES: 180
150 Bergen Ave.
Mattituck, NY 11952
PHONE: (631) 298-0100
www.macariwines.com

MANOR HILL VINEYARDS
ESTABLISHED: 1997
ACRES: 55
14035 Middle Road
Cutchogue, NY 11935
PHONE: (631) 734-WINE (9463)
www.manorhillwines.com
No tasting room

MARTHA CLARA VINEYARDS
6025 Sound Ave., Route 48
Riverhead, NY 11901
PHONE: (631) 298-0075
www.marthaclaravineyards.com

THE OLD FIELD VINEYARDS
ESTABLISHED: 1974
ACRES: 12
59600 Main Road (Route 25)
Southold, NY 11971
PHONE: (631) 765-0004
www.theoldfield.com

OSPREY'S DOMINION VINEYARDS
ESTABLISHED: 1983
ACRES: 75 under vines
44075 Route 25
Peconic, NY 11958
PHONE: (631) 765-6188
www.ospreysdominion.com

PALMER VINEYARDS
108 Sound Avenue (Route 48)
Riverhead, NY 11901
PHONE: (631) 722-WINE (9463)
www.palmervineyards.com

PAUMANOK VINEYARDS
1074 Main Road (Route 25)
Aquebogue, NY 11931
PHONE: (631) 722-8800
www.paumanok.com

PECONIC BAY WINERY
ESTABLISHED: 1980
ACRES: 200
31320 Main Road (Route 25)
Cutchogue, NY 11935
PHONE: (631) 734-7361
www.peconicbaywinery.com

PELLEGRINI VINEYARDS
ESTABLISHED: 1991
ACRES: 70
23005 Main Road (Route 25)
Cutchogue, NY 11935
PHONE: (631) 734-4111
www.pellegrinivineyards.com

PINDAR VINEYARDS
ESTABLISHED: 1979
ACRES: 667
Main Road (Route 25)
Peconic, NY 11958
PHONE: (631) 734-6200
www.pindar.net

PUGLIESE VINEYARDS
ESTABLISHED: 1980
ACRES: 50
Main Road (Route 25)
Cutchogue, NY 11935
PHONE: (631) 734-4057
www.pugliesevineyards.com

RAPHAEL

ESTABLISHED: 1996

ACRES: 60

39390 Main Road (Route 25)

Peconic, NY 11958

PHONE: (631) 765-1100

www.raphaelwine.com

ROANOKE VINEYARDS

ESTABLISHED: 2000

ACRES: 10

3543 Sound Avenue

Riverhead, NY 11901

PHONE: (631) 727-4161

www.roanokevineyards.com

SCHNEIDER VINEYARDS

ESTABLISHED: 1994

ACRES: 22

2248 Roanoke Avenue

Riverhead, NY 11901

PHONE: (631) 727-3334

www.schneidervineyards.com

No tasting room

SHERWOOD HOUSE VINEYARDS

ESTABLISHED: 1996

ACRES: 38

2600 Oregon Road

Mattituck, NY 11952

PHONE: (631) 298-1396

www.sherwoodhousevineyards.com

No tasting room

SHINN ESTATE VINEYARDS

ESTABLISHED: 1998

ACRES: 22

2000 Oregon Road

Mattituck, NY 11952

PHONE: (631) 804-0367

www.shinnestatevineyards.com

TERNHAVEN CELLARS

ESTABLISHED: 1994

ACRES: 5

331 Front Street

Greenport, NY 11944

PHONE: (631) 477-8737

www.ternhaven.com

VINEYARD 48

ESTABLISHED: 1982 (formerly Bidwell)

ACRES: 33

18910 Route 48

Cutchogue, NY 11935

PHONE: (631) 734-5200

www.vineyard48.net

WATERS CREST WINERY

ESTABLISHED: 2001

22355 Route 48, Unit 6

Cutchogue, NY 11935

PHONE: (631) 734-5065

www.waterscrestwinery.com

ACKNOWLEDGMENTS

I am very grateful to the following people and organizations for their kind assistance, enthusiasm, and support:

At Abrams I'd like to thank my editor, Andrea Danese; Eric Himmel; Laura Tam; Miko McGinty; Rita Jules; and Darilyn Carnes.

Also Dr. Ismael Denenburg, Harris Sarney, Chris Mare, Dr. Robert Towner, Thomas Langhauser, Ellen Kosciusko, Richard Wines, Eric Fry, Margaret Shakespeare, Tom Amara, Mattituck-Laurel Library, Hallockville Museum Farm and Folklife Center, the Southold Historical Society, and the Long Island Wine Council.

Editor: Andrea Danese
Designers: Miko McGinty and Rita Jules
Production Manager: Jacquie Poirier

Library of Congress Cataloging-in-Publication Data

Haralambou, Harry.
 North Fork living : rustic splendor on Long Island's East End / Harry Haralambou.
 p. cm.
 ISBN 13: 978-0-8109-9300-6
 ISBN 10: 0-8109-9300-7
 1. North Fork (N.Y. : Peninsula)—Description and travel. 2. North Fork (N.Y. : Peninsula)—Social life and customs. 3. Country life—New York (State)—North Fork (Peninsula) 4. North Fork (N.Y. : Peninsula)—Guidebooks. 5. Historic sites—New York (State)—North Fork (Peninsula)—Guidebooks. 6. Vineyards—New York (State)—North Fork (Peninsula)—Guidebooks. 7. Wineries—New York (State)—North Fork (Peninsula)—Guidebooks. I. Title.

 F127.L8H27 2007
 917.47'210444—dc22

 2006036116

Printed and bound in China
10 9 8 7 6 5 4 3 2 1

HNA
harry n. abrams, inc.
a subsidiary of La Martinière Groupe
115 West 18th Street
New York, NY 10011
www.hnabooks.com